Intangible Economies

Intangible Economies

Edited by Antonia Hirsch
Fillip Editions 2012

Folio Series: B

Contents

Preface

The current economic crisis has now lasted for almost half a decade: a slightly surprising development, given that capitalism's paradigmatic push toward growth and expansion induces the sort of optimism that seems to manufacture its own factual realities. Despite the prognostications of doomsayers in 2008, deep in our hearts we seemed to believe that this crisis, too, would blow over in just a few months.

It is the persistence of the current crisis that has enabled a more thorough and sustained discussion of terms such as value, credit, debt, and exchange. In fact, it may have permitted a rethinking of these terms' signification, allowing older texts to be reconsidered in a contemporary context and begging the question: When does a crisis become "the new normal," something not to be overcome, but rather to be inhabited as a new set of paradigms?

Some of the effects of the crisis seemed to not fully unfold until at least two years after its 2007/08 onset. Within the art world and the broader cultural sector, the collapse of the art market, drastic funding cuts, and a difficult job market severely impacted cultural producers—the artistic precariat—that commonly eke out a living and a practice based on a combination of sales, stipends, and casual jobs.

It is against this material background that this book emerged—a context that continues to lend the topic urgency. However, rather than analyze art market dynamics and governmental funding policies (thereby perpetuating the prevalent tendency to debate economic concerns as fiscal phenomena), this anthology aims to articulate

the amorphous intersection of affect and economy as an existential paradigm that is axiomatic to any society and, by extension, also represents the foundational source of creative production.

The essays in this volume regard economy as a system in which what we call "exchange" is actually a dialectical operation that creates representation. The abstract and abstracting quality of value becomes a fulcrum in this constellation, both in its functional role in a capitalist economy and in its relevance to an ethics. While affect is to be recognized as both a generator and a consequence of economic exchanges, it is, conversely, also the modality of those exchanges that structure affect, resulting in the topographies of the sensible that underpin everyday life.

The present book started out as a series of casual conversations among an affective network—a group of friends and colleagues. These dialogues initially occurred in the course of investigations occasioned by my own art practice, and it was the inspiring nature of these conversations that gave rise to the idea to deepen and formalize the discussions while retaining their open and highly speculative character. The project was devised in several stages, first allowing contributors to put forward their theses, to then present and test their ideas with a readership and in front of a live audience, and to finally articulate them for this book. Thus, seven of the invited artists, curators, and writers contributed essays to *Fillip* magazine;[1] in the fall of 2011, a three-day conference was held in Vancouver where (often revised) versions of these papers were presented in dialogue with each other and the audience. Here, the openness of the live format was mobilized by several presenters, offering performative presentations or supporting their ideas with comprehensive image-essays that performed a discourse in their own right.

This anthology begins with a text by Melanie Gilligan. In setting out the tenets of her video work *The Common Sense* (2012) Gilligan simultaneously maps out key aspects that also define this book's scope, closely examining the particular ways in which affect, feeling, and emotion animate capitalist structures. Evoking an economy of representation, Hadley+Maxwell's theatrical script challenges models of the artist as compromised mediator between an imaginary and a shared reality. My conversation with Olaf Nicolai explores the thesis that a particular economic system will create its own economy of signs, and therefore necessarily must produce particular forms of cultural expression. Using the poetically named "letters of indulgence" dispensed by the Catholic Church during the Middle Ages as his point of departure, Jan Verwoert speculates on an economy of faith fuelled by a potent mix of debt and redemption as embodied in a contract with a higher power. Monika Szewzcyk's essay is a meditation on the potential agency of the blank as a space that denies representation, and by extension, valuation. Discussing works by N.E. Thing Co. and Cildo Meireles that, in turn, engage the iconography and material form of paper money, Juan A. Gaitán reflects on the inextricable historical linkage between the circulation of imagery and national wealth manifest in land and natural resources. The potlatch has been heavily romanticized and is conjured regularly as a paragon of an alternative economic paradigm based on generosity; in her essay, Candice Hopkins dismantles this myth of cultural purity and innocence by incisively demonstrating that as a—by no means dead—tradition, the potlatch is subject to, and agent in, a process of mimicry and exchange that while inf(l)ected by capitalist forces, seems nevertheless able to project a third space. Patricia Reed's concluding essay positions ethics as based on a

surplus, its politicity[2] mobilized by what cannot be accounted for in current spheres of normativity.

Intangible Economies continues the trajectories of two previous projects that adopted a similar format: *Judgment and Contemporary Art Criticism* (published in 2010 in the same Folio series as the present volume)[3] and *Vancouver Art & Economies* (2007),[4] which was closely modelled on the 1991 publication *Vancouver Anthology: The Institutional Politics of Art*.[5] While deploying diverse approaches, all of these projects attempt to situate the question of practice against the changing parameters that condition its modality, be they economic, institutional, or academic. *Intangible Economies* departs from this lineage in that it considers the question of economy primarily from the perspective of what animates individual production in ways that often don't announce themselves as relating explicitly to questions of economy.

All of the projects I name above involved conferences or lecture series that culminated in books and, just like *Intangible Economies*, all of these projects owe much of their success to the Vancouver audiences that populated the respective conferences and talks. This public rigorously critiqued, argued, and submitted the positions advanced by the invited contributors to intense scrutiny, a gesture that is in itself a generous investment. Exemplary of these discussions, this volume also contains a transcript of the respondent session led by Clint Burnham at the *Intangible Economies* forum in Vancouver.

Two of the antecedent conference and publication projects were produced either exclusively by Artspeak (*Vancouver Art & Economies*) or in association with Fillip (*Judgment and Contemporary Art Criticism*). The *Intangible Economies* forum, in turn, would not have been possible without the support of this vital collaborator, and I extend

a special thanks to Melanie O'Brian, who committed to co-presenting *Intangible Economies* during her tenure as Director/Curator of Artspeak. My thanks goes also to current Artspeak Director Kim Nguyen and Associate Director Peter Gazendam.

Of course, nothing at all would have been possible without the contributors assembled within this book— Juan A. Gaitán, Melanie Gilligan, Hadley+Maxwell, Candice Hopkins, Olaf Nicolai, Patricia Reed, Monika Szewczyk, and Jan Verwoert. Thanks are also due to the respondents during the forum, Clint Burnham and Marina Roy.

The project would also not have been possible without the indefatigable perseverance of the Fillip team: first and foremost Jeff Khonsary, and editors Kristina Lee Podesva, Kate Steinmann, Magnolia Pauker, and Jaclyn Arndt. Copious thanks also go to Colin Griffiths, Jonathan Middleton, and the numerous volunteers that contributed their generosity and skills.

The project was made possible with the financial support of the Canada Council for the Arts through its Visual Arts Projects Program, and the City of Vancouver. The participation of Olaf Nicolai was in part made possible through the Goethe Satellite Vancouver Series. Jane Irwin and Ross Hill made an incredible contribution to the project by providing the GreyChurch Collection & Project Space as the setting for the project's forum. Fillip would like to also acknowledge the ongoing support received from the Canada Council for the Arts, the British Columbia Arts Council, the City of Vancouver, and the Andy Warhol Foundation for the Visual Arts.

—Antonia Hirsch

1. *Fillip* 13 (Spring 2011): Candice Hopkins and Jan Verwoert; *Fillip* 14 (Summer 2011): Hadley+Maxwell and Monika Szewczyk; *Fillip* 15 (Fall 2011): Juan A. Gaitán and Olaf Nicolai (interview); *Fillip* 16 (Spring 2012): Melanie Gilligan and Olaf Nicolai (artist's project).

2. I was introduced to this term by Patricia Reed's writing. She describes it thus: "A neologism in English, 'politicity' is a translation of the French *politicité*, indicating the capacity to be political."

3. Jeff Khonsary and Melanie O'Brian, eds., *Judgment and Contemporary Art Criticism* (Vancouver: Fillip Editions and Artspeak, 2010).

4. Melanie O'Brian, ed., *Vancouver Art & Economies* (Vancouver: Arsenal Pulp Press and Artspeak, 2007).

5. Stan Douglas, ed., *Vancouver Anthology: The Institutional Politics of Art* (Vancouver: Talon Books and Or Gallery, 2011).

Antonia Hirsch

Intangible Economies

An Introduction

What does it mean to speak of "economy"? Etymologically, the term stems from the Greek *oikonomia* (household management) from *oikos* (house) and *nomos* (law, regulation, management); only in modernity did "economy" begin to signify the wealth and resources of a country, i.e., political economy. Meanwhile, the notion of a household already conjures much more than abstract fiscal transactions: it implies people living together under one roof.

The term "intangible" reinforces an understanding of economy as made up of more than rational facts and figures. The concept has entered into the conventional teachings of economics and various other discourses such as law, where it variously describes such assets that cannot be physically measured—that literally cannot be touched. The word is used to describe phenomena such as employee morale, quality of life, and copyrights. The intention of this book, however, is to focus on one particular intangible with regard to economy, that of affect.

Affect, while a common enough term, describes, in fact, a difficult-to-grasp phenomenon that alternatively could be described as an "intensity" resulting from sensory input. It is pre-Symbolic, not yet culturally coded, and based in embodied experience.[1] Economic activity frequently produces affective relationships—i.e., relationships that evoke an intensity in their participating parties, for example in the process of trade and the division of labour. Conversely, affect, and in particular desire, also generates economic transactions, and can be considered a fundamental motor of any capitalist economy: it is the *needing* and *wanting* that demands to be satisfied by goods or immaterial values such as care, attention, or love.

Focusing on the interconnected nature of affect and economy would be impossible without a consideration of the gift because, as a transaction, it is explicitly bound up with affectivity. Marcel Mauss establishes that far from being an aberration of modern economies, the gift forms their very foundation. Reflecting on economic forms in the various societies on which he bases the empirical study for his seminal essay *The Gift: The Form and Reason for Exchange in Archaic Societies*,[2] he states that *the market is a human phenomenon that, in our view, is not foreign to any known society—but whose system of exchange is different from ours. In these societies we shall see the market as it existed before the institution of traders and before their main invention—money proper. We shall see how it functioned both before the discovery of forms of contract and sale that may be said to be modern..., and also before money, minted and inscribed.*[3]

Money—this most tangible aspect of an otherwise abstract system—functions like a commodity, but does so as a universal exchange equivalent, a floating signifier that is still expressive of the affective charge inherent in the gift. While the idea that a gift "pays for something" is some-what of a taboo, it is understood that a gift can engender a kind of debt, and thereby instantiate a social bond. Representative money—as in promissory notes (documenting a debt)[4] and other currencies whose material value is less than their face value—emerged in Europe during the Dutch Golden Age, with its now famous credit crisis engendered by a craze for tulips. Money is peculiar in that it only signifies by way of circulation, asserts value only through exchange, and as a stand-in for an abstract debt we must trust that a dirty little bit of paper can be a placeholder for something that has use value, not just exchange value. This trust is by definition a social function and in the case of paper money and coins made of base metals, it performs

the miracle that alchemists long pursued in order to transform lead into gold.

Parallel to personal debt being rendered abstract by the increasing pervasiveness of representative money in the early bourgeois society of seventeenth-century Holland, a change in social hierarchies took place. Social position in that society now included a burgeoning middle class of affluent merchants, and thus became also based on wealth and possession and not just on blood lines, as had previously been the case.[5] The depersonalization of debt through the invention of representative money can therefore be considered as but one facet of a broader set of concerns during the seventeenth and eighteenth centuries that heralded the beginning of modernity in Europe.

Meanwhile, the role that the gift may have played in the proto-economic social structures described by Mauss is also inflected by a notion of giftedness—an idea that in postmodern times has become problematic in its correlation to the gifted (genius). Today the presupposition that an artist must possess singular abilities is questionable, even though the art market thrives on this assumption. The idea of the creative gift implies something supernatural, something that exceeds the artist's skill, forming a kind of transcendent element; the fact that what the gift enables is not entirely of the artist's own making also constitutes a debt—albeit, in a secular society, this is a debt owed to an unknown or unspecified creditor. And yet this debt must be returned, the gift's product put into circulation.[6]

I suggest that economy can be regarded as a system in which, through exchange, a type of dialectical operation enacts representation. Having earlier conjured the etymological roots of economy *(oikos/nomos)*, it is tempting to assume that *nomos*, the word for law and regulation, also forms the etymological root for "naming." However, the

latter term derives from a different word: *onomos*. Nevertheless, this etymological confusion—conflating regulation and management with naming—remains compelling when considering economy as a system where an act of representation determines what can stand in for something else. In linguistics, and by extension in naming, Ferdinand de Saussure has taught that this essentially arbitrary relationship between signifier and signified is only operative within a given system. In Saussure's teachings, this "system" is a language—a cultural construct that, to be called a system, must underlie somewhat consistent rules, or customs. While the effect of signification is not a given and arises from its use and enaction, it is subject to constant, more or less subtle, change because signification has to be continually performed and in every instance of enaction slight changes are able to occur. It is a system that exists only through a doing.

This process of establishing signification is essentially one of trade; one could even say it involves a kind of bartering: I put forth a word and mean it to say X, you accept that word by using it in a slightly different context thereby altering its meaning minutely, rendering it X^2; I say, I'll pay you five bucks for this sack of potatoes; you say, I'll let you have it for seven, and in the end we agree on six.

This seemingly simple establishment of a good's value—i.e., the establishment of what it can be represented by—involves material, land, and people. All of these elements must connect in complex ways and the abstraction that is necessary for this operation to take place is at once at the base of any system of representation and is also integral to Marx's theory of alienation. The notion of alienation also already contains the idea embodied in the Hegelian *Entäußerung* later mobilized by Marx to express workers "expending," or "selling," their labour only to subsequently encounter it in the form of commodities.

By highlighting abstraction, I may appear to be characterizing economy as a kind of inanimate, mechanized system. Yet quite to the contrary, if an economy is considered as a system of exchange, it requires actors that perform this exchange. And while fundamental to human nature, its particular formation is man-made, and economic dynamics operate as an articulation of social structures that, in turn, are based on actual individual relationships.[7]

In his exploration of gift economies Mauss identifies an important facet: namely the connection of the economy with the notion of (moral) values through its enactment of interpersonal relationships, once more emphasizing the aforementioned factor of *performativity* in representation. This type of representation may take the form of a script, as for a play, a film, or "history"—or a law or customs as expression of an ethics founded on a set of values.[8] Mauss highlights how in what he calls "archaic societies" economic activity is interwoven with the social through "contractual morality, namely, how the law relating to things even today remains linked to the law relating to persons."[9] He goes on to state that *this morality and organization still function in our own societies, in unchanging fashion and, so to speak, hidden, below the surface, and as we believe that in this we have found one of the human foundations on which our societies are built, we shall be able to deduce a few moral conclusions concerning certain problems posed by the crisis in our own law and economic organization.*[10]

Mauss mentions a crisis and, indeed, his essay *The Gift* was published in 1923–24, just a few years prior to the Great Depression (1929–33) and contemporaneously with the German Inflation Crisis (1914–23). By definition, a crisis is a point at which previous assumptions that ensured the smooth operation of whatever system we might consider fail. It represents a rupture in the flow of things not

unlike that of a revolution, suggesting an interconnection between the precariousness of a crisis, the inherent revolutionary potential of such a crisis, and the libidinal force—expressing the pursuit of an ideal—that arises from this mix, forcing a reflection on what really matters existentially, what is of essential value.[11]

When I think of crises in pictures, what I conjure are often images of accumulations of people. People in line-ups, people in military formations, people huddled in shelters, or people protesting. These images perhaps come to mind most immediately because I recognize in them the strange power of physical proximity—of affectivity—in large groups of people bound by a volatile energy that both fuels and seems to resist the drive of the crowd to represent itself to itself, to articulate itself as a social body.

Interestingly, recent movements such as Occupy have inaugurated new types of group engagement in the sense that they seem to employ very distinct modes of communication and discourse, as evidenced for example in the call-and-response format of public address, or the deliberate refusal to define clear, overarching demands that are otherwise considered fundamental to a productive public dialogue.[12]

In accepting the notion of an economy functioning as a system of representation—at the intersection of "picturing" and "representing interests"—it also becomes recognizable as fundamental to the process of subject formation. The German word "*Entäußerung*" offers a poignant clue to this idea because it not only translates into the English terms "divestment," "externalization," and "alienation," but it also contains the German reflexive verb "*sich äußern*" which means to speak out, express oneself, to pronounce, or to manifest. This complex of meaning seems to illustrate the connection between cultural production, whether it be in writing, visual arts, or other disciplines. It also invokes a

quality of becoming self through expression; that is, externalizing a part of oneself—Jacques Lacan's entry into the Symbolic order.

The Slovenian philosopher Rado Riha stated, "eine Idee ist ein Lebensakt" (an idea is an "act of living," an existential act),[13] a significant statement in the context of this book. It is a project, after all, that trades in ideas expressed primarily through language, their most common vehicle. In its necessary abstraction even the most basic linguistic articulation requires an act of faith, namely that the signifier is, in fact, transmitting the signified. The exchange of complex abstract ideas multiplies this miraculous transmission of meaning to the nth power. Yet ideas can signify only in a dialectical matrix, an exchange, and they accrue value only in their circulation. And it is in this quality that they strangely resemble money.

It is the sometimes mind-boggling abstraction of ideas traded that points out their pivotal role in an economy of desire: the idea will always be more connective than the realization of that idea. Since it is an individually idealized construct, it is embedded in a desirous, libidinal order. And, ironically, it is precisely the misunderstandings on which a *shared* idea is inevitably based that make it so connective, so powerful as a social bond.[14]

Äußerung/Entäußerung marks the moment when a subject emerges, an entry into the Symbolic order, into language, and by extension into a social matrix. At the same time, another kind of partaking in a social matrix gives rise to a much more material alienation through the Marxian alienation of labour, the expenditure of one's labour power. This alienation, this abstraction, marks a loss.[15] Yet, also connected to the word-complex *Äußerung/Entäußerung* is the expression "*außer sich sein*"—to be beside oneself. This, too, describes a loss: the dialectical losing oneself,

being alienated from oneself, and at once becoming self, finding oneself positioned. It describes the quintessential affective state: an unmediated intensity.[16]

It is Jacques Derrida's project in *Given Time: I. Counterfeit Money* (1992) to establish the notion of the gift that is so central to Mauss's project—and quite contrary to the sociologist's thesis—as extra-Symbolic.[17] For Derrida, any gift understood as such or intended as such by the donor or recipient ceases to deserve the designation of "gift"— something freely given without implied obligation (of return). Hence Derrida's gift defines itself as external to an economy of exchange, of tit for tat; it refuses the representation that is fundamental to the Symbolic order. Derrida writes: *A gift that would neither give itself, nor give itself as such, and that could not take place except on the condition of not taking place—and of remaining impossible, without dialectical sublation of the contradiction? To desire, to desire to think the impossible, to desire, to desire to give the impossible—this is obviously madness. The discourse that orders itself on this madness cannot let itself be contaminated by it.*[18] For Derrida, a gift given seems something truly lost, and the loss, rather than marking a privation, actually describes the entry into an entirely different order: the impossible.

If economy is an articulation of a social matrix and vice versa, one might ask whether this is a closed circuit—one always mapping the other, caught in an entropic system. It is easy to see how affect—and in particular, desire—can, as a disruptive force in this constellation, produce change or "innovation" (the latter a marketable form of the former). If it is possible to "make a loss" the way Derrida describes, *sich zu veräußern*, to be beside oneself, moved by an affective force, then Derrida's gift marks a bridge between an ideal and a material reality, an impossible condition where the ideal is not rendered obsolete by its attempted realization.

It would be both naive and ignorant to position cultural production as generative of this gift, but it is perhaps the indeterminacy in relation to both where and what kind of value can arise in cultural production that gives it agency and that opens up a space for the impossible.

1. For a detailed discussion of the relationship between affect, feeling, and emotion, see Melanie Gilligan's "Affect & Exchange," page 25 of this volume as well as Brian Massumi, *Parables for the Virtual: Movement, Affect, Sensation* (Durham, NC: Duke University Press, 2002).

2. Marcel Mauss, *The Gift: The Form and Reason for Exchange in Archaic Societies* (London: W. W. Norton, 1990). The gift economy and in particular the cultural form of the potlatch have inspired the imagination of artists over many decades, regardless of how well the custom was actually understood. This preoccupation is evident, for example, in the bulletin entitled *Potlatch*, which ran from 1954 to 1959, issued by the Lettrist International and affiliated with the Situationist International, or, more recently, in works associated with relational aesthetics, such as Rirkrit Tiravanija's cooking performances.

3. Mauss, *The Gift*, 4.

4. See Jan Verwoert's essay "Faith Money Love," page 117 of this volume.

5. Anne Goldgar, *Tulipmania: Money, Honor, and Knowledge in the Dutch Golden Age* (Chicago: University of Chicago Press, 2008).

6. See Lewis Hyde, *The Gift: How the Creative Spirit Transforms the World* (London: Canongate Books, 2006).

7. The Foucauldian term *dispositif*, which translates into the English "apparatus," outlines the multifaceted formations

of these relationships. Foucault describes the *dispositif* as *a thoroughly heterogeneous set consisting of discourses, institutions, architectural forms, regulatory decisions, laws, administrative measures, scientific statements, philosophical, moral, and philantropic propositions—in short, the said as much as the unsaid. Such are the elements of the apparatus. The apparatus itself is the network that can be established between these elements.* Michel Foucault, *Power/Knowledge: Selected Interviews and Other Writings, 1972–1977*, ed. C. Gordon (New York: Panthenon Books, 1980), 194–96.

8. See Hadley+Maxwell's "Someone That Happens," page 99 of this volume.

9. Marcel Mauss, *The Gift*, 4.

10. Ibid.

11. Over the past century there have been numerous books, some of them considered seminal, that touch on the entanglement of economy and affect. In addition to Marcel Mauss's writings, there are Georges Bataille's *The Accursed Share* (1946–49) and Jean-François Lyotard's *Libidinal Economy* (1974), all of which were written during or around significant crises, including the Great Depression and the Second World War, as well as the Vietnam War and student revolts of the late 1960s. More recently, initiatives by artists and curators that approach the topic of the economy include Harald Szeemann, *Money and Value/The Last Taboo: Geld und Wert/Das letzte Tabu* (Chicago: Art Stock, 2002); Dòra Hegyi and Zsuzsa Làszlò, *Periferic 8 Biennial of Contemporary Art: Art as Gift* (Iasi: Asociatia Vector Iasi, 2008); Ted Purves, ed., *What We Want Is Free: Generosity And Exchange in Recent Art* (Albany, NY: SUNY Press, 2005).

12. See Monika Szewcyk's "Investing in the Blank," page 51 and the Forum Discussion Transcript on page 209 of this volume.

13. Rado Riha, "Die Idee als Denken der Politik," lecture, KW Institute of Contemporary Art, Berlin, March 2, 2010. Riha's statement stands, of course, in close connection to Schopenhauer's notion of Will. See Arthur Schopenhauer, *The World as Will and Presentation,* ed. David Berman (London: J. M. Dent; Rutland, Vt.: Charles E. Tuttle, 1995).

14. For a more complex reading of the notion of misunderstanding, consult Patricia Reed's "Economies of Common Infinitude," page 181 of this volume.

15. I came to the term *Entäußerung* somewhat naively, aware only of its relevance to economy through Marx's writings. I made the observation that the word also embraces the notion of *"sich äussern"*—to "externalize oneself"—and extrapolated in my own construction of thoughts a more philosophical meaning from it. Only later did I learn, thanks to Wolfgang Winkler, that this idea is extensively discussed by Hegel. I do not pretend to be conversant in Hegel's philosophy, but nevertheless wish to indicate a source for further reading on the topic: Georg Wilhelm Friedrich Hegel, *Phänomenologie des Geistes*, Kapitel VIII, "Das absolute Wissen," http://fillip.ca/iz9k. Also see Karl Marx, *Ökonomisch-philosophische Manuskripte aus dem Jahre 1844*, Drittes Manuskript, "Privateigentum und Arbeit," http://fillip.ca/c1ko.

16. It seems but a small step from here to Stéphane Hessel's outrage. Stéphane Hessel, *Time for Outrage: Indignez-vous!* (New York: Twelve / Hachette Book Group, 2011).

17. Jacques Derrida, *Given Time: I. Counterfeit Money* (Chicago: University of Chicago Press, 1994).

18. Ibid., 35.

Melanie Gilligan
Affect & Exchange

In recent years, contradictions inherent to capital accumulation have forced an economic crisis and created an impasse in which extremes of economic inequality are intensifying. Rather than addressing these imbalances, most existing governmental structures seem to merely sustain the social order while assisting this process of uneven distribution. New social movements that include wide swathes of the population have begun to ignite across the globe, if only momentarily, in reaction to this situation. In this context, I want to present a series of arguments and speculative ideas that I have been developing throughout my work as an artist and in my writing.

Having worked for the past six years with the subject of what a massive economic crisis such as the current one would do to the political landscape, my focus has been on representing systemic economic shifts while contrasting them with their affective impact on people. I have concentrated my attention on the forces that shape political life beyond the representational politics of parties and voting—in other words, the intersection of biopolitics and capital. Throughout my practice certain questions recur: What are the potentials for collective action in the present and how must it be reconceived in an age of ever intensifying economic determinism and biopolitical control? How can struggle toward collective goals also take the full range of each individual's needs and desires into account? Can the individual subject be reconceived to incorporate the collective dimension that is always already contained within it? Can recognition of the importance of affect and emotions in politics help bring about new social scenarios? And, on the other hand, how do non-rational aspects of the subject,

such as affect and emotion, become embroiled in processes of capital accumulation? Ultimately, I intend that all these inquiries answer a larger question: What can help us change the current political and economic landscape and enable us to overcome capitalism in favour of a new system in which accumulation no longer determines human interaction?

Obviously, some of these questions are monumentally complex; for me, a useful means of approaching them is to think through fictions. Philosopher Denis Diderot used imagistic moments in his writing (which he called hieroglyphs) in order to activate the senses and affects as well as the mind, and I work similarly in that I write theory that is also fiction and fictions that are also theories. Here, the fiction that I deploy is *The Common Sense*, a TV-series-like video project currently in development. Its plot is a thought-experiment bringing the basic elements of these questions into play and figuring out their ramifications. The plot, resembling a science fiction, goes something like this: *The story is situated in a fictitious "now" after a world-wide revolution against economic inequality has erupted. What has catalyzed these events is the invention of a new technology that allows people to feel each other's emotions. Empathy and political solidarity suddenly become concrete and visceral sensations, bringing about strong desires for social change across the world. The relationship between individual and collective is suddenly profoundly transformed. Emancipation from economic bondage becomes the order of the day for many, but the problem is less figuring out what needs to be destroyed than what to build in its place. Moreover, this technological development that allows people to feel each other's feelings is not unambiguously good, nor does it solve all the world's social problems. While it creates possibilities for new modes of existence and collective social formations, it also leads to new contradictions and conflicts.*

Capitalism currently derives validity through its role in mediating all individual interests into coordinated relations of exchange, thereby sustaining the complex concatenation of value relations that have come to support all people's survival. However, my fiction posits that if one can feel another's needs as intensely as one's own, individual needs become collective in a profound and ontological sense, and the necessity for a system that mediates the relation of an individual's needs to the totality of everyone else's dissipates. I focus my story of revolutionary upheaval on emotions and affects because these seem to be at once overlooked and misunderstood, but also incredibly important. Crises of the capitalist system hit us in the belly, in the nervous system, they mobilize our desires and fears, the place where the body's physical needs and drives meet thought.[1] In a capitalist economy, people satisfy their needs (for nourishment, shelter, etc.) through the use values of commodities; yet at the same time the availability of each of these commodities is determined by its exchange value, which is external to use and fluctuates according to the movements of supply and demand, determining its market price. In an economic crisis like the one currently unfolding, people become acutely aware of how these exchange fluctuations control the most basic conditions of their physical existence. As such, the systemic crises of capital directly connect, through an umbilical-like tie, to immersion within physical, affective experience.

The approach I took in my serial video narrative *Popular Unrest* (2010) was to look at how emotions and affects are instrumentalized in capital accumulation and biopolitical control. In this text, I want to consider the other side of this predicament and ask what *potential* lies in affects and emotions relative to today's and future politics. The anti-government-cut protests and mass riots in the UK,

anti-austerity protests in Greece, the Los Indignados move-
ment in Spain, the Arab Spring uprisings and protests across
the Middle East and North Africa, as well as the Occupy
movement in North America that have occurred since late
2010, all share the quality of sudden massive upsurges of
frustration and desire, of collective grassroots actions with
people demanding change without being led or co-opted
by existing organizations. Los Indignados and the Occupy
movement especially seem to be riding a wave of feelings
and ideas that are by no means uniform, but nonetheless
manage to cohere sufficiently to give rise to mass action.
At this moment, when multiple, self-organized people's
movements are taking on an active and important role in
public life, it is significant to contemplate what bonds them
together in the absence of strong leadership or explicit,
shared principles and values.

Coverage in popular media as well as discourses within
academic, political, and socioeconomic contexts, whether
progressive or conservative, tend to position affect and
emotion as irrational, biased, and illegitimate, and there-
fore dismissible—except when they instrumentalize public
feelings in support of specific political goals such as a war.
This residual legacy of Enlightenment epistemology con-
siders emotions unalterably tethered to the incommunica-
bility of individual experience while, in contrast, rational
thought is seen to have the ability to open onto the social
world because its innate medium is language.

To illustrate, Bertolt Brecht famously intended to acti-
vate thinking rather than feeling through his plays. In a text
contrasting conventions of the naturalistic dramatic theatre
with his own epic theatre, Brecht described the main qual-
ity of the former as "feeling" that "provides [the audience
member] with sensations," while his own theatre is charac-
terized by "reason," which "forces him to take decisions."[2]

Against affective immersion in theatrical representation, Brecht preferred a distanced appreciation of events that, he believed, allowed the audience to understand that characters, and by extension they themselves, are "alterable and able to alter"; in other words, their subjectivities and political roles are socially constructed and therefore can be reconstructed through political struggle.

By contrast, some contemporary philosophical and other academic and scientific discourses understand affect to *overcome* this relegation of feeling to the inner world of the individual. A good deal of this work departs from writings by seventeenth-century philosopher Baruch Spinoza, who saw ideas and affects as two distinct modes of thought—with the idea as a mode of thought defined by its representational character and affect as a mode of thought "which doesn't represent anything."[3] Spinoza defines affect as the body's ability to affect and be affected, creating "modifications of the body whereby the active power of the said body is increased or diminished, aided or constrained."[4] When the body receives external or internal physical sensation, it responds somatically to these stimuli and they coalesce as affects, prior to registering in the conscious mind of an individual. Subjectivity is therefore radically open to the world and to the other by way of this preconscious affect.

Spinoza's proposition elucidates how affect escapes the confines of the individual subject's interiority. To pursue this thesis further, it is useful to attempt a distinction between affect, feeling, and emotion, and to ask whether there is a concomitant social dimension to any of these phenomena, bearing in mind that the distinctions may be tenuous as such phenomena tend to elude rational analysis and nomenclature. In defining a theoretical framework for understanding affect, Brian Massumi proposes that affects are *pre-personal* while emotions are *social*. Massumi also

mentions feelings, which can be interpreted to exist some-where between affect and emotion, namely as affects that register in the subject's conscious world of personal signi-fication. Pre-personal affect is, according to Massumi, "a non-conscious experience of intensity" that "cannot be fully realised in language…because affect is always prior to and/or outside of consciousness."[5] Affects precede cog-nitive identification with a constituted subject, stand prior to social contextualization, and cannot be "owned" by a specific individual. This corresponds with what Spinoza would call non-representational thought. Conversely, Massumi calls feelings and emotions "recognized affect." For Massumi, affects transform into conscious emotions, comprising dimensions of social relation and "discur-sively defined" signification that are socially communi-cable concepts—an operation that occurs retrospectively. Thus, emotions acquire an independence from the individ-ual body from which they emanate, engaging instead with social and political life. It is therefore possible to surmise that feelings are an intermediate stage where initial pro-cessing of affect emerges in the individual psyche, describ-ing a point between pre-personal affects and emotion as a social process. As such, feelings are the only point in this process that can rightfully be considered confined to the individual's inner world.

It is an assumption of the various hard sciences con-cerning subjectivity—such as neuroscience, cognitive sci-ence, cognitive psychology, and artificial intelligence—that subjective experience is determined by physiological changes, and the popular media tend to concur. In my new video project, *The Common Sense*, technology allows people to feel each other's feelings, but not to know each other's thoughts. This technology is therefore only able to read affects and convert them into data, reflecting a fact of

contemporary scientific research: that it is unable to register conscious thought, just physical outcomes generated by affects such as changes in body chemistry, temperature, blood pressure, etc.—in other words, Spinoza's non-representational aspects of thought.

My fictional scenario further suggests that affects are also potentially more susceptible to biopolitical control. If emotions are linked to the realm of traditional party politics and political action, affect, I suggest, is what connects subjectivity to biopower. It is no coincidence that the word "feeling" can indicate both physical and emotional sensation because the realm of feelings describes the blurry border between body and thought, which, for the contemporary sciences, articulates preconscious affect as a bridge to grasping the otherwise elusive qualities of human behaviour generated by conscious thought.

Biopolitics, for Michel Foucault, is a distinct form of power that deals neither with society, nor with the individual, but emerges as a conception of the social body as the object which government seeks to sustain. Biopolitical power treats populations as a body whose health requires care and, as such, must be treated as a total system. Biopower acts on this system preventively, reforming it biologically, politically, and scientifically to optimize the survival and productivity of the population as a labour force. Biopolitical forms of governance aim to maintain the functioning of the social body within a relatively homeostatic range through pre-emptive regulatory actions aimed at averting forecasted dangers—such as economic crises or terrorist attacks—which could imperil the life chances and productivity of, not individual bodies, but the entire social body. This need to recognize and productively process aleatory and unpredictable phenomena that can impact a population is precisely the reason why affect is increasingly

important in our culture: it is the physical, and so verifiable and localizable, link to unpredictable conscious thought.

Today, responsibilities that used to fall to the state, such as the social reproduction of labour power through providing health care, education, etc., have devolved to individuals themselves, who now must look to private services to meet these needs; similarly, biopolitical planning and pre-emption have become common practice for private businesses, representing corporate and financial interests. In this model, businesses police individual behaviour as a means of ensuring profits (e.g., in various kinds of insurance), or individuals self-police to avoid costly charges. Accordingly, more and more contemporary structures of social reproduction are negotiated on the free market. Through the highly financialized global market and its relentless demands to maximize profit, powerful mechanisms have evolved that allow companies to operate with a biopolitical modus operandi of prediction and pre-emption that mirrors the behaviour of the state. As a result, we see a more profound merging of the capitalist subject's social reproduction with the reproduction and expansion of capital. Individuals are asked to use principles of intelligent investment regarding their personal human capital, and their actions must not only be effective, but project a picture of future smooth functioning. Maintaining health, efficiency, social skills, conviviality, physical attractiveness, and countless other qualities means that we protect ourselves as our own best investment, an investment from which we cannot divest ourselves. Little investment in one's own human capital makes for a business risk, and if business will no longer invest in you, no one will. The examples above are extended instances of what Karl Marx defines as real subsumption,[6] in which the enhancement of productivity and the decrease of the costs of worker's reproduction allow the

capitalist to extract more surplus value. As a condition of labour under capital, real subsumption becomes generalized and, as such, impacts more and more aspects of the individual's existence. People allow these forms of real subsumption into the most personal corners of their lives because it is in their immediate interest and, in some cases, necessary for their survival.

The Social Body of Contemporary Capitalism

Although representational electoral politics today is still predicated on a social body that is composed of sovereign individuals modelled on the modern bourgeois citizen, in the contemporary tango of biopolitics and capital, individuals become mere cellular units. They break down into information parcels in the data representations of state and capital, "dividuals"[7] endlessly divisible and reducible to consumption preferences, affiliations, and online user-histories. As manifold characterizing data sets, individual identity and behaviour are fragmented; we are broken apart and reassembled algorithmically—mapped, assessed, targeted, and predicted regarding our usefulness for capital accumulation. Capital has always linked all activity through the socially negotiated interconnection of exchange so that any value is related to the movements of the total system. Now new forms of calculating individual identities are increasingly unifying those identities into one social body: capitalism. Consequently, I assert that capitalism and its diverse markets *are* the social body that biopolitics protects.

Biopolitics has evolved as the perfect political form for advanced capitalism and its future orientation assists a corresponding tendency of capital accumulation. Health

for capitalism means constant expansion—"economic growth," in popular parlance—and, we are told, it is essential to our survival. In the pursuit of growth, capitalism comes to acquire remarkably subjective qualities. As Marx explains, capital is a substance that propels its own self-expansion and self-reproduction (or its self-valorization, as Marx calls it), and as such it acquires a certain agency of its own.[8] Marx draws a parallel between capital and an independent subject when he says: "Value is here the *subject* of a process in which, while constantly assuming the form in turn of money and commodities, it changes its own magnitude, [produces] surplus-value from itself... and thus valorizes itself independently."[9] When Marx says "subject" here, he is playing on Hegel's use of that term, meaning that value moves according to its own internal (quasi-dialectical) logic of progression. However, he is also describing the uncanny condition experienced by all wage earners, whereby capital, brought into being by people as a means to exchange their labour and goods, becomes itself the main determinant of their activity, and capital's expansion becomes the aim for which they are compelled to strive. Exchange value stands "over and against" them just as in capitalism, a worker's labour comes to stand "over and against [the labourer] himself" in the form of the commodities he produces.[10] It is also in this ability of value to become autonomous where capital's future-orientation lies; the process of self-valorization must take place after investment and production, through exchange at a later date. Capital's expansion acquires a general focus on the future, which, as we will see, takes on further dimensions of agency today.

The global economic crisis of the past five years has particularly highlighted the interconnected nature of capitalism. What I call the social body of capitalism—said quality

of subjecthood and interconnectedness—is more visible in times of crisis when fear of contagion adds instability to markets' already volatile tendencies. A major trend in finance that has developed since the onset of the crisis is behavioural finance. Its goal is for traders to better understand and outwit the collective emotions, or animal spirits,[11] of the market, while also better managing their own emotional responses. Financial crashes and investor fear is not new; however, there are now financial instruments[12] created to ensure profits in any future outcome, thereby adding incredible volatility to the markets and instigating a much more perilous future as they redistribute the risk worldwide. Ironically, in order for individual investors to expand their own capital, they look for looming crises as opportunities. Investors are ostensibly afraid of the risk of buying a nation's bonds, therefore demanding a higher return on the national debt they are holding—but in actual fact, this is now a common way to make money: to ride the waves of fear in the markets in order to buy low and sell high. I argue that capital is a social body because it develops from this future-orientation a tendency toward collective reaction that then translates into behaviours, decisions, likes, and dislikes.

This subject-like agency of value and of capital is increasingly palpable in the activity of the financial markets as the euro crisis persists, collapsing nations and ousting politicians, and also in countries like Greece, Ireland, Portugal, Italy, and Spain, which have been forced by markets and international financial organizations to implement austerity measures as a means of cutting their deficits and even more disturbingly, to suppress protesting populations battling against these measures. In the past few years, and especially during the euro crisis, the roles of governments and financial markets have actually appeared to merge

as financial markets increasingly affect social policy. In November 2011, the financial markets effectively ousted Italian Prime Minister Silvio Berlusconi,[13] an event followed by an urgent scramble to put a new government into place before the opening of the markets on the next business day. On November 18, 2011, the *Financial Times* published a striking headline: "Rajoy begs for 'more than half an hour': Spanish conservative leader asks markets for time on economy,"[14] which means that Mariano Rajoy, the Spanish conservative leader who was expected to win a general election the following Sunday, was using the *Financial Times* as a way to speak to the spirit of the market.

Nowadays, it is a common enough occurrence to hear financial news announcers talking about what the market "wants" and "feels." Through collective financial market emotions such as fear and wariness, the financial markets effectively mobilize forces to administer social laws and ordinances more powerfully and with more finality than the United Nations or any other international governing body. With the International Monetary Fund and World Trade Organization as its foot soldiers, the market's "feelings" become instant realities. Massumi uses the term "affective facts" to describe moments when contemporary governments—and, one might add, markets—convert possible outcomes into very real facts through the self-propelling force of affect. According to the theorist, affect provides a continuity and connection where actual or factual outcomes have yet to solidify, so that pre-emptive measures transform forecasted future events into conditions in the present.[15]

In this context, it is important to understand capital as a totality, because capitalism reproduces the whole of social relations[16] and capital production only happens if capital's constituted totality is already presupposed.[17] However,

despite the fact that the financial markets take on a quality of agency in a similar manner as value, the collective will of the financial markets does not entirely represent something akin to the collective decision-making process of capital as a totality. Marx described that totality as the "total social capital," the disparate, incalculable whole of all the individual capitals in their dynamic concatenation, and reproduction, contending that capitalism cannot be understood without conceiving of this dimension of abstract totality. However, the gestalt that is formed through the collective thinking and action of financial investors represents the financial industry's own appraisal of the movements of capital as a relational whole. It does not express the totality of capital creation, but rather the decisions of the few able to capitalize on the movements of capital, giving rise to a partial and skewed image. Nevertheless the market is treated as if it *is* that collective mind of capital.

Exchange puts all commodities and activities into abstract relation—including people's production and their social reproduction through, for instance, labour, consumption, education, health care, and leisure. Exchange links millions of individuals because relations of equivalence are established through the measure of value, the labour embodied in a commodity. Money then allows this equivalence to be put into practice—such as, for instance, the equivalence between two commodities: "The value of this ham equals two pieces of plywood." These two different commodities do not have to be directly compared because they can be traded, their value measured via a third commodity, money. Money comes to represent a third term that is in a sense a measuring stick that externalizes the judgment that determines equivalence. The sophisticated complexity of the contemporary financial markets pushes this process of making disparate commodities equivalent into overdrive.

Today investors can compare the rates of return on any tradeable commodity, be it service work, factory labour, food, oil, metals, real estate, or currencies, and demand that they are competitive in comparison with one another. As a result each person's labour, wherever he or she is located in the global nexus of accumulation, is increasingly subject to pressures to render his or her labour competitively profitable (e.g., work for decreased wages to increase productivity). Contradictorily, the incredible abstraction of capital that puts all human activity into relation, an ability which under other conditions could hold a wide-ranging collective potential, only exists to be deployed for an extremely narrow and destructive purpose: that of accumulation through extracting value. Capital's need to expand (it cannot exist without expanding) constrains people's social and collective existence, since through measurement and exchange workers face their own labour—in the form of products of labour—as alienated from themselves. In the current economic crises we see the unleashing of further intensive biopolitical regulation and the expulsion of labour power from production (e.g., layoffs) because it is becoming ever more difficult for capital to ensure future value accumulation.

What follows will be some quite speculative and potentially contentious conclusions that I have drawn from my experiment in fiction. As Marx suggests, capital may not be the end condition of life for humans but a phase that sets the ground for a much better organization of human energy. What many people lack today is an idea of what that "something better" could be, having lost the belief that an alternative system to capitalism—such as socialism or communism[18]—is workable or desirable, and are haunted instead by the indelible images of failed revolutions. This might be why movements such as Occupy Wall Street do not project a picture of the changes they want to see but

rather the affective intensities of needing things to change. It is therefore important at this moment to allow for political thinking that is speculative and even far-fetched. Here is one possible conclusion to the storyline of *The Common Sense*: *We find ourselves in a future moment, when the full implications of the new, affect-connecting technology have been realized. A new collective form of self-government has evolved around the technology whereby individual interest no longer exists but rather the technology mingles all emotional feeds, giving a sense of the collective feeling of every person around the world.*

If, as in my video fiction, individual needs were overcome entirely, it would no longer be necessary to consider how these needs are mediated and put into connection. But as this technology does not exist (and many would be incredibly thankful it does not), and individual consciousness is a condition that must be done justice and grappled with, I am wondering whether some possible form of self-organized mediation of individual needs that is not in itself a form of exchange or population management could be part of a discussion of future communization. Toward this aim, I would like to briefly consider how capitalism itself, a system that is really just people plus money, is able to evolve a self-propagating, self-sustaining complexity that acquires collective behaviour, decision-making ability, and affects. The ailing system of capitalism has dimensions of self-organization, but these are always tempered by the control exerted through the ostensibly fair but entirely exploitative and inequitable exchange relations of labour in capital accumulation. While it puts the unfathomable complexity of all individual human needs and desires into abstract relation, it does so by aggregating wealth in the hands of an ever more exclusive few while broadening poverty and misery. Are there ways of retaining this ability to

construct relations and logics in practice while eliminating value and the value measure? If so, this could be very useful for a society that is collectively self-organized. But this would be contingent on a host of questions: Who would be building this society? Would certain people have the blueprint and not others? If we think of human action today as linked by, but not by any means reducible to, the totality of capital, the question, theoretically speaking, is how to abolish value while preserving the virtual potential inherent to capital—that of the abstract connection of human activity. Collective action needs then to be reconceived in terms of its own total collective system logic and the fight against capitalism must be understood as an assault on the system as a totality. To this end, I would like to consider how one might imagine new social forms that are adequate to today's conditions.

The conclusions that I draw here will move concisely through a series of ideas for the sake of brevity. First, I refer to a revolutionary event that attracted Marx's attention in 1844: the Silesian weavers' riots.[19] Marx says of the event: "We have seen: a social revolution possesses a *total* point of view because—even if it is confined to only one factory district—it represents a protest by man against dehumanized life."[20] He goes on to say that from the point of view of the particular individual, social revolution is able to address issues that face the collective, and he credits the logic of Silesian weavers with more insight than the great German philosophers and political vanguard of their time. Reading Marx's analysis, it is clear that it is not the weavers as individual geniuses under discussion but rather the genius of their actions, which, one can assume, would have combined affective impulse with rational decision-making. Commenting on Marx's discussion, Raya Dunayevskaya calls what is operating here "not only [a] revolutionary

force, but…Reason" itself.[21] In other words, the activity of the group takes on a total logic, a thinking of its own, not of individuals, but of the group and the class as a whole.

But what is this coherence in collective action such that it acquires a collective logic? Is it the result of shared frustrations and anger? Or of shared demands and grievances, rationally discussed and planned strategies put into action? Obviously, the historical remoteness of the weavers' rebellion works against our finding a definitive answer; however, it is useful to consider the concept of transindividuality, an idea proposed by philosopher Gilbert Simondon, in order to comprehend what allows the distinct actions of a group to combine into "reason" itself. Simondon's understanding, summed up by Jason Reade, is that "the very things that form the core and basis of our individuality, our subjectivity, sensations, language, and habits, by definition cannot be unique to us as individuals. These elements can only be described as pre-individual, as the preconditions of subjectivity."[22] As Brecht after Marx made clear, we are constructed by our social world, and so the social components that make us, as well as our biophysical "sensations and drives that make up the biological basis of subjectivity,"[23] are transindividual qualities that cut across our separate individual subjective lives and link us in differential relations to one another. There are moments when the preconscious intensities of affect, in their reaction and non-linguistic association with others, can work in such a way that they respond to social collective logics. We can conclude from our earlier discussion of affect, feeling, and emotion that these two non-individual aspects pass through the subject as feeling. From this perspective, feeling comes to resemble a door perpetually swinging open—either in the direction of the body's physicality on the one hand, or toward the collective dimension of the social world on the

other—briefly internalizing and reforming the external as actions and thoughts. This double openness of transindividuality holds great potential for the emergence of new forms of collective organization.

Marx and Dunayevskaya describe a logic of the total system that articulates itself in *actions*, while previously I discussed the totality of the market that is increasingly being understood to embody a collective *thinking* of capital. If we consider more closely the collective logic that emerges *in exchange* (i.e., in action), it is helpful to take a look at Marxist philosopher Alfred Sohn-Rethel's concept of what he called exchange abstraction.[24] Sohn-Rethel founds his definition of exchange abstraction on the act of commodity exchange, explaining that the abstraction brought about in exchange does not necessitate the formulation of concepts of equivalence in the mind of an individual. Rather the abstraction at work in all exchange occurs through social practice. Money allows the abstraction of equivalence to be realized in practice rather than conceptualized by the individual because with money, exchange negotiations by those bearing values in the form of commodities can now refer to money as an externalized form of judgment. This provides a sense of what the collective thinking of capital really is—individuals carrying out a logic in their actions, without the necessity of conscious thought or collective organization of decision-making, through an externalized measure. The logic that they are carrying out is a logic of the total system, of capital's presupposed totality.

In a sense, the operation of exchange abstraction shares similarities with what Marx and Dunayevskaya describe in the Silesian weavers' revolution; both display a logic that emerges through collective action, a thinking-through-practice that is independent of individual conscious thought. What conducts the Silesian weavers' logic

is affect; in exchange abstraction the factor that coheres behaviour into a system logic is a means of externalizing judgment, value, and money, the means of measuring labour. The measure mediates individual needs between people through enabling exchange. In my fiction, the sharing of affect is potentially a means of eliminating the need for value and measure, replacing money's externalizing, abstracting function by offering an alternative connective medium. Affect is not a phenomenon that is conducive to measure. However, the measurement of that which is not conducive to quantitative measurement is the core of capital's tendency toward crisis and its tendency to subordinate. It is precisely the insistence to impose measure on what does not conform to measurement—phenomena such as social skills or risk—that exerts a wholly capitalist kind of brutality. For instance, labour possesses dimensions beyond the qualities measured as value. Value is only ever a pathetic approximation that comprises one aspect of labour, its productivity within time, yet this concept has come to *define* labour. A good description of real subsumption via measurement is provided by the world of technology startups where, famously, the key to developing a sought-after, billion-dollar technology is to invent a way to quantify things that are as of yet unquantifiable.

While all our activity continues to be submitted to value as its measurement, seemingly emancipatory alternative means of organizing work (e.g., through self-organized workers' collectives or the limitation of labour-time to only the amount socially necessary for production, thus eliminating surplus value) will eventually give way to a return to capitalist business as usual, as many historical examples have shown.[25] The same is true for alternative exchange systems; for example, Pierre-Joseph Proudhon's idea of "labour-money": time-chits whereby labour is directly exchanged,

unmediated by money.[26] Marx criticized labour-money as simply rejecting the mediation of money while perpetuating the measurement of value.[27] It was clear to Marx that overcoming capital could only be effected by doing away with the measurement of value altogether.

If as long as the value measure is in place, and all attempts to live differently are swiftly drawn back into the capitalist vortex, then the most pressing question is how to eliminate value and its measure, money (an idea that most would consider fiction). For contemporary ultra-left theorists of communization such as Gilles Dauve and the group Endnotes, the aim is to avoid imagining the story of how communism might come about in the way many conventionally have done: first capitalism must be overthrown and then communism can be put in place. Instead, these thinkers propose a process of communization in which revolution consists of practices that in themselves challenge value's stranglehold on existence and dissolve the value measure. The instigation of situations where "everyone participates on the production of their own existence"[28] would need to be an ongoing part of revolution. However, many of these thinkers intentionally refrain from attempting to imagine what form these practices would take or how, if at all, they might be organized.

For Marx, the development of the productive forces in capitalism, which include all human capacities, provides the means of realizing communism as a latent potential. Which then begs the question: What aspects of capitalism can we transform in order to assist the process of extinguishing value? Capitalism enables an infinitely complex interrelation and (im)balance between the needs of billions of individuals through the process of exchange equivalences. Today, the concept of mediation necessarily brings associations of exchange value and money, or

management by the state or by businesses, but would these associations still prevail in a world without value? Rather than having to delimit communal life to a local scale, as most discussions of communization seem to advocate, is it not preferable to imagine how a system of externalized practice-thought could acquire its own self-moving autonomy which is useful to communization? Could exchange abstraction's thinking-through-practice—emptied of its core mechanism, the measurement of value—be transformed into a new version of the collective reason-through-practice akin to the Silesian weavers' riots? What other kind of externalized judgment could create a thinking-through-practice and how?

At the end of this investigation into the current state of capital's economic and biopolitical totality, a feat of imagination is needed to picture how our own total system logics can overthrow the totality of capital. Affect, rooted in the physical and non-conscious, is understood by science to be universal and material, and so it can, at least in this sense, be externalized. Could affect then hypothetically aid the process of communization by fully realizing and unfolding its potentials rather than being relegated to just another tool in the accumulation of capital? A better understanding of the transversal openness of our subjectivity appears to offer a promise for building new practices that emerge from solidarity rather than the opposition of competing needs.

And yet, a shift out of capitalism is a process for which the imagination cannot prepare as the end of value's domination would create unforeseeable conditions and forms. Current notions of prediction and measurement would no longer apply. At this point fictions become important, and faith in fiction is needed in order to help construct truths that currently don't exist.

1. See my work *Self-Capital* (2009) regarding my approach to translating these conditions to a video work. Find *Self-Capital* online in three parts via my YouTube channel: http://fillip.ca/86jz.

2. Bertolt Brecht, "The Modern Theatre is the Epic Theatre," in *Brecht on Theatre*, trans. John Willett (London: Methuen, 1964).

3. Gilles Deleuze, lecture on Spinoza, January 24, 1978, trans. Timothy S. Murphy, http://fillip.ca/35bk.

4. Benedict Spinoza, *Works of Spinoza*, vol. 2, trans. R. H. M. Elwes (New York: Dover Publications, 1955), 130.

5. Brian Massumi, *Parables for the Virtual: Movement, Affect, Sensation* (Durham, NC: Duke University Press, 2002). The reading of difference between affect, feeling, and emotion is taken from Eric Shouse, "Feeling, Emotion, Affect," *M/C Journal* 8, no. 6 (December 2005), http://fillip.ca/g1m4.

6. Real subsumption is a means of increasing the surplus value extracted from labour through boosting productivity. There are two ways in which the capitalist can increase the quotient of surplus value that he or she makes in production: formal and real subsumption. Formal subsumption is the extension of time in the working day. Real subsumption is the implementation of novel technological, social, or organizational processes (to name a few) that increase productivity, hence decreasing the amount of time needed to create the same amount of surplus value. If less socially necessary labour is required in a workday and the capitalist maintains a workday of the same length, this will deliver a larger amount of surplus value. Real subsumption is a condition that increasingly touches all parts of our existence as more and more aspects of our lives are optimized to increase productivity and profitability.

7. Gilles Deleuze, "Postscript on the Societies of Control," *October*, no. 59 (Winter 1992), http://fillip.ca/k2yv.

8. The process of capital accumulation that enables capital's own reproduction and expansion (as theorized by Marx in its simple, not expanded—more complex and non-linear—form) involves capital investment in production, which produces commodities that are sold for more capital than what was initially invested, which in turn is reinvested in producing more commodities, which bring in more capital, and so forth, creating a cycle of expansion. This expansion and multiplication of capital (on an individual level) happens through realizing the value of commodities (or valorizing them) in circulation and exchange, a process of expansion that is mirrored on the level of capital's self-valorization as a whole.

9. Karl Marx, "The General Formula for Capital," in *Capital* (1867), vol. 1, chap. 4, http://fillip.ca/a5tb; emphasis added. Marx goes on to say that "its valorization is therefore self-valorization. By virtue of being value, it has acquired the occult ability to add value to itself. It brings forth living offspring, or at least lays golden eggs." To be clear, when Marx, or I, say "value," this is defined as the socially necessary abstract labour embodied in a commodity. This definition of value as "socially necessary" labour means that the labour inherent to a commodity is determined by contextual conditions such as the price of the workers' housing, food, and other consumption, as well as the rate of employment, demonstrating how each variable is always determined by all the other variables and thus the total system of capital.

10. Karl Marx, "Estranged Labour," in *Economic and Philosophical Manuscripts of 1844* (1932), http://fillip.ca/ujoe. "All these consequences are implied in the statement that the worker is related to the *product of labor* as to an *alien* object. For on this premise it is clear that the more the worker spends himself, the more powerful becomes the

alien world of objects which he creates over and against himself, the poorer he himself—his inner world—becomes, the less belongs to him as his own."

11. John Maynard Keynes, "The State of Long-Term Expectation," in *The General Theory of Employment, Interest and Money*, (Cambridge, 1936), http://fillip.ca/1lsn.

12. For instance, credit default swaps (CDS) that are at the heart of the current euro crisis—which are literally a contract (mainly backed by banks) agreeing to swap a debt asset should the debtor default—are, in volatile times such as now when the European bond market is collapsing, instigators of a much more perilous future as they redistribute the risk of debt far beyond Europe.

13. Many articles can be found describing the situation in these terms, including Guy Dinmore, "Could Berlusconi Gambit Buy Him More Time?" *Financial Times*, November 8, 2011. After Berlusconi's resignation the article stated that Berlusconi's "coalition is under notice from European partners and panicking debt markets that he will honour his commitments quickly." See also Victor L. Simpson, "Silvio Berlusconi Resignation: Billionaire Slain by the Markets," *Huffington Post*, November 8, 2011, http://fillip.ca/uw3j.

14. Victor Mallet, "Spanish Frontrunner Begs for 'More than Half an Hour,'" *Financial Times*, November 18, 2011.

15. Brian Massumi, "The Future Birth of the Affective Fact," *Conference Proceedings from Genealogies of Biopolitics*, accessed January 9, 2012, http://fillip.ca/0std.

16. "It is not only workers and capital that is reproduced, it is the state and all its organs, the family structure and the system of gender relations, the constitution of the individual as a subject...and so on." "Crisis in the Class Relation," *Endnotes*, April 2010, http://fillip.ca/xh4g.

17. It is a totality in Hegel's sense, in that, after passing through different stages, the totality preserves within itself

all of these stages as elements in its structure and can only be comprehended as a whole, not in its parts.

18. I myself subscribe to the notion that communism as first envisioned by Karl Marx was never realized in any of the real world social systems that came about in the last century.

19. In Silesia—belonging, in 1844, to Prussia—crowds of weavers fighting against poor labour conditions rioted, destroying machinery along with the deeds to the machinery, demanding money from local merchants.

20. Karl Marx, "Critical Notes on the Article: 'The King of Prussia and Social Reform. By a Prussian,'" http://fillip.ca/0a2q. Originally published in *Vorwärts!*, no. 63, August 7, 1844.

21. Raya Dunayevskaya, "Practicing Proletarian Reason," accessed December 30, 2011, http://fillip.ca/8pek.

22. Jason Reade, "The Production of Subjectivity: From Transindividuality to the Commons," *New Formations*, no. 70 (Winter 2011), 118.

23. Ibid.

24. Alfred Sohn-Rethel, *Manual and Mental Labour: A Critique of Epistemology* (London: MacMillan, 1978), 25–29.

25. Gilles Dauve, "When Insurrections Die," *Endnotes*, October 2008, http://fillip.ca/dvou.

26. The contemporary art context equivalent to labour-money is *Time-Bank* by e-flux. See http://e-flux.com/timebank/.

27. Karl Marx, "The Chapter on Capital," in *Grundrisse*, accessed December 30, 2011, http://fillip.ca/qw5e.

28. Dauve, "When Insurrections Die."

Monika Szewczyk
Investing in the Blank

Part 1. Some Advice

An initial conversation with editor Antonia Hirsch about my contribution to *Intangible Economies* brought to the fore some unfinished business: having written about "the blank," that rare phenomenon when a block to meaning-making enters the picture, I realized that my attempt to frame the experience produced certain provocations that could be too easily seen as coquettish unless the project continued. (The reader is advised to refer to the earlier essay "Drawing the Blank," which appeared in the Spring 2008 issue of the journal *F.R. David*, published by de Appel Arts Centre in Amsterdam.) In debating possibilities for this new essay, Antonia suggested that "it would be good to discuss the exchange value of the blank."

My first thought was: "I cannot." Exchanging the blank for something else, giving it a value (the act that facilitates exchange), putting a proverbial price on it, would defeat the purpose of my attempt to think through this phenomenon of irreducibility, which sets the imagination roaming even as it stops it cold in its tracks. What I can do instead is talk about investment because, like this simultaneous pause and adventure of the mind I just mentioned, investments, speculations, or ventures are not so much about spending (exchanging), but about forecasting, even prophesying, the infinite growth of value—a value that resists definition but that stops growing when it is exchanged for something else, however precious.

The contrarian, or the concrete economist, will interject with a clarification that investment *is* spending—a purchase of an uncertain future. And, furthermore, it is only when investments yield real returns that we can consider

them to be good. I will grant that this is indeed the case, and if what follows comes to resemble a theory of exchange, I will not have wasted my time. But the real aim in positing something as abstract, intangible, and invaluable as "the blank" through concrete figures is to produce an image of the imagination at work.

Part 2: The Selfish Part

What exactly am I talking about when I invoke the blank? For some years now, each time I see a billboard that is painted over and bereft of advertising, I try to photograph it, or at least take some time to consider what it means to face such a thing. Usually, I encounter these vacant surfaces amidst other billboards filled with advertisements—the capitalist world's most profound assault on public space and on the imagination, the violence of which is perhaps most palpable in regions more recently embracing consumer capitalism such as the former Eastern bloc, large parts of Asia, and Latin America. Advertisements are there to "stimulate demand," which is forever underperforming, according to the business sections of most newspapers. They not only make you part with your cash but also circumscribe the freedom of your will, direct your desire, and define your needs and your wants. By employing various strategies including seduction and humour, advertisers attempt to trigger a host of complex emotions such as moral satisfaction, guilt, and even deep disgust to continually mould the mind and shape human relations—through what Guy Debord called spectacle.[1] Because these operations rely on stimulations of sensitivity that are continually worn down by use, we become *less* sensitive. Ironically, some of the most effective advertisements seem to be those that feature human subjects

displaying a total lack of desire, whose expressions leave unclear whether they are fulfilled or spent. The only thing that is clear is that they are wearing Gucci or Prada, etc.

A good case in point is Kate Moss: look into her eyes in any number of advertisements and notice the impassive gaze of Manet's *Olympia* (1863) or of the barmaid in *A Bar at the Folies Bergère* (1882). Is this simultaneously fulfilled and unfulfillable human *the* model subject of capitalism? This seemingly insensitive self has persisted in different guises for decades. As capitalist expansion reached a point of excess prior to the Great Depression, Buster Keaton epitomized the blank stance; my favorite example of this is to be found in the film stills from *Go West* (1925) where he occupies the frame with a cow—their expressions some-how difficult to distinguish. His deadpan stare opens the door to a reading of the blank face as a form of transcen-dence.[2] And if here the line between human and animal dissolves, elsewhere the barrier between the human and the divine tends towards collapse.

Around the time of the fall of the Berlin Wall, Thomas Ruff teased the blank out of each one of the subjects of his oversized passport photos. His conflation of passport and portrait images proves that in effecting blankness (when we pretend to be cargo) we may cross borders in life and beyond. Indeed, the blank face is not only the stance of the citizen but also the mask of divine transcendence, as exemplified by the Pantocrator motif of the icon painting tradition. All icons condense in Kazimir Malevich's *Black Square* (1913), perhaps *the* paradigmatic blank of moder-nity, and the moment when the blank migrates from the portrait to the monochrome.[3] And is there not a hint of Suprematism in every blank billboard out there?

While this is perhaps not the place to attempt an elabo-rate fusion of Sigmund Freud's and Karl Marx's theories

in support of a general statement on the psycho-economic status of advertising, it is worthwhile to mention that these two men, who compete for the title of modernity's most paradigm-shifting thinker, share at least one important theme: that of the fetish—this figment of the imagination that marks the investment of wild powers into a thing, a commodity. I propose that, if advertising is there to create commodity fetishes, it may be in the empty billboard, this blank (my fetish?), that the spectacular charm of advertising can be, if not broken, then outdone. It may be that this blank is the place where something other can emerge. I should note (in agreement with Bruno Latour, Michael Taussig, and Anselm Franke) that there is no use in trying to break the spell of the fetish. Much more important— for the cause of emancipation—is the ability to invest in a fetish of one's own making.[4] Faced with a blank, aware of its stark neutrality, we begin to confront our desires—a bit like a writer staring at an empty page.

Part 3: The Self in Parts

If Malevich's *Black Square* is the quintessential modernist blank—modernism being that moment of historical consciousness when human emancipation and individual autonomy became unambiguous ideals and when works of art sought to exemplify these conditions in objects— perhaps the quintessential postmodernist blank is Allan McCollum's series *Plaster Surrogates* (1982–90).[5] In postmodernism, these dearly held ideals of emancipation and autonomy are seen as both an impossible and somehow oppressive ideology. Fragmentation—of the autonomous self or of the perfect art object that was meant to mirror and aid the constitution of the ideal modern subject and a holistic

worldview—is foregrounded. Postmodern artworks affect modernism as charade. In McCollum's work, the black square on white ground (recalling Malevich) morphs into a rectangle that is no longer painted by hand but that is cast in plaster and multiplied, automating the exemplary status of Malevich's painting through reproduction to a point of absurdity. The aura (that sense of a soul or inner force that makes the fetish) is drained from these works, yet postmodernism's ironic and humourous air pervades them. The fundamental lack implied in the word "surrogate" applies to the objects as well as to the subjects that confront them. Indeed, if modern art objects were meant to reinforce the integrity of modern subjects, the quintessentially postmodern *Plaster Surrogates* produce a viewing subject who is as fragmented as he or she is wanting. Nowhere is this made more patently obvious than in Andrea Fraser's scripted performance *May I Help You?* (1991), which casts an actor as a staff member of a commercial gallery. This assistant greets actual visitors and by way of a one-way conversation projects a full spectrum of values onto an installation of approximately one hundred of McCollum's *Plaster Surrogates*.

In crafting her performance script, Fraser culled the gallery attendant's lines from disparate sources. Among them are excerpts from a Sotheby's catalogue featuring writing by Ester Coen on the collection of Lydia Winston Malbin (the pinnacle of fine taste expressed as desire for the pricey as priceless), among other texts on collectors who ascribe something other than a monetary price tag to their precious collections; selections from Pierre Bourdieu's seminal study *Distinction* (the proof that aesthetic taste is far from disinterested but rather a sign of social class, which in itself is also a product of lineage rather than controllable achievements), among other sociological studies that take the art world as their subject; Raymond Williams's essay "Culture

Is Ordinary" (an emphatic disagreement with culture's rel-
egation to a financial elite and to select objects or spaces
deemed worthy); and an interview with the artist Allan
McCollum himself (a rejection of certain artworks that are
patently produced to mystify and exclude him).[6] This to
note just four of the dozens of fragments that comprise the
carefully constructed script, which moves from express-
ing sentiments of confirmation, pride, and comfort through
compensation and refuge, to alienation and indignation in
relation to the blank, numb art objects.

It may be worthwhile to consider one such shift of
attitude—which in turn underscores the multiple invest-
ments in the blank:

```
The Staff member's manner is gracious and
unconcerned. She is self-assured, authoritative
but unthreatening....

"It's a beautiful show, isn't it. And this..."

She walks over to one of the Plaster Surrogates.

"...is a beautiful piece."

She pauses for a moment, looking.

"I would say that this work is the apotheosis
of abstraction. It's an abstraction that implies
an absolute simplification and reduction within
a language of well-balanced purity. It has
extraordinary colors and formal intensity. The
first time I saw it I fell in love with it...."

She moves to another Plaster Surrogate.
```

The absolute affirmation and sense of fulfillment is soon
shattered; further on, the same attendant changes her attitude:

```
Standing in front of the object she turns to
the visitor.
```

"You know, if you're not one of those people who
affects history—and most of us are not—then how
are you supposed to enjoy looking for personal
meaning in the souvenirs of that class of people
who manipulate history to your exclusion? I
think it takes a pretty blind state of euphoric
identification to enjoy another's power to
exclude you."

The above quotations illustrate the two opposing poles
of a subjective spectrum, but it should be noted that the
almost seamless passage between unmarked quotations,
between attitudes, between polarities of class—*almost* and
not *entirely*, because the stage directions do call for subtle
shifts of attitude between seven distinct sections—does not
preclude a sense of a fundamentally fragmented self, even
if it produces a feeling of a totality that is as scripted and
multiple as it is exhaustive and true.

What Fraser shows—and what she in many ways
lampoons—is the wide range of subjective projections trig-
gered by one and the same artwork, an artwork that is
repeated multiple times to underscore its generic charac-
ter. There is an implication here that McCollum's *Plaster
Surrogates* stand for every work of art and, moreover, that
all these artworks engender a kind of deep primordial lack,
which must be filled with speech.

Because the performance synthesizes several dispa-
rate subjective texts into one "helping" word from the gal-
lery assistant, what comes to the fore is a general sense of
insufficiency and fragmentation or insufficiency due to frag-
mentation. The words spilled and the emotions invested in
McCollum's blank surrogates seem to say everything about
the speaker's social position. This confessional performance
positions audience members as spectators of their own frag-
mented consciousnesses (and, by extension, because of the
surrogate status of McCollum's work, any audience in front

of any artwork). This comes across as a subjective insufficiency, I think, more than the objective insufficiency of a blank work; even if such works are seen to lose their aura and emerge as the empty ciphers of questionable class distinction, the most disturbing sense is that, in front of any artwork, but perhaps especially in front of the blank ones, our desires are not our own. Of course, the fact that blank works bring to the fore this realization may be seen as their productive force, but must they be seen (as I think they are in Fraser's performative engagement of McCollum's surrogates) as forces that disempower us or simply bring to the level of consciousness our already existing disempowerment?

Fraser's understanding of her practice (as well as the work of several more senior artists associated with the project of institutional critique) as precisely this type of consciousness-raising critical activity is neatly summarized in her essay "From the Critique of Institutions to an Institution of Critique." Here she refutes the pervasive understanding of institutional critique as the critique of outside forces. Taking up the contention, so prevalent in the postmodern condition, that there is no outside of capitalism and that postmodern subjects are condemned to a kind of implication beyond their control, she notes: *So if there is no outside for us, it is not because the institution is perfectly closed, or exists as an apparatus in a "totally administered society," or has grown all-encompassing in size and scope. It is because the institution is inside of us, and we can't get outside of ourselves.* Notably, the "selves" here could be read as applicable to the multiple selves in each of us and to a multitude of persons. Fraser concludes: *Finally, it is this self-questioning—more than a thematic like "the institution," no matter how broadly conceived—that defines institutional critique as a practice.*[7]

Consider that, in the matrix of fragmentation created by Fraser's performance (which externalizes and splits

the subtext of the self) and reinforced by McCollum's *Surrogates* (multiplying the singular blank of Malevich), there is still a kind of hegemony at work: while she reconfigures the understanding of institution as an internalized set of controls, and then externalizes this institutionalized self and further splits it in her somewhat schizophrenic script, there remains a sense of entrapment, which is further reinforced by the looping structure of the performance video. The self we see is a kind of late-capitalist, globalized, post-human, post-utopian, schizophrenic, consumerist self—the subject of analysis and, as the title of Fraser's video suggests, in dire need of help. Even those words that signal this self's comfort and pride in class distinction tend to flow to avoid the silence of the blank. (And we might note that when she looks up from the pictures and stares straight at us, the actress in the video becomes caught between the blankness of the *Surrogates* and that invisible yet all pervasive blankness of the camera.) Here, in agreement with Lacanian notions of language, her words demarcate the subject as constituted by a lack in perpetual need of the talking cure. However innovative the use of silence in Lacan, it tends towards this therapeutic speech. However naive it may seem, I'd like to escape this loop.

What about considering the visual silence of the blank as that which allows us to listen to other signals?—radio signals from Mars, for example, to borrow a thought from the poet Jack Spicer by way of a text by the artist Judy Radul.[8] If in watching *May I Help You?* it seems that just about everything in the book(s) can and has been invested in the blank(s) on display, it may be worth noting that the great emphasis of this investment is predicated on a lack felt due to class inferiority that is summarily thrown out the window in the last lines of Fraser's script (quoted above). The composite self that Fraser displays is a sociological one, one

that is characterized primarily by class. It may be that, in so exhaustively circumscribing the blank in the discourse of class, the performance opens the door to another understanding: what is really missing in this confrontation with the *Surrogates* is a silent contemplation of, and confrontation with, the dumb thingness of the works as such.[9] While such a response could perhaps be understood as enacting yet another sociological "type," a mapped response—which might be called Cagean, pseudomystical, hippy, meditative, Zen-like[10]—such mapping too quickly circumvents the real potential of a confrontation with a blank. Such a confrontation does not even need to be thought of as a therapeutic situation. Rather, the silence visually inscribed in artworks, things, or images—that quintessential quality of neutrality or escape from the binary tensions that form meaning, in short, their blankness—tends to leave a surplus.[11]

Part 4: The Difficult Part

Having deconstructed just about everything, how do we continue to invest in blanks, in spaces that do not fill the imagination with ready-made pictures of desire, but with images and values that are of our own construction, constructed by an alien part of ourselves (the one from Mars, say)? How to leave the script behind, or how to write our own script? One option, which I entertained in my earlier text, "Drawing the Blank," is to create blanks rather than wait for them: to see a blank where there is a bank, for example. This means that one need not wait to encounter images or sites that momentarily block the predetermination of our desires so that we can invent new ones. Rather (learning from such encounters perhaps), we may begin to inject blankness into spaces that are all too fully

circumscribed by the logic of capitalism (or a general social logic that capitalizes on our sense of absolute alienation). This productive approach does not understand blankness as lack and yet another opportunity to conduct commerce.

As a solitary exercise, such projection will only get us so far. In conversation, where others are present, and the silence, the space between words exchanged, is always already something of a blank, we might listen and find an opportunity to neutralize the structures that currently define desire. However, this conversation need not always happen in the company of other people. It might occur as an exchange with the self or, more precisely, with another mind within the one we think we know and own—call it the Martian (but, please, do not Google "Scientology" and "inner alien"). Perhaps it is through this type of investment, a kind of capitalization of the blank that uses aspects of the logic of capital against its most numbing effects, that new values can emerge.

The difficult part is, of course, not to stop the essay here, with the (these days) pervasive wide-open door of all theoretical speculation where the indeterminate new and different and alternative to come is voiced but not specified. My editor has (quite rightly) urged me to elaborate on the notion of surplus I dangled at the end of the last section, to put my money where my mouth is (proverbially). This is often the part where words fail and the rest of the page remains blank, where I get to confront my desires, *for real*... as does the reader, perhaps.

In "Drawing the Blank," I offered many examples of blankness in an attempt to put a frame around something rather intangible, to iterate instances where we fall silent, in wait of radical alternatives. In this text, I made it my task to consider what this situation produces, *other* than a welling up of proscribed desires and greater consciousness of

fragmentation and alienation and imaginative dead ends.

What else can be invested in the blank? These days we often hear of a loss of imagination on the part of the Left—as if such an ideological designation were still possible—a kind of collective instance of "drawing a blank" on what it is that "we" want in terms of property, community, governance, the future. But the general sense of this communal stupefaction, which, when fully registered, might bring with it a sense of urgency, is easily lost amidst the visual and aural noise, and so we go on. If more blanks are produced or found, precisely in places where imagination fails—if this collective stupefaction becomes *more* palpable as such—there might be a chance to exchange the blank for another image of tomorrow. For now, rather than following the logic of debt by *borrowing* images (from advertising, say) to invest in each blank we find, the opposite operation is needed: Ask not what to invest in the blank—ask what the blank can be invested in! Recognizing the value of this silent surplus will not come in a flash at the end of an essay. It is rather a matter of daily practice.

[Apart from the Above]

When I first began to write this essay, the so-called Arab Spring was beginning to dominate the news. I was very impressed with the ability of the Egyptian protesters to refrain from too quickly defining their demands beyond the singular rejection of the Mubarak regime—their radical negativity produced a gaping hole in the public imagination. The Egyptian example was interpreted in novel ways in subsequent attempts to rethink democracy that are still under way, such as the Occupy movement. Some might argue that the carving out of a power vacuum made way for

the capturing of governmental forces by the Egyptian military and the Muslim Brotherhood, the much-feared Islamist force. And to be sure, the situation in the Middle East is far from the ideal state of suspension that the revolution projected in early 2011. But the example remains a powerful measure of what is possible. Consequently, my first instinct was to reflect on the notion of the blank in light of the stubbornly indeterminate aims of the people gathering in Tahrir Square. But I waivered, as Antonia Hirsch advised me of the somewhat problematic nature of such reasoning (I had thus far only considered artistic phenomena, and this new angle required more ground, more context).

Since the publication of what you have read above, I have had the chance to discuss this essay twice in some detail. On one occasion I presented the paper in a public discussion moderated by Antonia Hirsch that took place in the context of the NY Art Book Fair (NYABF), which coincided with the inaugural days of the Occupy movement in September 2011. The presentation included an array of projected images, much broader in scope than what I had used in the initial print version.[12] I had found an image of Occupiers gathered around a man holding up a sign, photographed from the back, so that his placard appeared blank. This was close to an anchor for my argument, certainly as powerful an emblem of the movement's potential as the infamous Guy Fawkes mask (which Antonia called up later in her introduction at the Vancouver forum).[13] In the course of our illustrated exchange in New York, I presented the image along with some slides of the crowds gathering in Tahrir Square as well as one image of the enigmatic Sphinx at Giza—a reminder that the social force of the blank had been deployed since time immemorial. I wanted to keep things open and highly associative.

Here, Antonia defended my desire to speculate. Somewhat predictably perhaps, we received quite a lot of criticism (particularly from an art historian in the audience) for free-wheeling with visual materials in the service of a speculative argument. And yet, I, at least, came away convinced that more of this collective mental work was needed rather than less.

For the most part, the crowds gathering at NYABF that September behaved as if nothing was happening in Zuccotti Park. I wonder if perhaps the silence, the seeming indifference of the public to the nascent Occupy movement, derived less from total political disengagement than from the fact that people concluded they were out of their depth—somewhat like I had, in deciding not to mention the Arab Spring in my original essay. Perhaps they awaited a vocabulary with which to process the present—drawing a blank, as they say, in the meantime.

A month later when I presented the essay, along with even more new images, at the *Intangible Economies* forum in Vancouver, the Occupy movement became a ubiquitous reference during all the discussions, and my speculations on the blank met with much intellectual nourishment from the likes of Clint Burnham, who immediately recognized that I was after the notion of a space kept open and indeterminate—i.e., a truly public space. Yet despite this affirmation, I realize that the problem of choosing examples of what I refer to as "the blank" and of all too loose political conjecture around this phenomenon has not been solved. This represents a kind of inherent contradiction in my argument. To give the blank definition, to give it "a face" of any kind (and for my colleague Juan A. Gaitán, especially perhaps a human face), remains an irresolvable demand.

A chasm opens up between the moment when we proverbially draw a blank (run out of ideas, suspend

verbalization, halt the making of meaning) and the moment when we begin to invest in an existing blank or a blank of our own conjecture (deposit certain political desires, say, even if it is for a politics that resists the colonization of desire). To cross this chasm, a kind of leap of faith might be required, or, at least, quite a lot of confidence in the more abstract capacities of the mind. I do think that to build this confidence, concrete figures are required. The images I have used in service of my argument are thus at once things that are clearly framed (as images) and yet contain much resistance to meaning-making and clear interpretation; they are places where the mind can rest, but this rest is not of the stagnant type. It is a place to vacation with remainders, surpluses. In other words, however abstract the thought, the mind grasps it through something tangible. In the case of the blank, art still seems to provide more robust concretization of ideas than the inherently fragile sphere of politics (and its attendant news coverage). But the two are best related as a dialectic rather than a binary. For this reason, I have asked that a new image be inserted in the republication of this essay.[14] I am looking for more. *La lutte continue...*

1. Here it may be worthwhile to underline that, for Debord, spectacle is not so much the myriad of advertising images we confront but the human relations and the imaginations produced by this image environment.
2. A question I am still contemplating is the extent to which the hilarity of Buster Keaton's blank stare, with its ability to produce convulsions of the diaphragm (Walter Benjamin's nicely corporal synonym for laughter), is perhaps superior to the more hypnotizing effects of blanks operating in

advertising when it comes to enabling the viewing subject to become more self-aware in his or her confrontation with the blank.

3. It should be noted that in the first Suprematist exhibition, *0, 10: The Last Futurist Exhibition*, which took place in 1915 at a gallery in St. Petersburg, Malevich quite deliberately installed *Black Square* in the upper corner of the exhibition space and thus precisely in the traditional site for the installation of an icon in Russian homes—making the equivalence between icon and monochrome all the more palpable.

4. Latour's argument is succinctly summarized in Anslem Franke's essay "On Blood Flow," in Valérie Mannaerts, *An Exhibition Another Exhibition* (Berlin: Sternberg Press, 2011), 17. He refers to Bruno Latour's *Sur le culte moderne des dieux faitiches* (Paris: La Découverte, 2009) and Michael Taussig's "Viscerality, Faith and Skepticism," in *Magic and Modernity: Interfaces of Revelation and Concealment*, ed. Birgit Meyer and Peter Pels (Stanford: Stanford University Press, 2003).

5. Beginning in 1982, the American artist (a member of what has come to be known as the Pictures Generation) began to create multiples of picture-like plaster casts that resemble Malevich's *Black Square* in that they are composed of black rectilinear centres framed by large white margins, albeit in an oblong format, perhaps bringing them even closer still to those other carriers of blankness—portraits. Much like Malevich (but with more of a reference to the secular space of the gallery than the sacred corner of an Orthodox home), McCollum installs his surrogates in rows so that they replace pictures in a gallery. A generic quality pervades the installations, and the title triggers a projection of other pictures onto *Plaster Surrogates*.

6. For an online version of the full script, including bibliographic details, see Andrea Fraser, "May I Help You? A Performance by Andrea Fraser," *Art Lies*, accessed April 1, 2011, http://fillip.ca/v7ks.

7. See Andrea Fraser, "From a Critique of Institutions to an Institution of Critique," *Artforum*, September 2005. Available online at http://fillip.ca/yf4x.

8. American poet Jack Spicer's notion of the artist as someone who is able to receive "radio signals 'from Mars'" (importantly, as opposed to the more religious notion of the artist as a vessel for divine inspiration) is explored by Radul in a short text introducing a workshop on the artist's talk, presented at the symposium "Rotterdam Dialogues: The Artists." I introduce it here to keep us tuned into possibilities that are strange but not overly pious and to sustain Radul's argument of the artist as listener and therefore somehow on the side of the audience. See Judy Radul, "About," in *Rotterdam Dialogues: The Critics, The Curators, The Artists*, eds. Zoë Gray, Miriam Kathrein, Nicolaus Schafhausen, Monika Szewczyk, and Ariadne Urlus (Rotterdam: Witte de With Publishers, 2010), 168–69.

9. We might see a section of Fraser's *Official Welcome* (2001) as flirting with this option. At one point in this speech, which is collaged from the welcoming addresses given in various art-world contexts that the artist herself performs (while stripping and then getting dressed again), the artist (almost in her birthday suit) steps aside from her podium and announces, "Today, I am an image, an object," and stares out blankly, remaining still and silent for an uncomfortably long time. Yet, while she offers this unsettling moment of silence, the space is again infused with a mocking air that does not quite enable the audience to entertain something other than the view of a scripted behaviour in the art world reinforced by the rest of the work.

10. Perhaps the omission of this type of response, with its Buddhist inflection, which holds the door open to a kind of forgetting of the self, is not entertained within Fraser's approach because there the sociological and Lacanian constitution of a self is all important.

11. Here, too, a can of worms is opened to a whole field of deliberation, shared in part by Maurice Blanchot and Roland Barthes, who each dwells at length on the notion of neutrality or the neutral and who each relates neutrality to silence, to the space between speech in conversation, to the site beyond language and its necessary binaries. See Roland Barthes, *The Neutral*, trans. Rosalind Krauss and Dennis Hollier (New York: Columbia University Press, 2005) and Maurice Blanchot, *The Infinite Conversation*, ed. and trans. Susan Hanson (Minneapolis: University of Minnesota Press, 1993).

12. Monika Szewczyk, "Investing in the Blank," *Fillip* 14 (Summer 2011).

13. Interestingly, the image I used has now appeared along the official entry for the Occupy movement on Wikipedia.

14. See page 233.

Olaf Nicolai and Antonia Hirsch
Chant d'Échange

Antonia Hirsch – Two summers ago, when I started re-searching the idea of "economies of desire," you lent me a tonne of books on this topic and we had a number of conversations that were really inspiring for me. But later I thought, "Hold on, how come you have all these books on money, desire, exchange, and so on?" It's not something that is obviously evident in your work. Then I remembered *Die Gabe*, a project you started in 1993, I think. It was a series of folios that each consisted of six to ten pages of loose-leaf paper. Some folios contained images or more complicated die-cut components, and the contributors, of which there are seventeen to date, are from all sorts of disciplines, not just art. Thinking about this work, I wondered why you chose to call it *Die Gabe* (The Gift) because, in many ways, one could say it's an edition like any other.

Olaf Nicolai – The precepts of *Die Gabe* were not quite those of a regular edition; I wanted to create an opening, something that decisively didn't perform a self-documentation through the presentation of my own works but instead featured the works of others that were important to me. The idea was to produce something on behalf of somebody else and to make it freely available, even though at the time I didn't have access to significant economic resources. Today it would be considered modest what one of those folios cost to produce back then, but I probably put the equivalent of a month's worth of income toward each *cahier*. At the same time, obviously, this gesture of giving something was tied to expectations that translated into one condition: those who I invited were to refer in their contributions to the work of

yet others in turn—artists, writers, scientists, or to found objects that were somehow important to them.

Hirsch – The way you describe it, the project seems not only to borrow its name from Mauss's famous essay, but it also seems to refer quite explicitly to the *kula*[1]—the gift circle that Mauss describes.

Nicolai – That is part of the premise of the project, but even though I had read Mauss's essay on the gift, I don't think I was specifically aware of the *kula*. The text I remember reading at the time describes the potlatch, and I was interested in how the gift isn't entirely neutral, how it is always coloured by something—that there are always social interests negotiated along the way. The gift is commonly understood as something impartial, or indifferent, and you have to look a bit more closely to figure out that a gift can be more threatening than even an overt challenge. And by that I mean not only the poisoned gift, but rather that in the act of giving, a negotiation takes place that is bound by certain rules or etiquette, something akin to diplomacy.

Hirsch – …where a certain kind of debt is being put into place.

Nicolai – Yes. A relationship is being created. And also a kind of community comes into place. I don't mean in the sense of an artist group—more like a symbolic order that is held together by a symbolic "ribbon" that represents the give and take in the group in which one shares, but that cannot be joined at will.

Hirsch – But *Die Gabe* wasn't your first publication project, was it?

Nicolai – No. The first time that I did something like a publication project was a book called *LECTION* (Lesson), which was basically the first catalogue that was co-produced by me and my gallery, Eigen+Art [Berlin]. This was in 1990, and Gerd Harry Lybke [the co-founder and owner of the gallery] had the idea that we could also do catalogues, something that had just then become possible. Before [the wall came down] this wasn't an option [in the GDR, the German Democratic Republic—former socialist East Germany] or, if you did produce publications, they had a very exclusive character. If a book was produced with a very low print run—say one hundred copies or less—it was treated like an artist's book, which meant it didn't have to be presented to the censors for approval. After [the wall came down] we could do larger runs and proper distribution became possible. Around this time, he [Lybke] met Erich Maas[2] who didn't yet run his own publishing house. Maas was one of those dyed-in-the-wool Kreuzbergers from the old West Berlin scene.[3] He suggested doing a publication that would be very simple, without frills. He sat down with me one afternoon and explained how we could produce something with a run of one thousand copies for one thousand German marks. So I thought about it and two weeks later I showed up at his place with a box of material. I told him that I didn't really want to picture my work in this publication, but rather show what I was thinking about while I made work: texts, pictures, all sorts of stuff. Then we arranged the material, I told him how things connected for me, and we tried to somehow transpose this onto pages. The finished book became a kind of sourcebook; the next two books I produced by myself, and together they became something of a trilogy that was called *Material*.

Geschichte und Eigensinn (1981) by Oskar Negt and Alexander Kluge was a really important reference for this

project.[4] It's a kind of cultural history where text and image are brought together in what seems to be an associative way—treated very equivalently, not only to make theory more tangible, but also to evoke a different dimension that, in a purely textual form, in pure discourse, doesn't become accessible. Whereas in Kluge and Negt's book the text provides a narrative into which the elements of the collage are embedded, in my publications I tried to push the principle of collage further without the mediating text. In my case, the narrative comes about simply through the way in which the elements are tied in with one another.

Hirsch – The particular way in which concepts are articulated seems relevant in terms of your publications, but also in relation to conceptual art in general: the circulation of concepts is important, but if the concept is reduced to language alone, something is potentially missing. Images and objects circulate differently in our experiential sphere—which is spatial and temporal. When we encounter texts, especially more demanding ones, we engage with them deliberately and we have to invest time into understanding them, whereas images we are often exposed to unintentionally, for example in the form of advertising, especially in public space.

Nicolai – Conceptual art was important. I was really fascinated by it in the mid '80s, but I have to say that conceptual art, in its really clear, straight form—like the early works of Lawrence Weiner, [Joseph] Kosuth, or Robert Barry—were quite foreign to me. I had seen a bit of it in reproduction, but I simply never had had the opportunity to see the works themselves, meaning that I had not had opportunity to apprehend the concepts in their entirety. The same with [Daniel] Buren: I knew the picture, but I knew neither

the context the work was produced in, nor that which it responded to. And when I started, at the beginning of the 1990s, to look into these practices more deeply, I had a problem: I could follow rationally, but I always felt that the concepts only ever properly unfolded through intentionality. These artists proposed the emergence of the concept as something that had to be actively, consciously perceived—as such, this kind of intellectual reception had to become an essential aspect of the artwork. The works presupposed and directed themselves towards a necessarily self-reflexive viewer. I have to say that this apparently exclusive focus on the rational seems to me as if describing the tip of an iceberg with nothing underneath—i.e., the entire sensual dimension was being neglected, which seems symptomatic of a deep distrust of the sensible.

I encountered a similar distrust during my time at university in the 1980s when I studied, among other subjects, linguistics. There, I was introduced to [Gottlob] Frege's[5] differentiation between sense and reference, which was being applied to linguistics and semiotics, where it appeared as the differentiation between denotation and connotation. Connotation always exists in the subjective field—all the emotional aspects that are brought to a hard, core term. But when dealing with language, especially with poetic texts, this dualistic model doesn't work. You can't access those texts like that; you'll end up just passing them by. You can say, "This affects me," but if you are asked to describe *how* it affects you, this polarized model of language fails you. This kind of concept of language is purely functional. But what is really key, after all, is not that meaning is transmitted, but the way in which a subject relates to meaning. This is what is being articulated through language; this is *the* defining character of language. What I tried to do—and this is what got me interested in linguistics in the first

place—was to find out whether there are any models where connotation, the mode of articulation, forms the central core and denotation, the question of meaning, becomes more or less a side effect...where the core term is more a kind of temporary consolidation that has to take place for communication to be able to occur, but that is actually movement in which one exists as an active speaker in a field circumscribed by connotation.

Hirsch – So, you are proposing almost a conflation of sense experience and emotion. Can you elaborate a bit on how you see the connections among these two?

Nicolai – I'm not trying to suggest a hierarchization of the sensible. A text that I really like because it leaves me productively confused is Jacques Lacan's *Transference*. In this seminar, Lacan discusses the enjoyment experienced by the praying mantis and oral pleasure relative to the nipple.[6] He very decisively dismisses the notion of the nipple as a precious object of human eroticism—as he calls it— based on a function, namely of satisfying hunger and the pleasurable memory that is attached to this process. It isn't the satiation of hunger that is the source of pleasure, but a retroactive construction that is based on a demand and the "beyond" of love that is projected by this demand. This leads Lacan to the notion of a dialectic of desire. What I think is important here is that in sensual perception, or sensual experience, we are already dealing with a construct. It is a kind of "flexion"[7] that has woven into its specific form what reflection attempts to grasp as sense.

This is relevant for art production from the perspective that libidinous passion can hardly be understood as the source of free creativity. If one were to consider libidinous passion as the source of creativity, one would have to refer

not to an open and authentic libidinal structure, but to a specific formation.

This idea of an authentic libidinous structure was very palpable in the GDR of the 1980s. As a retreat from a pervasive pressure to conform, libidinal passion, authenticity, and freedom were short-circuited. Expressivity was the dominant mode and while each iteration was generated from a deeply personal position, one could observe the repetition of the same forms, images, and formulas in artistic production in general. Another path, usually one chosen by the older generation, was one of cultivated interiority, both in habitus and in their works. Gerhard Altenbourg and Carlfriedrich Claus are the most incisive representatives of this type of approach. Using the terminology of Marxist cultural sociology, one could describe theirs as a late-bourgeois style without bourgeoisie.

Hirsch – I guess you had a different perspective from artists in the West because you lived not only in a different political, but also in a different semiotic, system.

Nicolai – I was only able to perceive things through the media and through books and magazines, which meant that I didn't experience how and under what circumstances, for example, conceptual artworks came to be made. I think this is quite important. Because what I didn't see and couldn't experience, and only slowly came to understand, is that even this limitation, this seeming exclusive focus on information, develops a sensual quality. For example, the works by Lawrence Weiner aren't read, they are seen. They are pictures.

[When I first saw his work] I also lacked exposure to the universe of typography—as in advertising and other forms of publicized information that Weiner's works refer

to. That wasn't really part of my world; I only had access to those in a very filtered way. Even though I watched West German public television or listened to the radio, these were essentially quite leftist, intellectual media, meaning that they alone didn't really allow me to comprehend the entire spectrum of what people [in the West] were actually engaging with. I did not have access to something like *BILD*,[8] for example. I just knew how it looked, but I never really had a chance to read it and therefore didn't know the way in which it translated information into its design. In the case of the *Frankfurter Allgemeine Zeitung*,[9] you have to read the consecutively written articles to gain any information. *BILD*, a tabloid, on the other hand, proposes ideologically problematic contents lacking in complexity, but it conveys them on multiple levels in a semiotically complex combination of language, typography, and image—like a collage.

Hirsch – In the context of this notion of the circulation of ideas, I think it could be interesting to consider how a barter system was much more present in the GDR's economy than it was in the West. In the GDR you had to deal with all sorts of shortages that could be somewhat mitigated by bartering, whereas in the West, pretty much anything could be bought with money. So I'm wondering whether in that society, where a barter economy formed a sort of matrix that facilitated the exchange of things that made life better, or even viable, whether this particular exchange behaviour perhaps also extended to ideas?

Nicolai – For a barter economy to function, interaction between individuals is necessary. It involves processes that cannot be depersonalized, meaning that emotion plays a role in many economic processes that, in a capitalist

market economy, are conducted in a much different manner. This particular economy structured the sensible differently. It assigned distinct, sometimes ideologically driven, values to sensual experience, thereby producing different emotional patterns. There was a dialectical relationship between this valuation of sense experience and emotional patterns that played out particularly within the format of the barter economy.

Whenever something is given or denied, a personal relationship is negotiated alongside that material exchange, which supercharges the situation. The GDR's economy of scarcity that gave rise to a barter economy then generated complicities and dependencies that the Stasi were able to instrumentalize. Since much was possible only by way of favours, these could also be revoked and thereby used as leverage. And because for many this led to a very self-aware and self-conscious attitude, one occasionally had to negotiate slightly paranoid tendencies.

In addition, this particular structuring of the sensible affected what you referred to earlier with regard to an idea's potential "tradeability" in the context of a barter economy: due to the fact that this was an economy where at times the very basics were at issue, a mere idea didn't really have an exchange value. In other words, within this system the idea didn't develop an object-character in the sense of me saying, "I'll give you this idea and in exchange you'll cook me a meal sometime." On the contrary, communication, conversation, the exchange of ideas was almost like common property. Very rarely was there an instance where someone would say, "You've stolen my idea." When you start to jealously guard your ideas—this only happens not only when you are able to exchange those ideas, but when a kind of market develops for the ideas in question. Conceptual art simply couldn't possess that value [in the

GDR]. If people worked conceptually, they were regarded as stimulating, but not so much as artists—a creative practice was perceived very much as materially contingent. Attitude became much more a medium for articulation in that these people were considered "characters" who lived a certain lifestyle that one admired. The articulation of this lifestyle alone was ascribed the status of an artwork, but there was no market that would have allowed for this to become a tradeable good.

Hirsch – Okay, I understand that—but I'm still fascinated by the question of the idea and its circulation because, as far as I understand, education was regarded as extremely important in the GDR, so one would assume that there was a certain respect for intellectualism, for a culture of ideas. Wasn't education one of the "German" values that was upheld, while much else was rejected because it belonged to the ostensibly corrupt, capitalist, and basically fascist West Germany?

Nicolai – I would say that education in the sense of upbringing and academic learning was important. Those two were always connected. What was at stake in education and academic or professional training was the communication of very specific worldviews.

Hirsch – Also in order to predetermine specific roles for people in society?

Nicolai – That, too. After all, the GDR was a society that assumed that it could plan and design things, not only in the realm of a broad economic context, but down to the biographies of individual people.

Hirsch – So, in other words, the planned economy existed not only in a material sense, but also, possibly, in the world of ideas, and since a planned economy has no market…

Nicolai – Well, actually, it does have a market—it just functions a little differently. The GDR's planned economy had several "markets." The GDR had a domestic market that, in turn, was part of a larger international market that existed among socialist states. This socialist market was free of speculation, prices were fixed, and it therefore didn't involve a very elaborate credit economy. But of course, this socialist market was inevitably and ultimately tied into an even larger, global market that also included capitalist states, so the idea of market autonomy was not viable and the Berlin Wall was a perfect metaphor for the kind of thinking on which the GDR's economic ideology was based. This is where we get back to the question of the idea—ideology was incredibly important in this context. The state implemented measures that it could absolutely not afford: social services were offered in order to create ideological allegiances. Nobody would talk about the fact that this was an economic disaster—or, rather, no one took the few who did seriously. Seen from an economic standpoint, the most dramatic issue for the GDR was the unity of economic and social policy, a great sounding idea, one through which social housing programs, etc., were promised, but, from the outset, weren't sustainable. Basically, a criterion was introduced into economic policy that couldn't be economized: social contentedness. To create this condition, certain measures had to be taken. Not only because of the "socialist cause," but also as a strategy of conciliation that became increasingly important in the race against Western consumer culture that developed in the 1960s and '70s and that had become impossible to ignore, even in the GDR.

Hirsch – So, the economy focused on basic needs, but the desire for that which is, as it were, unnecessary—or wish fulfillment—was basically ignored as a factor contributing to a sense of contentment.

Nicolai – It's kind of similar to what I described earlier with regard to language: an economy also doesn't just satisfy certain needs—basic needs like food and protection from the elements—but it satisfies these needs in a particular kind of way, and thereby always exceeds the "existential" aspect of those needs. There were people who stood 100 percent behind what that state represented for them—who idealized the state regardless of what the reality might have been. If you asked them to articulate their world view, many would offer the perspective of workers at the end of the 1920s on the verge of ascending into the middle class—people whose existential needs had been taken care of. They had secure jobs, there was free education, they could partake in culture, they could take holidays, they didn't have to worry about health care, and they could look after their families. But all of this existed only up to a certain level! It was a kind of functional fixing: cover the basic needs and add a bit extra on top. There was a complete disregard for the fact that there are dynamics that are propelled by an individual's wishes, by desire, by all sorts of things, and that these dynamics are not only important, but that they are actually the driving factors for an individual's biography, as well as for society as a whole and its economy. This blind spot relates to the fact that the government didn't have any concept of innovation within an economic system. If you look closely at Marx's theory of surplus value, there is no explanation as to why there is innovation at all. [Joseph] Schumpeter[10] severely criticized this aspect of Marx's theories. According to Marx's thesis, an economic system would, at some point, have to grind to

a halt because the rates of profit are saturated. So why do people carry on? This is where one could end up arriving at a very conservative drive theory: Is what propels us simply that we always want to be better than others, or richer, or could there also be something else that motivates us? For the GDR, motivation was a big problem. How can you motivate someone if you tell them, "You earn the same as everybody else, no matter what"? So when the GDR government started to subtly introduce various bonuses, they had to do so very carefully, because it was clear that with the bonuses, one would also introduce social differentiation.

Hirsch – And ideologically, that's disastrous.

Nicolai – If you think this issue of desire and its role in an economy through to its logical conclusion, it means that an economy can only evolve when you permit these dynamics to remain at play. But a phenomenon like desire is something that cannot be controlled, and I mean this not only in terms of ideology. This is why it had to be restricted, and this way of thinking, this matrix, also applies to how the sensible is dealt with. It's an old problem that you can find in the history of philosophy, specifically during the Enlightenment era. When you attempt, as [Gotthold Ephraim] Lessing tried, to convert certain bourgeois attitudes into virtues or positive values—without ordering people to act in a certain way, but, rather, by allowing them to participate in the fate of others so there can be a sort of cathartic comprehension—you start up a machine that basically participates sensually, that identifies, that acts mimetically, that mirrors. This "imagination machine" starts to play through various scenarios.... But the question then becomes: How do you stop this process again? People will not only discover the other in the process, but they will also

discover the other in themselves. This means that they start to feel desires and needs that they previously didn't even know they had! And these are desires whose virtue hadn't been determined. I mean, it's absurd to believe that you would know from birth which need or desire is "good" and which is "bad." So these impulses had to be kept in check. It is a question of the interplay between the other and the Other; that is, how feelings and ethics relate to one another.

This is why during the Enlightenment era, and in particular in German Enlightenment literature, there is always the question: How can we keep passions under control? Because this instance of sensibility is not necessarily social, but it can only articulate itself through the social, and circulate in it; yet as a drive, as a motor, it can be completely asocial—at least when viewed relative to how the social is commonly understood. And that is the fascination of German Romanticism. The dynamic of sensuality was given sway in all sorts of directions, even to the point where it manifested as madness. In literature, [Johann Wolfgang von] Goethe was a figure, similar to [Ludwig van] Beethoven in music, who attempted to stem this somehow, to…

Hirsch – …to channel it.

Nicolai – Yes, exactly. It's no coincidence, after all, that the entire ideological aesthetics of social realism refers back to the classics. [Georg] Lukács, for example, developed his theory based on a classical theory of symbols that stood in stark opposition to the Brechtian approach and favoured a strategy of identification for which the main reference was German literature, especially Goethe, [Friedrich] Schiller, and Thomas Mann.[11] Applied to visual art, you would find these elaborated in the gestalt concept (e.g., Ernst Cassirer, Erwin Panowsky), which can be seen as an attempt to

implement a semantic concept in the perception of form. Of course, form speaks to you on a sensual level, but suddenly, the senses are assigned certain values, meaning there was an attempt to introduce a value judgment at the level where there really cannot be one yet because sensibility as such carries no rational value. You can't say, "You love incorrectly," or "You love correctly." All you can say is, "I love and it makes me suffer," or "I am happy in love," but the feeling that you describe...

Hirsch – ...is essentially value neutral.

Nicolai – Or you can say: it is absolutely full. And that is a problem. You cannot assign value to feelings and emotions the way you assign them to decisions. And to the degree to which there is a society that conceives of itself as a didactic, evaluating society that consciously organizes itself around certain ideas, there is an attempt to establish valuation at the level of the sensible.

Hirsch – I'd like for us to get back to a couple of things that you mentioned earlier and that, in my view, specifically relate to two of your works and that are, in turn, connected to this idea of sensibility and also to corporeality. Your new project, *Escalier du Chant*, is a piece that was commissioned by the Neue Pinakothek Museum in Munich. For this work, you invited twelve composers to produce a cappella works based on current events to be performed on twelve Sundays throughout 2011 on the stairs of the gallery, where visitors and singers mingle during these performances. Together, the songs are intended to form a sort of chronicle of the year.[12] In connection with this project, you recently stated in an interview[13] that it is the spatial proximity between visitors and singers that produces a kind of agency, a desire

to act. I thought this was an interesting point to make because what you seem to propose is that bodily empathy generates agency—which is convincing. After all, it is the body that is our "sensing machine," and through sensory input we develop affective responses to these stimuli. In this context, I would also like to bring up another work of yours, *Chant d'Amour* (2003),[14] a work that, in some sense, is diametrically opposed to Escalier du Chant. The work is a sort of restaging of Jean Genet's film *Un chant d'amour* (1950). Yet your piece is without actors, and you introduce an element of crass commercialism. Where Genet's film uses a natural straw as one of its central elements, you introduce a McDonald's drinking straw. This work also trades on sensuality and affect, but not, let's say, a more neutral or empathic affect as in *Escalier*. Rather, in reference to Genet, it has a clearly erotic tone. Yet through the work we find this absolute physical isolation of the body, not only in the Genet film, but also in your rendition of it, where there is not even a body *present*. So in *Escalier du Chant* there is the suggestion of a political motivation—partially because of the current events that become the composers' inspiration, while Genet's film is also highly political. Not only did it present homosexuality at a time when it was a social taboo, but his, as well as your, work also represents subversive power relationships in which (state) authority cannot ultimately control (physical) desire. So I guess what I'm asking is how do you see the relationship between affect—in all its various forms—and something like agency or political consciousness?

Nicolai – Well, what fascinated me so much about *Un chant d'amour*, aside from the setting, was the role of the voice, which, in this case, is absent.

Hirsch – Exactly. One wonders, why is the piece called *Un chant d'amour*? There is no song; in fact, it's a silent film. You have been dealing with voice, and its absence, quite a bit recently—for example, in your work *Innere Stimme* (Inner Voice, 2011).[15]

Nicolai – That was a development that surprised me as well.... In *Chant d'Amour*, I didn't initially plan to do anything with voice, but directly next to the Volume! Foundation, who had invited me to make the work for their space in Rome, there is a prison called Regina Coeli (Queen of Heaven). It's named after a monastery, which used to be in this location. The building is striking not only because it is immediately recognizable as a prison, but in particular because of its sight barriers. These are tilted barriers in front of the windows so the prisoners can't look out, but light can still enter the cells from above. These barriers look somewhat like minimalist objects. They formed the basis of one of the works in the gallery where I reconstructed such a barrier and installed it on a wall inside the space. Anyway, the sight barriers have the effect that outside of visiting hours, the inmates communicate with their families through the windows by calling to one another, like in a call-and-response-style song. The crazy thing is that *Regina Coeli* is also the name of such an antiphon—it is one of the important Marian antiphons of the Christian Church. When I became aware of all this, I realized I wanted to do something that had to do with voice. I wanted to find a way in which I could connect the idea of the voice with the space, specifically this kind of cell space that doesn't permit you to look beyond its walls. This is how the straw became a central focus point. In Genet's film, a cigarette is shared through this straw, which is inserted into a hole in a wall that separates the cells of the film's two protagonists—which is to say, breath is shared.

I had begun to increasingly view singing as an alternate kind of breathing and this is how, thinking about the project in Rome, the space opened up for me. After all, the drinking straw indicates the absent body, because the straw needs a mouth, and the mouth somehow evokes a body.

Hirsch – Or rather, now that we are talking about this, it occurs to me—though perhaps this is a little too literal—that the walls of the cell could also be read as the boundaries of subjectivity, where the straw becomes the only opening…

Nicolai – That was also the reason why I decided to use a McDonald's drinking straw. The drinking straw has, of course, an etymological and historical link to agricultural straw—a material that has many metaphorical connotations, as in "to clutch at straws." In a strange way, the drinking straw can come to also represent nature…. So to counter this, I wanted to introduce an object that refuses this superficial naturalization, and the McDonald's straw fulfilled that criteria. Plus, there are a large number of McDonald's franchises in the city centre of Rome (and in close proximity to the gallery), which, for Italy, is a big deal. I became interested in articulating a paradox, namely between, on the one hand, the straw at which you might be clutching—or in this case, with reference to Genet's film, the straw that pretends to facilitate exchange—and, on the other hand, the straw that is connected to an economy that is incapable of reasonably satisfying needs and desires. This is the crux of the matter for me, the paradox that arises from the connection between the needs and desires that articulate themselves through an economic structure and the needs and desires that are ostensibly satisfied by that economic structure—I think it would be reductive to describe this constellation simply as alienation….

Something that seems relevant here is that Genet's film was shot in La Rose Rouge in Paris, a night club that belonged to the financier Nico Papatakis, and the actors really were guests of his club and the Montmartre gay scene.

Hirsch – How do you mean, it would be reductive to describe this constellation simply as alienation?

Nicolai – In a short text[16] Pierre Klossowski proposes that the mercantile character of the libidinous has been completely misunderstood in modernity. By this he isn't suggesting an economic determinism, but he speaks of a dialectic of customs and usage. The use object is inseparable from the customs of usage, as he puts it. If you take this idea seriously, then the differentiation between use value and exchange value would not result in a simple opposition. It would be too limited to talk about a perversion of the use value through exchange value. Klossowski takes this even further by comprehending economic structure as a substructure of affect. This in turn means that the affective isn't simply structured by economic norms, but that affects are articulated within economic structures and that the formation of these affects takes place through these structures. So, affect and economic structure don't oppose each other. Differentiation of the economy is paralleled in an altered sensuality, in transformations of the sensorium. I don't mean that there are different feelings, "new" feelings—what transpires are other complexes of articulation and actions through which feelings are being "formatted" and distinguished. Jonathan Crary lays this out beautifully in his *Techniques of the Observer*.[17] What seems to be mutually exclusive is actually mutually constitutive: Crary demonstrates that alienation through modes of production, the emancipation of the senses, and the constitution of an

individual focused on self-actualization are interconnected and mutually contingent. He describes precisely how the disciplining of factory labourers, scientific research on the human organism, and the specialization of the senses are mere facets of one and the same process.

Hirsch – What I liked about your choice of the McDonald's straw is that it pulls you back to a reality that is in almost brutal contrast to the Genet film, which is elegiac in many ways. At the same time, your introduction of such a prosaic element heightens the transcendental quality of the desire that the work evokes—the will to connect and exchange. In that moment it seems basically to refuse commodification.

At the same time it's really fascinating how, especially when we look at *Chant d'Amour*, the voice marks the moment of subject formation. The characters in Genet's film, like the inmates at Regina Coeli, have had their freedom restricted. In other words, they do not have access to all aspects of liberty, and are thus without agency, without "voice." And yet, as you describe, the prisoners of Regina Coeli seem to actually reclaim subjectivity through the use of their physical voices.

Nicolai – *Chant d'Amour* actually also involves a poster that didn't get so much attention in the context of the exhibition, but it's important to me. It's a poster with a quote by Walter Benjamin that I wanted to put forward and that relates to the work in the gallery, but that isn't connected to it in any obvious way. This text by Benjamin[18] reflects on whether, or to what degree, any power may have the right to restrict the satisfaction of needs and on what basis that restriction might be brought about. This is a very early text of Benjamin's where he more or less posits a condition of violence as a problem in itself and where he distinguishes

between secular and divine violence. This is an almost gnostic dualism, and in it, violence, state violence, is almost always presented as negative. Actually, Benjamin constructs his argument with much more complexity, but it is often read in this very dualistic way.

The point about this dialectic, as Genet presents it, is that not only are the police arbiters of violence, but that violence also plays an important role in fuelling desire. Thus violence can have a structuring effect, allowing certain formations to function. So the conclusion is not to look for a condition that is free of violence, but to ask what violence, in what form, and under what circumstances is one prepared to support? Basically it means opening up room for negotiation.

Hirsch – What do you mean by "support"?

Nicolai – To endure, to tolerate, but also to exercise. Societies rely on rules to function. [Jean-Jacques] Rousseau put it very nicely: the first person to put up a fence and say, "this is mine," created society. This could be the definition of a capitalist society that is based on the notion of private property because there the creation of any relationship presupposes private ownership—the ownership of one's own person as well as the ownership of things. But what is contained in this thought, and what, in my opinion, goes beyond the realm of any question of ownership, is that regulation, too, becomes a factor. And, whether you like it or not, the regulating function that is operative in relationships also has violent characteristics. One has to accept somehow that this structuring is not possible without violence, which also means that there is no living together without violence. The question is, however, to what extent do you believe in being able to resolve this through negotiation, in other

words, by legally codifying and thereby transitioning into a kind of Western model of democracy, as opposed to accepting a condition of permanent civil war that only ends when one party has finally finished the other off? Or is it possible to exceed these scenarios?

Hirsch – It seems important to revisit an issue that you raised earlier: that often when emotion and sensibility are mentioned in the context of art or art production, what comes to mind initially is an idea of lofty emotions, or lovey-dovey feelings linked to beauty—an idea of exactly those affects that have already been valued as "positive." It is almost as if there has been a conspiracy to undermine the power that emotion and sensibility exert by suggesting they are harmless, by sanitizing them somehow, also by denying their fundamental ambiguity. I also cannot help but note that the negotiation you mention is a form of trade—of ideas and values that must be assessed and possibly transformed in a process of being passed back and forth between two or more parties, as between artist and audience, by means of an artwork, for example.

Nicolai – Yes. What is meant when people speak about beauty? It certainly cannot be just about comfort. Beauty becomes a useful concept for me when considered as a formal category; that is, a kind of anti-psychology, not the expression of individual enjoyment, but instead as an articulation of specific formal constellations that exceed these very constellations. Otherwise, you are left with simply rapture. Beauty as a kind of turning point, as an exchange arena. Not only in the sense of [Rainer Maria] Rilke, as the beginning of terror,[19] but also as the beginning of something new, another sensibility. I am convinced that the works of Donald Judd are differently received

today than they were thirty years ago. And here we have the reception that you are talking about. One also in a way becomes an audience to one's own works. And there are moments where through them one's own "blind spot" can briefly appear like a flash.

At the beginning of this conversation I talked briefly in the context of Lacan about flexion. One could also consider one's own artworks as such flexions and consider their interrelationship based on the way in which they inflect each other and what forms appear in them. The author Anne von der Heiden demonstrated this for me once in a text.[20] I was surprised which of my works she positioned next to each other, which ones she put into relation with one another. A conceptual work, like the advertisement for a meteor shower (*Welcome to the Tears of St. Lawrence*, 2005), a poster work that samples the image of dripping blood from a castigation scene of Christ (*untitled, Blutstropfen*, 2000), and a realist sculpture (*A Portrait of the Artist as a Weeping Narcissus*, 2000) connected simply through the image of the drop. I can't say that didn't affect me.

1. Marcel Mauss, *The Gift: The Form and Reason for Exchange in Archaic Societies* (London, W. W. Norton, 1990), 21–22.

2. Erich Maas (1952–2001) was an artist, graphic designer, and publisher. He co-founded the Maas Verlag in Berlin in 1990. Maas published, for example, the first German translation of works by Kathy Acker.

3. Before the fall of the Berlin Wall, the Berlin district of Kreuzberg stood for everything alternative. Since during the Cold War era West Berlin was completely surrounded

by East German territory and was basically a capitalist island inside the socialist GDR, the West German government put special incentives into place to keep West Berlin running, which in itself was an ideological imperative. One of these incentives was that all young men registered in Berlin did not have to attend the otherwise compulsory military service. Needless to say, the city thus attracted many young people, particularly those of a sometimes radical, left political conviction. Since there was not much in the way of jobs in Berlin, the city population composed itself largely of very young people and people in retirement age. The district of Kreuzberg, with its significant old housing stock, also became the nexus of the German squatting scene, home to a large radicalized anarchist contingent.

4. Oskar Negt and Alexander Kluge, *Geschichte und Eigensinn* (Frankfurt: Suhrkamp Verlag, 1993).

5. Friedrich Ludwig Gottlob Frege (1848–1925) was a German mathematician, logician, and philosopher. See "On Sense and Reference," alternatively translated as "On Sense and Meaning" (1892).

6. Jacques Lacan, *Die Übertragung. Das Seminar, Buch VIII*, ed. Peter Engelmann (Wien: Passagen Verlag, 2008), 263 ff.

7. The term "flexion" originates with Pierre Klossowski and is picked up by Gilles Deleuze in *The Logic of Sense* (1990). Author Barbara Bolt describes it thus: *For Deleuze, flexion is that "act of language which fabricates a body for the mind…language transcends itself as it reflects the body."… The body that writes and is simultaneously written suggests a mutual reflection between bodies and language. As a double transgression between bodies and language, flexion is a "monstrosity" which effects de-formation at the level of matter rather than form.* Barbara Bolt, *Art Beyond Representation: The Performative Power of the Image* (London: I. B. Tauris Publishers, 2004), 157.

8. *BILD* is a right-wing tabloid that in the 1960s and '70s engaged in such inflammatory anti-left journalism that it was partially blamed for the shooting of Benno Ohnesorg. Ohnesorg was a student who had participated in the 1967 demonstration against the visit of the Shah of Iran in Berlin. The demonstration was quashed with excessive force. Ohnesorg's violent death was a catalyst for further unrest and made *BILD* one of the protesters' prime targets.

9. A conservative broadsheet newspaper published in Frankfurt with a layout akin to the *New York Times*.

10. Joseph Schumpeter (1883–1950) was an economist and political scientist. *Capitalism, Socialism, and Democracy* (New York: Harper & Row, 1975).

11. See Georg Lukács, "Es geht um den Realismus," in *Die Expressionismusdebatte: Materialien zu einer marxistischen Realismuskonzeption*, ed. Hans-Jürgen Schmitt (Frankfurt am Main: Suhrkamp, 1973).

12. For an online archive of *Escalier du Chant*, see http://escalierduchant.org.

13. "Wie der Sinn ins Sinnliche kommt: Die Kunst des Olaf Nicolai," *Zündfunk*, Bayerischer Rundfunk 2, March 13, 2011.

14. Jean Genet, *Un chant d'amour*, 1950. View online in full at http://fillip.ca/vkmd.

15. *(Innere Stimme) [2011] is based on 'Humoreske' Opus 20 for piano by Robert Schumann. On one page of the piece Schumann added a third notation between the treble and bass staves, which he named "Innere Stimme" (Inner Voice). This melody can technically not be played by the pianist as his hands are busy with the treble and bass staves but the melody remains present for the musician—it influences his interpretation of the piece. The audience, unable to see the score, can only imagine the influence of the "Innere Stimme." Using this extreme work of the romantic composer, Olaf Nicolai...addresses the conceptual level of*

the music with a continuous 30-hour-performance of the hidden notes, interpreted by…30 singers. With the performance, the mental dimensions of Schumann's music is transposed and unveiled in the gallery space of VeneKlasen/Werner [Berlin]. The now audible inner voices echo the original concept of seeming absence and ghostlike appearance, for its enduring repetition. Olaf Nicolai, "Symphony-Movement II: (Innere Stimme)," *Soundfair*, last modified October 2010, http://fillip.ca/pa39. See also *Olaf Nicolai, Innere Stimme* (Middelburg: De Vlesshal; Amsterdam: Roma Publications).

16. Pierre Klossowski, *Die Lebende Münze* (Berlin: Kulturverlag Kadmos, 1998).

17. Jonathan Crary, *Techniques of the Observer: On Vision and Modernity in the Nineteenth Century* (Cambridge, MA: MIT Press, 1990).

18. Walter Benjamin, "Critique of Violence," in *Reflections: Essays, Aphorisms, Autobiographical Writings* (New York: Random House, 1986).

19. Rainer Maria Rilke, *Rainer Maria Rilke Werke*, Band 1.2, *Gedicht Zyklen, Duineser Elegien* (Frankfurt am Main: Insel Verlag, 1982), 441.

20. Anne von der Heiden, "In Abeyance, or: Views and Visual Rays," *Parkett* 78 (2006), 100.

Hadley+Maxwell
Someone That Happens

Personae

The SHITE [shē-'te] *principal actor*
The WAKI [wah-kē] *secondary actor*
The JIUTAI [zhu-tay] .. *chorus*
The HAYASHI [ha-ya-shē] *instrumentalists*

Act One

Nō theatre[1] begins and ends in the mirror room. Hidden from the audience by a five-colour curtain, the musicians tune their instruments and gauge a cadence, and the SHITE sits before a full-length mirror.

Hayashi – The mirror is an instrument; it is reliable because it has the properties of dematerialization and of aspect: the becoming species, spectacle, specific, of materiality, but also the offering-up of what can be said about the properties of things. Aspect is an alchemy of essences and existences. The *shite* dons his mask and, in perfect simultaneity, the creaturely presence in the mirror dons a mask. An other-face moves to the fore. This face is an *other self*. There is a living struggle between actor and mask that is the becoming-character of the role—this is what forms in the mirror, and she will be the last player to cross the bridge onto the stage.

Before SHITE appears on the stage, WAKI will address the audience and describe the conditions for the appearance of SHITE. WAKI's first responsibilities include introducing

himself, describing where he is from and where he has been travelling, and opening up the story so SHITE may enter in character.

Waki – We are currently considering our relation to artistic practice as a reworking of what continues to threaten artistic practice in general: the lingering of a traditional conception of aesthetics that presupposes the artist as prior and separate from artwork, audience, curator, polis, economy, world, language, and authorship. It is our experience that artistic praxis has more to do with negotiating the boundary between a system of signification and what it claims to signify insofar as it touches upon, struggles with, or bears witness to our living desires and their material realities. This text is an experiment across a series of paradigms familiar to forms of theatre such as the tragic and comic mask (or *persona*), the mirror and its image, the unmediated living being and the face, in which an economy of representation is played out to open up the possibility of a figure that does not willingly fit the tragicomic models of subjectivity. We are interested in the f-l-e-e-t-i-n-g distinctions we can generate between capturing subjectivity and producing a sense of self.

Artists address the world, a world, or a number of worlds in the radical split they experience in the *presentation* of their work. The moment of presentation represents a critical tension between artist and world in which both are at stake for better or worse. We suffer this split, with one foot in the realm of the political, the social world that we are addressing, and one foot hovering in something that is not yet a world, not yet articulated, and therefore not yet political. Like in the mirror room behind the curtain, in which the face of an *other self presents itself*, the life of the artist bridges and, in turn, is formed by its traversal of

this separation, back and forth, forth and back, back and forth. The unrepresentable is an event within presentation. In the lingering proximity of this unrepresentable presence, presentation becomes representation. This perpetual exchange between presence and image is what we mean by an economy of representation—it is a movement that describes theatrical space and time in which we sense that we are sensing.

The most awful effect of trying to locate artistic responsibility is that it forces artists to stand on one side of the divide as incomplete persons, separated from their artwork and their own livelihoods. Such a mode of living could appropriately be called tragic. The "artist" identified, and thereby isolated, as a social or civic functionary faces only the responsibilities of an appointed office and the theatrical possibility of this dramatic persona. It is in a tragic mode that so-called reality and theatricality can be effectively blurred. This constitutes the artist as a character subjected to a drama written by, perhaps quite rightly, God knows whom! and not the one who creates artworks that in turn create the artist's living sense of the world. The comedic persona, alternatively, is not properly a form of subjectivity; it is a manner or attitude that permits a simultaneity of subject and object, artist and artwork (critic and criticism), artwork and world. Artists are not managers of the economy of representation, but important members of its household who keep the exchange from settling. What is a critical relation to daily living, to culture? Is it a matter of creating an infinitely cool distance? Or will it also accommodate us when we fall madly into obsession, in spiralling turns? Why should criticality mean that one must find a way to isolate oneself from this pulsating rhythm of the art of living and the living of art? Who has the guts to offer the entirety of his or her own image, without reserve, to reflection?

SHITE emerges, carrying a fan and wearing the mask of a young woman.

Jiutai – "The fact...is that there is no essence, no historical or spiritual vocation, no biological destiny that humans must enact or realize. This is the only reason why something like an ethics can exist...[otherwise] no ethical experience would be possible—there would only be tasks to be done."[2]

Hayashi – The *shite* is the last player to cross the bridge onto the stage. The arrival of this spirit—the actor + mask + performance—marks the event of Nō, of *someone that happens*.[3] This theatre plays out a process of subjectivity, the production of subjects, with the living being (the actor) coinciding with a persona (the mask) to create an image on a field of representation (the mirror, or stage). The stage, like the mirror, holds the image as aspect; the image found in these forms is subject to the perspective of its witness. The preparations of the mirror room are transcribed into the theatre, with the audience facing the paradigmatic struggle of *someone* against the destiny of the plot. The audience's role of recognizing this process of subjection is part of the movement of mask-subject-actor to actor-subject-mask, back and forth. It is in this sense that "each person, not the audience as a group, has an intense, private encounter with the performer." This is also the reason Nō plays are not performed in long runs—for, like the tea ceremony, "any ceremony can be encountered only once in one's lifetime."[4]

Jiutai – Half the audience is asleep.

Hayashi – The relationship between a Nō actor and his mask is special and severe. The face is considered to be the

most expressive tool in a performance. Covering the face with a mask is thought to be simultaneously the denial of access to the actor's normal repertoire of facial expressions and the production of the actor as an individual. Actor Kanze Hisao writes that in Nō an actor is "not even allowed to breathe as he pleases."[5] The living being is restricted to carrying out a highly formalized ritual, bound by the costume that restricts his movement, the mask that covers his facial expression, and the structure of the traditional form itself. The actor is subjugated to these formal elements but must fight to achieve them. Hisao describes the subjugation as reciprocal, a struggle of the actor against the mask and vice versa: "The Nō actor depends upon the mask to lead him to mindlessness while also struggling with it and throwing his energy against it…. The mask is an equal partner with the actor in accomplishing [true Nō acting]." The Nō mask does not obliterate the individual, but it restricts his access to methods of appearance that are *too available*—and thereby the "natural physicality, the pure life essence of the humanity of the actor is brought to the fore."[6]

Jiutai – The audience is half asleep.

Hayashi – Nō is an example of theatre as a political and philosophical exercise.[7] It is an exemplary exception in that it exercises the paradigm of being-in-a-mask or person(a) in such a way that all those involved, both players and audience, witness the process of becoming-image as well as the form that recognition can take within this process. Recognition itself is subtly altered as the audience senses the *seeming* of the act. Theatre involves the gathering of participants to witness a playing out of processes of subject production. Thus, theatre can be thought of as an exercise in playing out what it means to be human; creating the

sense of what *seems to be* is how an economy of representation is destabilized and put into play.

Shite – "If I pretend to see, I enter into visibility."[8]

Waki – The mirror is an instrument through which the actor both splits from and merges with his self-as-image, a paradoxical production of the performing character that results from the *sense of self* an image affords its bearer.

Shite – I bare my image on the plane of a mirror, a stage, a face.

Waki – It is this paradoxical image, the resonant and fleeting subject, the tense and magnetic and vibrating constituent subject, that we want to hold up as an example.

Shite – It is a sense of self I am trying to learn.

Jiutai – On the third day, a piece of white cardboard with two holes cut from it had been moved from the back (mirror) room to the stage, where it was strapped to the top of a small evergreen tree, ostensibly giving the tree eyes.

On the twenty-first day, the tree had been moved to the periphery of the room, off the stage, into the dark. It had the following note taped to its branches where the mask had been: *This is not about me.*

On the twenty-eighth day, there was a soundtrack in the darkened room. A woman's voice said: *My life as a rock was good. But after some time, being visible wasn't enough.... Eventually, I grew eyes. I wanted light to enter into me, and darkness as well. I needed an entrance space to blink open, a theatre space with curtains. This was because I had a desire to turn in on myself. I wanted to sense an emptiness that was*

full. Over time, this grew into an interior space that was both pathetic and dramatic, sculptural and theatrical. In this space was born love, poetry, and other romantic forms. Because of this turning in, this darkness, the groaning sound of criticism emerged. A beautiful dramatization occurred, it was like a war. The war allowed me to feel ecstasy....[9]

Waki – However—

Shite – The edge of language has promise for us, and it is a horror to lose it. Worse, it is a horror to abuse it. We can see its architecture best when it is reflected hypothetically in a full-length mirror. We can make out the entrances and exits of a model theatre, a spectral stage of uncertain dimensions—it shrinks when we back up, and it grows larger as we tread closer. Memory serves to make the space legible—or vertiginous, if the mirror is set at an oblique angle to the ground. I remember: Tooth, Door, Tour, Route, Gate, Truth, Ruth, but not how I acquired these names or how my tongue forms Dis- and Thud (our tongues form Kiss). In this aspectual space, thingly contiguity orders names spatially, though at first we encounter their ordering synesthetically and then in timely syncopation. In a mirror, names reveal their substantiality of pure continuity from inside to outside (through the back of the glass) of representation. We can discuss the status of the proscenium, but we will pass under this quickly. The stage will thrust forward and open into the round, through the surface of the reflective glass-to-image-to-figures unfolding inside. Blazing hot lights cast swaths of colourful attention across the floor, loudspeakers hum in cycles-per-second of textured electrical pulses, the strain of focused hearing channelled by the silent duty of microphones.

Jiutai – The audience is in the dark.

Shite – I lie.

Hayashi – The text is a script of the fear of forgetting: name, mask, persona, tooth, syn-. The text is before, between, and after the actor, the mask, and the audience. The actor the mask the mirror the stage the audience the slave the king the screen. The actor the musicians the prop the pope the rhythm the cadence the chorus the step the mask the fool the mirror the step the clock the stage the image the step the beloved the music the rhythm the audience. The etc. The creature the image the audience? Exigency is the texture of forgetting. Theatre happens only once.

SHITE exits the stage over the bridge.
She is followed by WAKI.

Kyogen (Comedic Interlude)

An Unjustly Informal and Peremptory Treatise on
the Fate of Tragedians and the Utopic Intimacy
of Comedians after Dante, in Almost Bullet Form,
Culled from Several Works by Giorgio Agamben

Nudity in the Garden of Eden was temporary,
apparently, and by destiny, the human flesh
succumbed to the groans of the libido that
followed on the heels of that fated (and
inappropriate) act of culinary curiosity.
This resulted in the stripping of the garments
of light the first couple wore in the earthly
paradise. Yes, garments of light, whose removal
revealed, or unconcealed, a corrupt animality;
this describes the root of the Western structure
of guilt (but also the familiar process of
"truth telling" as an exposure of corruption).
And so, if the natural guilt of the flesh
was originally covered by grace, the Fall of
mankind represents the loss of innocence to the
experience of corruption of the flesh, meaning
that (in this play, anyway) natural guilt
underlies personal innocence. More to the point,
corruption is a stain of the flesh, which is
objectively attributed independent of the will
of the person (remember, the first couple was
destined to Fall). The Stoics entered the Greek
concept of *hamartia* (meaning to stumble or fall
while walking—or to err) into the structure of
the Fall and original sin.[10] Consequently, this is
the moral structure of tragedy they handed down.
In short, the Western concept of tragedy is the
subjective experience of innocence lost to an
objectively asserted guilt in the form of a law,
fate, or destiny. Medieval scholars interpreted
comedy as the post-Fall era of mankind[11] in which
the Passion of Christ inverts the tragic effects
of nature and personhood by offering salvation
via personal expiation. In other words, Christ
transforms "the irreconcilable objective conflict
[of the corruption of the flesh] into a *personal*
matter."[12] One must be careful to note that the
comedic persona is not simply the inversion of
tragic subjectivity; the root of the relation
to guilt (original sin) is denaturalized in the

Passion, thereby personalizing the experience of guilt in the comedic relation. Even today, in great comedy, we encounter ordinary citizens and events as a universe of lovable fuck-ups. Dante's cosmology is a comedy[13] not simply because the human creature is born into a fallen state yet can overcome his fate and live happily ever after, but because he maintains the potential of a specific *attitude* of the innocent human being toward the persona or the mask as it was understood in ancient Greek theatre. The persona (in this case, Dante the sinner) is the figure that human innocence abandons to divine law. Comedic persona is not proper subjectivity; it is simultaneously mask and innocent actor that maintain a separation from a fated corruption insofar as they play a role but do not identify with it. The law then becomes an instrument of personal salvation. Tragedy, on the other hand, is marked by an *attitude* of complete identification of the actor with the person(a) or mask: Tragedians surrender to the fate of the person(a). Hollywood typecasting attempts to wed the identity of the actor to the face of the person, to the point where his or her on- and off-screen performances become indistinguishable. This is why tragedians experience guilt—whether it appears in the form of law, fate, or destiny—as a "Fall from grace" that they are subjected to and cannot overcome in their moral innocence.[14] We are particularly interested in thinking two ways of living with our masks: identifying with the persona and making use of the persona. The tragedian wants to *be* the mask in order to become the object of a positive identification (this is evoked today when we say that one should take personal responsibility—the identification with the mask has become so totalizing that it has disappeared). The comedian *makes use* of the mask to live a sense-of-self as the actualization of personal human potential.[15] The comedian uses representation to share the ability to relate, to permit one to act as someone (as Dante, for example). Or we could put it thus: the comedic persona is transitive; a sense of self occurs in the presentation of a form of human mediality itself.

Act Two

WAKI returns to the stage to introduce SHITE, who emerges from behind the curtain wielding a sword and the red mask of a demon.

Hayashi – What are the stakes of unmediated human being?

Waki – We need to be recognized by others in order to appear, even to ourselves, as human.

Jiutai – "The new ID cards include retinal scans and forty-nine items...they won't stop your identity being stolen, it just means when it is you're fucked: I've left my wallet in the hotel—I'm going to need new eyeballs and a finger transplant."[16]

Waki – Our relationship to recognition is currently in crisis as we shift emphasis from persona-identity to bio-identity. Our contemporary condition is one in which we are happy to be recognized by machines (the retinal or fingerprint scan) while we forget what it is like to be recognized for our "personality."[17] We are comforted by the idea that we can change our mask a hundred times and still have committed the same crimes.

Poets struggle with what it means to bring the word to its substantiation. This is the ethical concern of the artist whose livelihood it is to directly engage an economy of representation. Is there a proper attitude to adopt in this matter? War, in which blood is spilt in the engagement of humans face to face with one another, is the total substantiation of the meaning of the word in essence rather than the immaterial character of the word as idea. Drones with weapons, cyber "war," wars that involve humans killing

one another from a great distance using technological appa-ratuses to mediate the spilling of blood, involve the total substantiation of "war" in existence as word and idea. Why do we want to draw blood? Why do we say that *this is reality*? Why is suffering "reality" and joy some sort of madness? Have we lost all other sensitivities that would allow us to relate by other means? We substantiate our wavering ethical coordinates by debating governance instead of negotiating the relation between representation and what we consider real. We study the tyranny of global capitalism as if it were a demon instead of recognizing that we are under the spell of its theatrical apparatuses.

Shite – Crossing the stage, out the back door, and onto the street, we view wandering shoppers and vendors peddling their wares who are bored but not altogether indolent. Out the back door, things in this theatrical image turn inside out: mindless cameras register whatever passes by; gateless gates beep or remain silent as products from faraway lands of agreeable profit margins are conveyed through; spent chew-ing gum punctuates the sidewalk; swishes of emblazoned plastic cards release oily numbers that permit sanctioned (numbers of recognition) cash (quantified labour in num-bers) to crumple the air at dizzying speeds in the name of the bearer. This acting is a becoming-keyword of our behav-iours, accessible to smartphones, networks, and databases that grow smaller but still corporally stain the smooth sight-lines of offices. The hyperpresent audience of this inverted theatre remains hidden—it is pure *meta*; its level of interest in this management of behaviours is in relation to capital interest on investment at stake. Equally person-less perso-nas, obscured in shadows, watch from behind curtains or glass walls; their accumulations of tendencies-in-numbers benefit their interest in dramaturgy; they drive the plot from

the thresholds of the obscene mirrored stage. Recognition is not reciprocated; we accept it as acknowledgment of the "I was here-ness and not-yet criminal" found in the unique arabesques of fingerprints, irises, and nucleic acids.

Waki – Artists specifically work inside the ethics of the difference between tragedy and comedy because they study, alter, and shift the media that enable human mediality. The presentation of an artist's work makes it artwork; its appearance is the transformative moment, just like the Nō actor who appears in the mirror and then on the stage. Recognition (from the audience) is not knowledge production but an encounter of sense-ability, the recognition that something *seems*.

Jiutai – We do not know our friends; we love their attitudes.

Waki – Recognition of seeming is an ethics of sensing the living being coinciding with the persona, while not forcing the two into a fixed identity (thereby condemning the character to tragedy).

Shite – That's why we smile when I say "I lie." The paradox is perfect comedy: the announcement of the clothing hung on naked truth.

Waki – Recognizing the seeming of all things that are[18] belongs to us reflexively in our sense of self, since we have an outside that appears, a threshold called the face. The outside must happen to us, and in this sense we are subject to it, but we are not *reducible* to any one of the qualities the outside presents as our own.

Shite – "In my face, I exist with all of my properties (my being brown, tall, pale, proud, emotional…); but this

happens without any of these properties essentially identifying me or belonging to me."[19]

Waki – What does it mean to be what you seem? Not to be subject to the properties of your face, but to own them insofar as they do not belong to you? It is this sense of self as the constant movement between essence and existence, between the creature and the persona, the body and the word…

Shite – … an ethics of representational economy that I practice in the mirror room by looking into her eyes.

SHITE drops his sword. The clattering sword is amplified by microphones beneath the stage.

Jiutai – The audience jolts awake.

Hayashi – The text is a script of the fear of forgetting: name, mask, persona, tooth, syn-. The text is before, between, and after the actor, the mask, and the audience. The actor the mask the mirror the stage the viewers the slave the king the screen. The actor the musicians the prop the pope the rhythm the cadence the chorus the step the mask the fool the mirror the step the clock the stage the image the step the beloved the music the rhythm the audience. The etc. The creature the image the audience? Exigency is the texture of forgetting. Theatre happens only once.

1. According to historian Kunio Komparu, Nō is a classical stage art of Japan that arose out of a variety of sacred rituals and festival entertainments that reached their "maturity" in the Muromachi period (1336–1568). Its present form,

which involves the use of masks, chanting, and dance—
with little dialogue—dates back six centuries and often uses
tragic or spiritual themes. In a full day of Nō theatre, the seri-
ous plays are alternated with Kyōgen plays, which also use
masks but are lighter, often comic or parodic, and, by con-
trast, composed primarily of dialogue. Kunio Komparu, *The
Nō Theater, Principles and Perspectives*, trans. Jane Corddry
and Stephen Comee (New York: John Weatherhill, 1983).

2. Giorgio Agamben, *The Coming Community*, trans.
Michael Hardt (Minneapolis: University of Minnesota
Press, 1993), 43.

3. Paul Claudel, quoted in Komparu, *The Nō Theater*, 8:
"Le drame, c'est quelque chose qui arrive, le Nô, c'est
quelqu'un qui arrive."

4. Komparu, *The Nō Theater*, xxi.

5. Kanze Hisao, "Life with Nō Mask," in *Nō/Kyōgen Masks
and Performance*, ed. Rebecca Teale (Claremont, CA:
Mime Journal and Pomona College Theater Department),
70–73.

6. Ibid., 71.

7. It would be interesting to carefully follow the differ-
ences in the Japanese traditions of theatre and political dis-
course relative to those of the West. Our interest here is in
the potential of this model to enrich our understanding of
comedy in the Western tradition and to open it up beyond
our tragicomic sense of subjectivity. The direct relation-
ship between theatre and philosophy is exemplified in the
West by "Stoic philosophy, which modeled its ethics on
the relationship between an actor and his mask." Giorgio
Agamben, "Identity without the Person," in *Nudities*,
trans. David Kishik and Stefan Pederella (Stanford: Stan-
ford University Press, 2011), 47.

8. Lisa Robertson, "Perspectors/Melancholia," *Improper-
ties*, SMART project space, Amsterdam (2010).

9. Geoffrey Farmer, *God's Dice*, solo exhibition, Walter Phillips Gallery, Banff, Alberta (December 2010).

10. Giorgio Agamben, *The End of the Poem, Studies in Poetics*, trans. Daniel Heller-Roazan (Stanford: Stanford University Press, 1999), 11–22.

11. Ibid., 19.

12. Ibid., 12.

13. Ibid., 19–20.

14. We are drawing from several works by Agamben: *The End of the Poem, Studies in Poetics*, as well as *Nudities*. We are also paraphrasing several videos on YouTube, including *Liturgia and the Modern State*, posted October 2, 2009, http://fillip.ca/5n2x, and *A Genealogy of Monasticism*, posted May 12, 2010, http://fillip.ca/2xej, both taken from a series of public open lectures at the European Graduate School in 2009.

15. This is worth comparing to the "reflective awareness as to the mimetic faculty" that leads to the ability to "live subjunctively," as articulated by Candice Hopkins citing Michael Taussig (see endnotes 46 and 47 of "The Golden Potlatch," on page 178 of this volume).

16. *Frankie Boyle, Live at the Apollo*, YouTube video, 9:55, from a performance originally televised by BBC One, posted July 7, 2010, http://fillip.ca/kl6s.

17. Agamben, *Nudities*, 46.

18. Imagine, as a subtext, the poem "Description without Place" by Wallace Stephens (*The Sewanee Review* 53, no. 4 [autumn 1945], 559–65): "It is possible that to seem—it is to be, / As the sun is something seeming and it is. / The sun is an example. What it seems / It is and in such seeming all things are."

19. Giorgio Agamben, "The Face," in *Means without End*, trans. Vincenzo Binetti and Cesare Casarino (Minneapolis: University of Minnesota Press, 2000), 99.

Jan Verwoert

Faith Money Love

On Letters of Indulgence, the Technicalities
of Betrayal, and the Advantages of Sleepwalking

Tell me why, tell me why
Is it hard to make arrangements with yourself
When you're old enough to repay
But young enough to sell?

—Neil Young, "Tell Me Why"[1]

Money is a matter of faith. If no one put faith in it, money would have no value. Money needs you to invest faith in it. Yet it will never put faith back in you. It won't believe in you just because you choose to believe in it. Affairs with money are one-sided: you can go out and look for money, but money won't come round to look after you. You can hold money in your hand, but it won't hold you in its arms. You can foster its growth. But it won't hold your name in honour. It forgets you the second it leaves your pocket. Money is a deserter. The more love you give it, the more likely it will betray you. It's like in life. The ones who receive a lot of love are most likely to cheat on those from whom they receive it. They are given the power to cheat *on* their lovers *by* their lovers who, by putting faith in them, give them the confidence necessary to accomplish their betrayals. Love, as we know it, is an unconditional investment of faith in the value and power of others. Those who get the power have got all they *need*, so who could blame them for using what they *have* to get more of what they *want*? Precisely because economies are faith based, they thrive on betrayals. Without trust to be betrayed there are no profits to be made. Without some putting something at

stake, there would be nothing to gamble on. Neither now nor in the future.

Faith-based economies have a long history. Today people like to gamble on stocks and bonds when they bet on the future. In the past the Catholic church allowed you to put money on the things to come. You could purchase a claim on the harvest of life and an option on the reward of the faithful by buying a letter of indulgence. For centuries the church had already been selling sanctuary. But in the beginning of the sixteenth century, it took business to a new level. Son to the Medici banking dynasty, Pope Leo X (Giovanni de Medici, 1475–1521) got together with the then-biggest bank in Europe, the Augsburg Fuggers, to organize and expand the market for letters of indulgence. Printing them in great numbers was a primary use of the recently introduced letter presses. Distribution was facilitated by the fact that a major political player in Germany, Albrecht of Brandenburg (1490–1545), had taken on a giant loan from the Fuggers in order to pay a fee to the Vatican for holding three bishoprics (when *de jure* one was the allowed maximum). To redeem his debts, Albrecht struck up a deal with a task force of Dominicans led by Johann Tetzel (1465–1519). The monks would travel the lands, preach to the people, and sell them the letters. The revenue was split 50/50. Half went straight to the bank, which had its own people on the road with the monks. The other half went to Rome, where Leo put it into his main project, building Saint Peter's.[2]

So faith was big business. What an incredible realization it must have been to understand that this most common and infinitely renewable resource—the faith of the people—could be converted into capital and sold off as shares! Faith, moreover, did not just imply hope for heaven, but also trust in a social order, which the church justified as God given. In this sense faith was what the social contract

was built on (if we here understand "social contract" as the tacit agreement between the members of a society regarding the principles that govern their communal relations and determine their positions within the social matrix). Now, if the letter of indulgence is a piece of certified faith and faith is the basis of the social contract, it would seem fair to conclude that the letter in fact represents a copy of that contract, put up for sale. Like one would nowadays *buy into* a company, the purchaser of the letter would buy into the church, and thereby into society at large.

But why would you want to *buy into* a social contract that you are bound by anyhow? To license your dependency and receive a document to certify it. The tie between mortgages and credit works similarly today. In countries governed by a speculative economy, the best way to get credit is taking on a mortgage. In exchange for consigning yourself to a system of debt, the bank accepts you as someone worthy of credit. By purchasing a letter of indulgence you would likewise consent to your guilt, and this admission of your debt (toward God) would make you a certified creditor in the economy of salvation.[3] So when you buy into the system of debt, you pay to enter—not to exit—it. For the moment the church has given you credit. But to receive it, you declared yourself a sinner. And a sinner will surely sin again. So once you have accredited yourself as a sinner, you will only get further into debt. But people must have known that this is how it would go. So it's probably safe to assume that, rather than trying to come clean once and for all, they actually sought to further (and formalize) their entanglement in the economy of salvation through their purchase. In the name of your future *assumption*, the church gave you the chance to license your progressive *consumption* by debt. To be thus consumed guarantees a form of rapture. It is the rapture of feeling the abstract powers

that govern your life enter your immediate horizon of experience and become physically tangible. (When immaterial guilt becomes material debt, you *really* get screwed.)

When it reaches a certain level of social and institutional complexity, power appears to be more than merely the sum of its parts—it acquires the presence of a meta-subject; as such, it has been called "The Leviathan," "The Machine," "The System," or simply "The Man." Whether or not such a meta-subject exists—that is, whether power can take on a wholly new qualitative dimension through sheer cumulation—remains subject to debate. But the mere idea of such a subject is already powerful enough to produce strong effects, one being precisely the rapture of infinite submission.[4] It works like a mystical proof of God: you need a force that is bigger than you—i.e., The System—to validate the life you are living. Without it, you would be lost. To eradicate doubts, you must therefore consolidate the existence of that force by making its presence tangible and its effects irreversible in your life. There is no force like guilt to create intense reality effects. Nothing penetrates deeper than guilt. So you let guilt fill you with the rush of The System getting real. A letter of indulgence contractually confirms this arrangement. It's an arrangement for the future. As an accredited sinner you can rest assured that The System won't take you only once. To formalize submission—by means of a contract—is a masochist technique for intensifying the experience. It's a means to *eroticize* The System, consummate the social contract, and thereby consume a most intimate experience of power: You let the system fuck you, so you get to fuck the system. What a fest!

But what about those who profit from this arrangement? What sets them apart? Is it their freedom from faith? For this is how it would seem to work: if the exploited carry the social economy by investing faith in the conditions of

their own exploitation, the profiteers will reap the power and capital into which this faith can be converted. To reap it, they don't have to feel it. By definition, the powerful are unbound from the shackles of faith. Or, at least, this is what Machiavelli candidly asserts in *The Prince*, a manual for the use (and sustenance) of power, which he dedicated to Leo's father, Lorenzo de Medici, and drafted in 1513, the year the former became pope. Regarding faith, Machiavelli recommends: *You must realize this: that a prince, and especially a new prince, cannot observe all those things which give men a reputation for virtue, because in order to maintain his state he is often forced to act in defiance of good faith, of charity, of kindness, of religion. And so he should have a flexible disposition, varying as fortune and circumstances dictate.*[5]

If Machiavelli were right, then the "flexible disposition" toward matters of faith and religion would indeed be the prerogative and trademark of the selected few who are on top of the structures that all others submit themselves to. But is this really so? Consider two examples: Legend has it that a man by the name of Hans von Hake (1472–1541) purchased a letter of indulgence for two future sins yet to be committed from the notorious monk Johann Tetzel and confidently produced the letter a day later, when he waylaid Tetzel on the road between Königslutter and Schöppenstedt to rob him of all his revenue. Hake then donated the booty to the city of Jüterbog, where Tetzel's stolen money shrine (the actual box) is still on show today in the local Nicolai church. Was Hake a man of faith or flexible disposition? Or what about the peasant Peter Swyn (1480–1537), from the North German region of Dithmarschen: he was respected among the local peasants and serfs as their spokesperson and, at official functions, reportedly used to cockily wear atop his sturdy peasant pants the silk gambeson of a nobleman he had slain in battle. It is also noted that he saved

enough money to acquire a letter of indulgence in 1516 and travel to Santiago de Compostela on a pilgrimage in 1522. Faithful or flexible? What if, as Swyn's story would seem to suggest, the possession of a letter of indulgence, more than anything else, was a mark of social distinction, equivalent to a nobleman's coat or the ability to undertake an epic journey? We may have to assume that a more flexible, business-like attitude towards matters of faith (then as maybe now) is a stance that is equally also adopted by people who would still be among the faithful many.

For does the very act of buying a letter of indulgence not presuppose and require such a flexible disposition? Faith is the subject of the letter. Yet its purchase, strictly speaking, is a matter of technicalities. Is it even possible to consolidate matters of sheer technicality and matters of faith? In principle, one should exclude the other. When faith is brokered as an asset, it is commodified, not felt. To commodify faith is to betray it. So, technically, faith brokers are unfaithful. By the same token, being unfaithful is a question of technicalities. Betrayals require expert logistical skills (to coordinate a double life, concoct alibis, cover up traces). The unfaithful tend to be savvy, and vice versa. But what if that savviness were a disposition that accompanied conventional faithfulness? Is it not a recognizable trait that many people *both* like to invest faith in a given social system—for the sake of stability, be it at the price of their oppression—*and at the very same time* try every trick in the book to get the better of that system? Is that not actually the most common, conformist way to engage with society: to believe in the game and to keep it going, but still not miss any chance to cheat on its rules?

With the expansion of the market for letters of indulgence around 1500, increasing numbers of people would have taken the chance to educate themselves in the

techniques of doing business with the church, brokering faith/guilt. Access makes a difference. Since advanced Internet connections enabled real-time engagement in the stock exchange from home, day-trading has become a popular pastime (which in 2000 already accounted for 15 percent of NASDAQ trade). The *New York Times* reports that a Japanese housewife in her late thirties, Yuka Yamato, recently became a celebrity as she made over a million dollars when, bored with household chores, she started day-trading from her home computer.[6] That 75 percent of all day-traders continue to lose money in the risky game of acquiring and (short)selling stocks and futures online within minutes, if not seconds, does little to curb the popularity of this trend, reports *Forbes* magazine.[7] A parallel development is the rise of Internet gambling, which, according to the *Economist*, has changed the world of professional poker.[8] The paradigm shift is marked by the symbolic date of May 23, 2003, when Phil Ivey, known as "one of the sharpest and most ruthless players of his time," lost the World Series of Poker in Las Vegas against an accountant from Nashville, 27-year-old Chris Moneymaker, who came to embody the hope that poker could indeed be the everyman's road to riches.[9] Worldwide online gambling revenue soared to $26 billion in 2009, writes the *Economist*, which, to explain, cites psychological studies showing "similarities between gambling and faith: both expressed a need for reassurance, order and salvation."[10] So people like to be players. And believers, too.

A similar case could be made for real estate speculation. In the US, setting up shop as a real estate agent seems to be the profession people naturally default to when they rely on common sense as their key qualification. Accordingly, I recall a London cabbie telling me it was a good time to invest in property in Poland. He'd already done

so. The conversation came back to me when I recently received a letter from a British real estate agency informing me that the flat I rent in a Stalinist building on Berlin's Karl-Marx-Allee had not been bought by a Swedish family, as I had thought, but by them, and that they were going to sell it on to an Italian gentleman, whom—together with his younger companion and the Swabian representative of the British agency—I later had the pleasure of guiding around my apartment. Duefully elucidating the pros and cons of Soviet architecture, I couldn't help feeling like a roulette ball chatting with the expectant players while bouncing through the wheel. The perplexed look on the men's faces, however, seemed to indicate that they were somewhat unsure whether this was all still part of the deal they had expected. I haven't heard from them since.

But how can it be? How can a player be a believer? Would a savvy player not always hope to outsmart the naive believers who faithfully play to the rules? Now, what if all believers were secretly players who would then still invest faith in the social relations that everybody seeks to reap their profits from? In the end, it seems, it must again be everybody. When all believers are players, all players must also be believers. Otherwise there'd be no game. On the one hand, the "flexible disposition" Machiavelli recommends for princes is ubiquitous: put into play in the smallest manoeuvres and deals people come up with every day when they seek their advantage. On the other hand, no one would trick anyone if they didn't believe something could be gained from it. And in order to be able to enjoy the fruits of one's betrayals, one must still invest faith in the belief that what one did was worth the effort.[11] There is no real gain without faith in the fact that what one won was worth the price paid. This is why the notorious cheat will most passionately invoke the ideal of self-sacrificial

love, why the CEO who just fired hundreds will give an ardent speech about corporate culture, and why anyone who believes in their capacity to outsmart The System will equally religiously practice their submission to it. Faith gives you the power to interpret and experience the outcome of your deeds as meaningful, even (and especially) when the inherent logic of those deeds contradicts the very values you profess to have faith in.

To succeed in this game, one must therefore learn to accommodate the contradiction between playing and believing in one's actions without ever being troubled by them. There are ways to do this. It takes a skill akin to sleepwalking. You go through life performing little betrayals in an elegant silence that protects the integrity of the dream you remain in. You do what needs to be done and preserve the power to interpret it as you like. If some things won't work out as planned, don't stop, keep walking! This is how pickpockets do it. I learned this in Spain waiting for a train. One guy asked me for the time while another passed me by, his leisurely stroll remaining perfectly paced, as he slid one finger under the grip of my bag and started to walk away with it. When I saw it happen from the corner of my eye and grabbed the bag, he gazed back at me with a look of supreme tranquility, let go of the bag, kept walking, and disappeared among the people on the platform. Throughout the entire scene the tempo at which the events unfolded was never for a second out of sync with the lazy pace of a hot afternoon. It showed: an elegant crime creates no interruption in the order on which the sense of normality is based in a given social environment. Like a sleepwalking ballet dancer, a skilled pickpocket will know how to attune his motions to the rhythm of his surroundings so that whatever he does won't stand out as an event, but blend in with the general flow of things.

One of the reasons why Michelangelo Antonioni is so unbelievably good is that he can sustain such a tranquil pace for the duration of an entire movie. While watching, your mind will slowly be put in such a state of calm apperception that anything that passes will be part of a temporal continuum in which nothing and anything constitutes an event. In *L'Eclisse* (1962) this perceptual state perfectly matches the protagonist's state of mind. Vittoria (Monica Vitti) sleepwalks through the movie, leaving her partner, finding a potential lover, Piero (Alain Delon), whom she does or does not love, but eventually stops seeing as neither she nor he can determine whether anything happened between them or not. Even for the viewer it's impossible to tell whether it did or didn't.

Crucially, however, the movie is not just about how love (and faith) work, but also about how money works. Piero makes a lot of it as a broker at the stock exchange. It's where Vittoria's mother goes every day to gamble on stocks. This is how Vittoria meets Piero. She wants to find out about her mother's obsessions and joins her at the exchange, where she meets the man who embodies what her mother loves most: The System of money. She gives him a try to see what it means to make love to The System that her mother puts her faith in. The System then proceeds to betray the mother. There is a crash, and she loses all. She is devastated and expresses her frustration with the voice of the faithful reproaching God for his whims. Piero, however, remains untouched by the crash. When later a drunk steals his Camaro and dies, driving it into a lake, he similarly shrugs it off as inevitable expenses. Loss and gain are all the same to him. For he *is* The System, and The System, as such, remains unaffected by the ebb and flow of money, commodities, and lives within it. The house always wins.[12] Piero knows it and exudes it in his confidence. In

being with him, Vittoria comes to be with The System. Now, precisely because he is what her mother loves, he can make her feel like she is in a place sheltered from her mother's worries. In a sense he is the empty centre in the whirlwind of her mother's love. In him she can feel the emptiness at the heart of that love, which mirrors the nothingness at the centre of The System. But since nothing is all there is, there neither is very much to hold on to. And as the circulation of stocks is what he is about, she acts like proper stocks do and goes on to further circulate.

Are there any good reasons to interrupt the circulation? After all, it keeps you in motion. And as long as you keep moving you won't feel your mother breathing down your neck, insistently inquiring about faith, love, and money.[13] Of course you might ask: How much fun is it really to fuck The System and get fucked by it? And the answer is: lots, if you get to ride the wave. The only catch is that the fear of The System one day ceasing to love you will continue to loom large on the horizon. This fear feeds paranoia. But since this paranoia is the drug that boosts the performance of all players in the game alike, there is also nothing ostensibly dysfunctional about consuming (and being consumed by) it, is there? Now, if health presents no obstacle, then maybe happiness does. But what happiness? It cannot be the kind of redemption that The System promises as a reward for savvy machinations and faithful submission. What else could it be?

Could there be a happiness that lies beyond the economy of faith? Is that even possible when faith in some value is what one would have to have if one were to experience gratification? If it were possible, it would then have to be an *invaluable* happiness that exceeds the economic calculus of fulfilled expectations and success. The key to uneconomic happiness may be to stop eroticizing The System

and instead make love to someone in particular. But how do you even recognize this particular someone? It can't be a question of faith, because faith is anything but blind. Quite on the contrary, the faithful read too much into what they see. In the eyes of the faithful, people are defined by the status The System assigns them. As saints or sinners they are either good on the page or good for guilty pleasure (the pleasure of guilt). Savvy in their use of saints and sinners, the faithful always know which cog in The Machine they are presently turning. They must know. If they don't, they can't plan. And being able to plan is of the essence when you want to be on top of the game *and* in it.

If faith and savviness produce double vision, awareness of the world around you might only start with a blindness to faith and savvy options. It might come through smell, taste, and listening. It's how we sense the presence of other creatures when they move in our vicinity; they make sounds and smell and taste of sweat, joy, fear, hunger, or food. There is something about the smell, taste, and sound of living creatures that reminds you of the fact that they can live and die, because sound dies away, smell dissipates, and taste is lost after a while. It's good to know that creatures can gain or lose: weight, for instance. Because as we see in *L'Eclisse*, The System can neither gain nor lose. To it, and those who embody it, it's all the same. For them life just goes on. But it doesn't. It ends, eventually. But before that it goes through all kinds of irreversible changes, each of them marked by gains and losses that defy any common measure. Because even if you sense that your life is filled by something new or marked by losses, how would you ever know whether any of it was good for something, when in the end all you might be doing, as a creature, is wiggling your way towards your eventual exitus. Yet that wiggle is a common motion. It's a sign of life all creatures produce.

Gods don't wiggle. All that wiggles is mortal. To sense the vivacious mortality of a fellow creature is a peculiar feeling. Being alive is a sheer *fact*. And as such it is a sheer quality. There is no measure to quantify it. Where is life in the body? What makes water wet? These are qualities that make something, as it is, what it is. But science knows no way to quantify them.[14]

Unquantifiable as it is, *sheer quality* computes in no value system. You can't own it or turn it into capital. Like the very particular smell, taste, and sound that evinces the particular vivacity and mortality of a singular creature, you can only avow it, gently, through an alertness to the potential of ever-renewed stupefaction in the instant of encountering it. You can't put faith in what stupefies you. There are no economic profits to be reaped from your own stupefaction. Neither is final gratification to be found in sheer qualities. Their experience does not resolve itself that easily. It would hardly seem apt to conclude indulging in them with a resolute "Amen." More likely it will be an "Umm… Err…Ihh…Ohh…Ahh." Spelling those sounds out, letter by letter, will hardly look good on a page, let alone fill it. Still, they may show: You indulge! Not in *faith* but in the *fact* of the sheer quality of someone's particular vivacious mortality. Outsmart that. You can't. Love and be loved, in that manner and key. If you dare. And indulge in it. Indulge!

1. Neil Young, "Tell Me Why," *After the Goldrush* (1970).
2. It is this market monopoly that Martin Luther sought to break; ironically, his writings were effectively printed on the same presses as the letters that he condemned, while the man who painted his portraits, Lucas Cranach, was also on the payroll of Luther's nemesis, Albrecht.

3. Tellingly, German does not really distinguish between "debt" and "guilt." Both are *Schuld*, the only difference being that for financial debt the plural *Schulden* is used, while moral guilt is referred to in the singular as *Schuld*. To express that someone "owes" you something, however, irrespective of whether this debt is of a financial or moral nature, one would indiscriminately use the verb *schulden*.

4. In the following I essentially paraphrase the argument Slavoj Žižek unfolds throughout his book *Enjoy Your Symptom* (New York: Routledge, 1992). Žižek here suggests that the "spectacle of belief" evident in Socialist Party support and show trials, for instance, could be understood as a desperate attempt to—against better knowledge—conjure up the "essential appearance" of a "big Other," a Symbolic order that would bestow legitimacy on the prevalent social order. See, for instance, page 46f. (The terminology Žižek uses here is Lacanian. Notably, however, he employs it in an unorthodox manner, since contrary to Lacan—who would seem to maintain that a Symbolic order defines the very structure of desire and thus pre-exists and predetermines all its manifestations—Žižek here insinuates a reverse dialectical twist whereby the very notion of an all-powerful Symbolic order may itself be seen as the product of a desire for such an all-authoritative structure to exist.)

5. Niccolò Machiavelli, *The Prince* (London: Penguin, 2003), 57.

6. Martin Fackler, "In Japan, Day-Trading like It's 1999," *New York Times*, February 19, 2006, http://fillip.ca/aob6.

7. Michael Maiello, "Day Trading Eldorado," *Forbes*, June 12, 2000.

8. Jon Fasman, "Shuffle Up and Deal: A Special Report on Gambling," *Economist*, July 10, 2010. I am indebted to Melinda Braathen for alerting me to the issue and lending me her copy (together with the Žižek).

9. Ibid.

10. Ibid.

11. This is one way of understanding the overall gist of Derrida's meditations on Baudelaire's short story "Counterfeit Money," in which the poet recounts witnessing a drinking companion give a beggar a large sum of counterfeit money, which the man keeps ready for such occasions in one of the many pockets of his vest. Baudelaire takes offence at the fact that, rather than having done this out of sheer perversion (which he would have liked), his companion actually professes to have done it to buy himself a ticket to heaven at a good price. In his book Derrida speculates on ways to escape the economy defined by these double standards of savviness and faith. In search of a gratuitous act that would defy these standards he arrives at an embrace of writing (the spouting of letters) as an uneconomical perversion. I will try to rephrase this concern at the end of this essay in terms of the question of the possibility of a gratuitous love. See Jacques Derrida, *Given Time: I. Counterfeit Money* (Chicago: University of Chicago Press, 1992). I thank Ines Schaber for pointing this book out to me.

12. The house indeed always wins: As the principle of corruption won't corrupt itself, its cruel consistency renders it highly stable.

13. I am here paraphrasing observations Lacan formulates in the seminars XVI to XX concerning the basic desire to be (recognized as) desirable, which, according to Lacan, defines one's entry into the Symbolic order of society. One of the multiple undercurrents of Lacan's thoughts here seems to be that the expectant gaze, in relation to which one wants to redeem oneself as loveable, is coded female/maternal, while the system of status inside of which one tries to prove one's worth is coded male/paternal. See Jacques Lacan, *The Four Fundamental Concepts of Psychoanalysis*

(London: Penguin, 1994), 203f.

14. Unquantifiable qualities that characterize something as what it is, as a whole, and that cannot be explained by any function of its parts—e.g., water being wet—are, according to Wikipedia, scientifically referred to as "emergent qualities." Giorgio Agamben goes back to medieval scholastics to explain those sheer qualities as the exemplary modality of rising forth that makes a being singular, and gestures towards a particular kind of love that would express a form of sheer attunement to that modality in which singular qualities emerge. See "Whatever" and "Maneries," in Giorgio Agamben, *The Coming Community* (Minneapolis: University of Minnesota Press, 1990), 1–4 and 27–30.

Juan A. Gaitán

Folding Money

Money is lost: if by robbery, the blame lies with the robber…; if by shipwreck, the cause is the chain of events.

—Plotinus[1]

This essay was originally written in 2005 and was conceived from the point of view of the history of art, which was then my full-time profession. The text remained initially unpublished, and so its original title, *The End of Money*, migrated with me to the space of contemporary art, where it became the name of an exhibition that I curated in 2010. The hypothesis of this exhibition was that money and images operate similarly today, as avatars of systems and conventions (of systemic conventions) of representation and value.

On one level the exhibition spoke to the desires and nostalgia for matter, which at times takes an intensely materialistic bent (the collecting of art and of objects of value falls into this category, as well as the current attachment to gold), and at other times an idealistic one, a non-fetishistic and non-mediated relationship to the physical world that often translates into movements of "return" to a pre-scientific, non-technological world. On another level, the exhibition considered the problem that this essay originally intended to explore, namely, the relationship between image and value that is established in or through monetary economies under capitalism. The status of the banknote as both symbol and avatar of this relationship was given much less prominence in the exhibition than in the original essay, in part because I thought that to focus on banknotes was both anachronistic with respect to current discussions of the economy and too didactic in the context of the discourse on the image that I wanted to explore.

The tone and the subject of this essay are products of a time very different from the context of 2011, when the text was eventually published.[2] In the Netherlands, where I was based for three years, art has become an ideology alien to the interests of the state and, as such, it is something that must be "reduced" (not to say crushed or whipped into shape) to more suitable proportions, which, in the terms set by state funding cuts, means by half. These reductions and the threat of the decimation of contemporary art favour a more patrimonial—material—sense of symbolic capital. In this present economy, which relies so heavily on intangible assets, there seems to be a new or renewed enthusiasm for tangibles. There have been numerous efforts to expand the notion of patrimony so as to include non-nationalistic expressions of this concept, making "patrimony" a more malleable category of symbolic capital (by including, for instance, the culture of immigrant societies) and non-tangible ones as well (for example, sonic and other non-material products of culture). Despite these efforts, the inclination of the current Dutch government has been to restore a direct correspondence between the idea of a National Culture and the material things that supposedly represent it: things, in other words, that can be transacted. This is perhaps not surprising in a culture that places so much emphasis on economic "common sense" (investment versus profit) and whose history is fundamentally determined by trade. Yet, beyond such historical essentialisms, it is important to note that the collecting fever that has transformed the art system in the past few decades might be symptomatic of a wider desire, perhaps even need, to establish stricter links between wealth and matter, a link effected through tangibles such as art, real estate, and gold.

To me, this current bent towards material wealth seems to bring a new sense of purpose to the works that

I address in this essay: *Money Tree* by the Brazilian artist Cildo Meireles and *Suite of Canadian Landscapes* by the Canadian duo N.E. Thing Co. Both works are from 1969, and both are directed at the unstable relationship between state and currency. Unlike what the title of this series suggests, these works are concerned precisely with the relationship between matter and value and the banknote's unstable condition as the signifier of a nation's wealth.

The historical and art historical material in the essay touches upon the circumstances that led to the current financial crisis. The meditations about money that were made by these and other artists in the late 1960s were still infused with a formal analysis that today may seem anachronistic in their being formulated on the object of currency (banknotes, for instance). In these works, banknotes, like paintings, are things in which the support (paper, canvas) is effectively cancelled by the image and what it represents, which is value. In order to become denominators of value, banknotes (and paintings) must renounce their materiality, all the while maintaining it intact, an aporia that is fitting of the kind of discourse I was tuned into at the moment of writing the text in 2005 and that I will here exemplify by invoking the following line with which Jacques Derrida opens his book *Given Time: I. Counterfeit Money*: "The King takes all my time; I give the rest to Saint-Cyr, to whom I would like to give all."[3] Where does Madame de Maintenon, author of this sentence, find this surplus time that she devotes to Saint-Cyr? The point Derrida begins with regards surplus, a notion that he suggests is synonymous with counterfeiting: *Madame de Maintenon, then, did not say, in her letter, literally, that she was* giving *all her time but rather that the King* was taking *it from her. . . . Even if, in her mind, that means the same thing, one word does not equal the other. What she* gives, *for her part, is not time but the*

rest, *the rest of the time: "I give the rest to Saint-Cyr, to whom I would like to give all." But as the King takes it all from her, then the rest, by all good logic and good economics, is nothing. She can no longer take her time. She has none left, and yet she gives it.*[4]

Thus, what follows here is an exercise in which I took up—like the artists that I discuss (Cildo Meireles and N.E. Thing Co.)—that which, from the point of view of value, appears as a mere supplement in the banknote (i.e., its pictorial "quality") suggesting that the pictures that appear on the faces of banknotes serve two functions: to cancel out the surface on which they are printed and to designate the "nature" of a given national economy.

* * * *

In June of 1974 *National Geographic* magazine published an article titled "Oil: A Dwindling Treasure," which compared the then-present crisis with the Great Depression of the 1930s. Thirty years later, in June of 2004, *National Geographic* published another article, this time entitled "The End of Cheap Oil?" in which the current crisis was compared to the former one: "You've heard it before, but this time it's for real: we're at the beginning of the end of cheap oil." Given the ominous sentiment that accompanied the 1974 shock, people then would have been hard-put to believe that in 2004, exactly thirty years later, "The End of Cheap Oil" would have been forbiddingly announced, once again. This latter *National Geographic* magazine's cover image features a crowded highway, at sunset, we suppose, contrasted so as to give the road a golden hue, rendering the cars as if they had come to a standstill (a confounding of the inflated automobile market and the drying up

of natural resources) and the surrounding landscape absolutely black. The shape of the highway suitably evokes a more or less iconic image of gasoline being discharged from a nozzle. If we agree that in this context the colour black (or the absence of all colour) is a signifier of oil, then we see that the landscape has been overtaken by the representation of a fundamental lack that projects itself as the pure negativity, or the mythical nothingness, that overdetermines the future. Having lost the source of "our" abundant lifestyle (oil, as the matter of energy), the repertoire of possibilities with which the future is commonly invested is reduced to absolute impossibility, the present being motionless because the future is impossible. In other words, *no energy = no progress.* This repertoire of impossible future Jorge Luis Borges sees embodied in money: *Sleepless, obsessed, almost happy, I reflected that there is nothing less material than money, since any coin whatsoever (let us say a coin worth twenty centavos) is, strictly speaking, a repertory of possible futures. Money is abstract, I repeated; money is future tense.*[5]

Yet, there is another side to this immateriality of money, one that is more strictly pictorial, or that comes from a "pictorial impulse" that Walter Benn Michaels associates with capitalism insofar as it is from it that we "return" (or turn our gaze) to nature—and this is critical for the kind of understanding of the banknote that I am addressing—and see it (nature) as a represented value: there is a distinction *between what it means to love a sunset and what it means to love the representation of a sunset. [The] difference is not simply between beauty and represented beauty; it is instead the difference between...beauty and mimesis. When we love glittery objects, we love beauty; when we love objects that look like other objects we love representation. Furthermore, the suggested paradigm of objects that "mimic other objects" is "natural objects that look as if they were artificial." Thus the representation*

that originally fascinates us is the natural reproduction of a man-made artefact, not the man-made reproduction of a natural one....

What attracts is the natural representation of the artificial. Such representation must be accidental...but without this accident, it seems, there would be no "primitive form of desire." We don't want things in themselves, but we can't begin by wanting representations of things in themselves either; we want things in themselves that look like representations. We begin, in other words, with the illusion that representation itself is natural, and without this illusion we would never develop any interest either in representation or in nature.[6]

The two works that I address in this essay, N.E. Thing Co.'s *Suite of Canadian Landscapes* (1969) and Cildo Meireles's *Money Tree* (1969), are here taken as opportunities to speak of the moment when the *standard*, which had hitherto been gold, was becoming the object of economic uncertainty and was causing a parallel crisis of representation.[7] Both of these cases—the *Suite* and *Money Tree*—display a certain kind of realism that is inherent in money, as well as the fact that, one way or another, money invariably ends up being tied to some construction of nature. Taking banknotes as their raw material, these two works question in different ways the form in which the economy is materialized in the hands of the subject.

In a text that he titled "Tax Advice"—the advice being, we presume, to not pay taxes—Walter Benjamin called for the need of "a descriptive analysis of banknotes,"[8] as it is possible to *believe* in money only insofar as its materiality goes unquestioned, yet "nowhere more naively than in these documents does capitalism display itself in solemn earnest."[9] (Of course, if fiat currency[10] is effectively removed from circulation and replaced by forms of payment that seem to exclude the exchange of tangibles—credit cards, etc.—that

very document of capitalism becoming invisible, on what will we perform such descriptive analyses?)

Was it this kind of "descriptive analysis" of banknotes that Iain and Ingrid Baxter expected viewers to perform on their *Suite of Canadian Landscapes*? By calling attention to landscape representations on Canadian banknotes, *Suite* opens a possibility for analyzing what seems to have been constituted as the *source* and *guarantee* of Canada's economic future—namely, nature—but it also did this at a time when, as with other countries, the economy began to see its future in industry and not in natural resources. The position that the landscape (as the representation of natural resources) was given within the context of a capitalist economy found itself at odds with the suggestion that these landscapes were at once the object of Canadian romanticism and somewhat obsolete images of the past.[11]

For *Suite of Canadian Landscapes*, Iain and Ingrid Baxter took the "complete series" of official Canadian banknotes and, by means of a mat, framed each of them so that all references to their status as money were, so to speak, erased, drawing an analogy to the way in which the artifice (of the banknote as a made object) must be concealed for capital to express itself in them in "solemn earnest." Hence, we must take note of the fact that two apparently opposite operations take place in the banknote: as money it appears as *enfolded* value, while the landscape necessarily appears as *unfolded* value. In his essay "Capital and Subsidiary," William Wood already indicates that this suite focuses our attention on the fact that, although giving the illusion of being descriptive, the images of nature that appear on banknotes are instead "inscriptive" of a territory that must be seen to lie still fallow before its capitalization, or its conversion into capital. Wood states, *The Canadian dependence on natural resources—encapsulated so acutely in the clear-cut forests*

of BC [the Canadian province of British Columbia]—is, one might say, fetishized, disavowed in the bank notes, consoling the carrier of the bill that there is still some exploitable land out there, or, worse, sustaining the illusion that Canadians have not totally dominated and capitalized upon the environment.[12] Indeed, *Suite* makes evident that, on these banknotes, the Canadian landscape enters a space of reflections: as visualizations of an idealized past, these "natural" landscapes must be experienced as images that bypass the present, propelling the economy (and us with it) into the future. The beholder's sight must therefore constantly be deflected from the present for this image of nature, or of the "wealth of the nation," to become visible. It is perhaps this deflection of the eye from the present that banknotes seek in presenting allegorical images in which the sense of time is always outside the present, at once historical and of the future.

A year before their *Suite of Canadian Landscapes*, but this time under the name of N.E. Thing Co., the Baxters produced a work called *1/4 Mile Landscape* (1968), in which they placed three signs along a quarter-mile section of a highway; these signs, as one drove past them, would determine three points of interaction with the surroundings: "Start Viewing," "You Are Now In The Middle of a N.E. Thing Co. Landscape," and "Stop Viewing." Three interrelated aspects of this work can be mentioned. First, the directives to start and to stop viewing, in all their obscurity, seem to incorporate the arbitrariness of the *commandment*,[13] and while formally reminiscent of a display of state authority, they appear to be signed by private capital (as signalled by the "Co." of corporation). Secondly, the strict directions expressed in these signs can be matched only by the sense of disorientation that, in driving along the highway, one must have experienced in trying to choose between the already established direction (as determined by the highway) and

the endless directional possibilities that "viewing" suggests. Last, and even more obviously, the claim laid by N.E. Thing Co. on the landscape ("a N.E. Thing Co. Landscape") makes the viewer aware of the apparent fact that everything in sight has been already claimed (by vision). The rhetoric of colonialism is quite clear, since this would (or at least should) immediately call up an entire history of colonization and First Nations land claims that has been very present on the Northwest Coast and in Canada as a whole. This adds the claims of private property through which capital is now no longer in the hands of the state—as it would have been up until the second half of the twentieth century—but in those of private corporations.[14] As in an episode in one of Kafka's bureaucratic nightmares, one seems to enter a territory where one is at once constituted as a foreign body and as the subject of an obscure regime of power. The one thing that is clear can be seen only from a distance not afforded the viewing subject: in the capitalist privatization of space, sovereignty becomes ownership, and this ownership can be extended to the bodies that happen to be inhabiting that very space, this time not as citizens but as denizens.

One of the upshots of privatization is, of course, that it bypasses the legal structures that in Canada and in other parts of the world have traditionally guaranteed land restitutions to original inhabitants. In the sense that the landscape is at once constituted as the archetypal expression of Canadian economic history and as the site where the body of the individual enters into a conflicted system of possessions and dispossessions, one may take these aspects of *1/4 Mile Landscape* as a set of instructions for looking at *Suite of Canadian Landscapes*—in which an antagonism between capital and nature is played out.

This opposition may be posited here as one between *production* and *recording*, which seems to be tied to a

problematization of the artist's function: the traditional artist-as-maker vis-à-vis the conceptual artist-as-recorder.[15] Putting aside the references to these objects as banknotes, the framing draws attention to the fact that what appears on them are engravings. As Wood has already observed, this is highlighted by the choice that the artists made to sign each "landscape" with their own initials and as artist's proofs. For Wood this constitutes "a joke on editioning and framing, signing and claiming to represent."[16] Perhaps more significantly, this gesture re-establishes in the image an "originary" state, making it evident that these landscapes have not merely *appeared* on banknotes but have been *produced* by an artist and in a medium that has been traditionally developed for the purposes of reproduction. This, in turn, can be easily transposed to the landscapes themselves, which, at least in the Canadian context, have a long and conflicted history of representation (many have indeed argued that the representation of the wealth of the nation as a pristine and untouched landscape has become a uniquely Canadian staple). We have therefore seen that in bringing up the uniqueness of the landscape, the Baxters are able to speak of the mythical character that nature has acquired in the Canadian imaginary as originary or productive of value. In this sense, these works broach the reproductive aspect of capital: although presented as unique, these landscapes in fact abound, being repeated as many times as the bills have been issued. Nonetheless, the artist's proof suggests that there is an original and that there are proofs, both of which must be taken out of circulation—a surplus that must be turned into refuse—and which at the same time prefigure the banknote itself. In this suite, the representation of nature—itself, as we have seen, a representation of wealth—is restored, so to speak, to a complicated moment when, as proof, it was not quite money; each landscape becomes unique[17] at the same

time as it prefigures endless repetition (endless not in the sense that it will never end, for in fact it will, but in the sense that as citizens we have no control over the issuing of bills). Endlessness is therefore experienced here not as an infinity but as absolute independence of the economic system from the subjective will; at a moment when the nature of the standard is being questioned, it is also experienced as the open possibility to re-establish the source of wealth as anything whatever. The signature of the Baxters on this series thus can be said to be a "pathetic" attempt at performing the individual's will on the economy by emulating the arbitrariness with which the economy sees the real world as the limitless realm for the imposition of its will.

At the same time, we may say that at a point when the representative standard is in question—that is, near the end of the gold standard in 1971—Iain and Ingrid Baxter's *Suite of Canadian Landscapes* throws the landscape itself, as the representation of *productive nature*, into question.[18] And they do this by attempting to replicate, at a subjective level, the strategies of appropriation that capital was performing on nature. Put simply, by showing that what appears on the banknotes is a representation of capital, the Baxters suggest that for capital nature is but the representation of wealth. In this logic, in the official banknote, which is itself a surface upon which exchange value is recorded or inscribed, the process of engraving obscures itself in order to present the image itself (of the landscape in this case) as a record of reality. In *Suite,* however, the framing of the bills appears as a gesture made by an artist-as-recorder who gathers these images, as ready-made representations, in order to reveal the artificiality that capital must conceal in order to function effectively. But it is only between these landscapes, which appeal to the past and seem thus anachronistic, and the scenes that would appear in the newly circulating banknotes (showing images

of industry or workers, and some of the landscape) that it would become clear that, at this time, Canada's economic dream was to enter the era of industrialization through the exploitation of coal, and fuelled by oil.

Perhaps compelled by the realities of an underdeveloped economy, Cildo Meireles reverses this perspective in *Money Tree* by focusing not so much on the iconography of the banknote (this he would do a couple of years later in, for example, his work *Zero Cruzeiro* [1978]) but on the form that money takes as its circulation patterns are affected by inflation. Here it is not a question of what kinds of representations appear on banknotes as guarantees of their validity, but what the circulation of banknotes itself represents. In an inflated economy like Brazil's at the time, a stack of bills would have been a familiar object, found for example in the hands of bus drivers or gas station attendants.[19] Meireles's stack of one hundred One Cruzeiro bills, cross bound with a rubber band, would have been therefore but a variation on a ready-made object that, despite its size and volume, would be more or less worthless. *Money Tree* thus withholds two important elements in the Brazilian economy (money and rubber), showing their interrelation in a sort of crass literalness. Having been an important element of the Brazilian economy, especially with the demand for Brazilian rubber during World War II, this industry began to collapse for the second time in the 1960s,[20] after the demand for rubber dropped significantly once the plantations in Asia began to flourish.[21] By 1969, the currency that Meireles used for *Money Tree* had been out of circulation for over two years (the One Cruzeiro banknotes had probably been out of circulation for longer, since inflation had surely rendered them worthless) and had been replaced temporarily by the Cruzeiro Novo, which was to then be replaced again in 1970 by a revalued Cruzeiro, after which the design of Meireles's

Zero Cruzeiro was fashioned.[22] It seems, then, that in this minimalist work Meireles is tying together two factors of inflation: industry as the underlying factor (rubber, in this case) and money as the surface on which inflation is made most evident and "palpable." Rubber—which, as we know, comes from the rubber tree—would therefore be at one and the same time that which would disallow the growth of this "money tree," and that which ties money together, binding the inflationary tendency of the Brazilian economy.

In Brazil, 1969 also marked the end of what, with some presumptuous Eurocentric parallelism, was called the Brazilian "economic miracle." In 1964, the military seized power in Brazil in order to, as Roberto Schwarz put it, "protect capital and the continent of Latin America from the threat of socialism."[23] Between 1964 and 1967, and under the motto "development and national security," Castelo Branco's government at once intensified the mechanisms of surveillance and control and brought inflation down from 100 percent in 1964 to 24 percent in 1969. But a number of factors brought the "wonderful" economic growth of Brazil (the Brazilian *Wirtschaftswunder*) to an almost abrupt halt. Early in 1969, decrees were passed by the military government according to which the militia and the police were put in direct charge of the federal government, a move that was made possible by the fact that in 1968 they had declared the Congress in indefinite recess. According to Joseph Smith, it was this move that made it "official" that Brazilians were ruled by the military—i.e., not by consensus (as it could have been imagined up to that point by some) but by force.[24] The revolts of workers in Minas Gerais, and the posterior formation of an urban guerrilla movement, made the underside of the "economic miracle" quite evident (and in this sense, it also made it evident that this had not been a miracle at all). At the same time, it began to become clear

that the world was beginning to experience a shortage of oil, which, as Fred C. Allvine and James M. Patterson suggest in their book *Highway Robbery*, can't be interpreted as being caused either by nature or by the oil exporting countries of the Middle East. While today it is more common to refer to the energy crisis as "the OPEC oil crisis," this must seem a strange nomenclature given that it focuses all the blame on the embargo that the oil exporting countries of the Middle East placed on the countries of the First World that had supported Israel over Palestine. As it turns out, this embargo was more a matter of opportunism: the opportunity of worsening a crisis that was already underway and that, at least according to Allvine and Patterson, was to give a small group of oil companies (Shell, Exxon, Oxy, etc.) a monopoly on the oil industry, gradually cancelling out independent distributors (as well as workers, through the implementation of self-service at the retail level).[25]

The repercussions of this crisis in the Brazilian economy were significant in a number of ways. During the early twentieth century, rubber had been stolen from Brazil and grown by Malaya, which was then under British administration and subsequently fell under Japanese rule during World War II. A dearth of natural rubber in the world trade—caused, among other factors, by rising costs of production—was counteracted by the popularization of synthetic rubber in the immediate postwar period. As a result, the Brazilian economy, which had hitherto been largely dependent on the exploitation of rubber, had to reorganize itself around an agrarian economy that, by the mid 1960s, was mostly in the hands of landowners whose production had focused on coffee, cotton, oranges, and cattle. The military coup of 1964 was therefore set against what was then seen as an internationalist right-wing landowner elite, while the motto of "development and national

security" indicated a desire to constitute a national industrial economy against North American economic imperialism. This new industrialized Brazil depended largely on the supply of cheap oil, but the prices of oil became increasingly volatile towards the end of the 1960s and throughout the 1970s.[26] Hence, the irony in Meireles's *Money Tree* has as much to do with the fact that under an inflated economy there is a proliferation of banknotes (which, as Sigmund Freud would have it, would seem excremental) as with the fact that rubber itself would appear to be a mere illusion for Brazilians. Once a natural resource and the force of the Brazilian economy, now rubber was an artificial product that had once forced the economy to restructure itself entirely and that now, having become an oil derivate, embodied the uncertainty of the future national economy.

This is the context within which *Money Tree* emerged, as a parody of accumulation. The accumulation of hard cash in one's pocket was but the formal manifestation of an inflated economy that, although issuing banknotes at an irrational rate, had no power to accumulate wealth. The minimalist literality of the work thus expresses the fact that "everything about capitalism is rational, except capital or capitalism itself."[27] The fact that the excessive visibility of money is a negative symptom is completely absurd, and it is this kind of absurdity that, according to Roberto Schwarz, characterizes Brazilian culture during this period, an absurdity that artists and musicians were incorporating, paradoxically, as the new "Brazilian character."[28]

* * * *

Sleepless, obsessed, almost happy, I reflected that there is nothing less material than money, since any coin whatsoever (let us say a coin worth twenty centavos) is, strictly speaking, a repertory of possible futures. Money is abstract, I repeated; money is future tense. The coin that Borges is holding in his hand—a coin that is worth, say, twenty centavos—is "strictly speaking, a repertory of possible futures." Strictly speaking, one of these possible futures regards the coin; it regards it as a thing (a disc made of metal alloy) detached from its denomination (twenty cents), as something worth more or less than twenty cents (of whatever currency).

This is an issue worth considering—namely, the issue of language and money: the word "centavos" is obviously the Spanish word for cents. Why did the translator choose to keep the Spanish word? Perhaps because the cent is already the smallest denomination in the lexicon of money, beyond which there are only mathematical fractions (half a cent; a quarter of a cent), and thus the Spanish word becomes the name of something even smaller than a cent: a centavo, a thing that is a whole but that has no corresponding name in the language of a healthy economy. But this might be unfair to the translator. Perhaps the translator thought that the reader should at least know what coin Borges was dealing in when he wrote his sentences—what kind of abstraction and what kind of future he had in mind when, already blind, in his mind he was flipping a coin worth twenty centavos while holding it in his hand and choosing, as he was wont to do, the idea over the fact, which is to say, imagining an entire repertory of possible futures.

In these futures this coin is an object of history, an object for a museum, once time (or, strictly speaking, historical contingency) has effected that which cannot be performed from a subjective point of view, namely, to see the object pass from one to another form of symbolic value. Regarding

the fact that what appears in a photograph is a former present, different from the one in which one looks at the photograph, Roland Barthes states in *Camera Lucida*, "I cannot undeceive myself."[29] The same operation applies to the banknote: regarding its denomination, its current value as currency, one cannot undeceive oneself. A banknote is worth what it states as its worth.

1. Plotinus, *The Enneads* (London: Penguin Books, 1991), 87.

2. Juan Gaitan, "Folding Money," *Fillip* 15, Fall 2011, 33–39.

3. Jacques Derrida, *Given Time: I. Counterfeit Money* (Chicago: University of Chicago Press, 1992), 1–2.

4. Ibid.

5. Jorge Luis Borges, "The Zahir," in *Labyrinths: Selected Stories and Other Writings*, eds. Donald Yates and James Irby (New York: New Directions, 1964), 156. Please see the postscript of this text for further thoughts on this excerpt of Borges's writing.

6. Walter Benn Michaels, *The Gold Standard and the Logic of Naturalism* (Berkeley: University of California Press, 1987), 157–58.

7. After a mounting crisis regarding the US dollar's gold convertibility, the gold standard was officially abandoned by Richard Nixon in August 1971.

8. Walter Benjamin, "One-way Street," in *Walter Benjamin, Selected Writings, Volume I: 1913–1926* (Cambridge, MA: Belknap Press of Harvard University Press, 1996), 481.

9. Ibid.

10. Fiat currency: currency that has value by governmental decree.

11. This would be evident in the new series of banknotes that, in 1969, replaced those that were used by N.E. Thing Co. in the *Suite*.

12. William Wood, "Capital and Subsidiary: The N.E. Thing Co. and the Revision of Conceptual Art," in William Wood and Nancy Shaw, *You Are Now in the Middle of an N.E. Thing Co. Landscape*, exhibition catalogue (Vancouver: UBC Fine Arts Gallery, 1993), 17.

13. Both Antonio Negri (*A Time for Revolution* [London: Continuum, 2003]) and Achille Mbembe (*On the Postcolony* [Durham, NC: Duke University Press, 2002]) have spoken of *commandment* or *commandement* as the instrumental characteristic of the modern nation-state, whereby all the mechanisms of dissemination that the state deploys are ultimately designed to express the rule of the state.

14. In his book *Geography Lessons: Canadian Notes*, Allan Sekula would show how, in fact, Canada, unlike the US, has remained strangely caught in the moment when control over national economies is transferred from the state to the private corporation. Allan Sekula, *Geography Lessons: Canadian Notes* (Vancouver: Vancouver Art Gallery; Cambridge, MA: Massachusetts Institute of Technology, 1997).

15. This artist-as-recorder appears in N.E. Thing Co.'s works in different guises, sometimes in the form of an office worker, sometimes in the works themselves, which look like visual evidence of land surveys and explorations that, although of unspecified purposes, replicate a language of representation of the landscape that suggests a future exploitation of the land.

16. Wood, "Capital and Subsidiary," 17.

17. This is in part what I take William Wood to suggest when he speaks of a joke on signing and claiming to represent.

18. In fact, the series of banknotes that in 1969 replaced

those used by the Baxters in their *Suite*, and that would circulate until 1979, featured similarly framed landscapes, but this time including more direct references to industrialization and the built environment. The series used in *Suite*, which circulated between 1954 and 1969, featured a number of landscapes that were open and upon which the traces of industrialization were almost invisible. It is also worth noting that as these banknotes have become rare, their value as collector's items has begun to conflict with the value of the work of art itself, an awful aberration of our system of value that allows the least "original" objects in circulation to turn into "authentic" collectibles.

19. As Dr. Carol Knicely pointed out to me, in an inflated economy with a devalued currency, stacks of bills tend to become a regular sight in buses, taxis, gas stations, etc. Surely Meireles noticed the "objecthood" of these stacks of bills as they were folded into a pile that would hopefully be worth something, since individually each bill would be more or less worthless, in that there would be nothing that would be worth as little as the amount stated on the bill.

20. Up until the 1920s, Brazil had had the monopoly on the world's rubber industry. However, the British had been establishing rubber plantations in their colonies, especially Malaya, where the production became significant enough during the 1920s and 1930s so as to destabilize the Brazilian economy. During World War II the Japanese took hold of several of these colonies and their plantations, which made Brazil once again the primary supplier of rubber for western Europe and North America.

21. As a result, in the 1970s, the government began a new campaign of modernization and development that would, amongst other things, revitalize the rubber industry in the Amazon. Of course, this meant the continuation of a series of historical and long-lasting traditions of abuse and slavery

principally affecting indigenous peoples of the Amazon, some of who were still living in relative isolation. And since the "discovery" of nature as a cause for activism, more or less during the 1960s, it has also been one of the principal grievances for environmentalists' peace of mind. As Alcida Rita Ramos has stated in her book *Indigenism*, these two groups have been engaged in a rather strange conflict whereby environmentalists tend to side with indigenous peoples only as long as they act according to the stereotype of existing in a "primordial" (i.e., intuitive) loving relationship with "nature." As soon as indigenous peoples display any sign of desiring to capitalize on their own lands, their own means of production, and/or their own knowledge, environmentalists (and other groups with them) accuse them of becoming assimilated into a corrupt system (capitalist or otherwise) and thus of being corrupt themselves. Alcida Rita Ramos, *Indigenism: Ethnic Politics in Brazil* (Madison: University of Wisconsin Press, 1998).

22. It is also significant that this One Cruzeiro bill was manufactured by the American Bank Note Company. This company, which changed its name in 1999 to American Bank Note Holographics, Inc., has for over two hundred years issued gift certificates, currency, food and gas stamps, traveller's cheques, social security cards, identification cards, passports, manufacturer's certificates of origin, certificates of authenticity, and other documents of the sort within the United States and all around the world.

23. Roberto Schwarz, *Misplaced Ideas: Essays on Brazilian Culture* (London: Verso, 1992), 126.

24. See Joseph Smith, *A History of Brazil* (London: Longman, 2002), 195–207.

25. Fred C. Allvine and James M. Patterson, *Highway Robbery: An Analysis of the Gasoline Crisis* (Bloomington: Indiana University Press, 1974), 210. *The mechanism by*

which supply was denied the independents is simple. Once there was a shortage—intentional or otherwise, the large petroleum companies merely cut off inter-refinery sales of gasoline to the buffer companies (smaller majors, independent refineries, and superbrokers) who traditionally sold gasoline to the price marketers. This was accompanied by a reduction in crude oil sales to the independent refiners who also were a prime source of gasoline for the discounters. By mid-1973, many independent refineries were operating at less than 70 percent capacity because of insufficient feedstocks. Yet the majors were running at 95 to 105 percent of capacity.

26. Smith, *A History of Brazil*, 203.

27. Gilles Deleuze, "On Capitalism and Desire," in *Desert Islands and Other Texts: 1953–1974* (Los Angeles: Semiotext(e), 2004), 262.

28. Schwarz, *Misplaced Ideas*, 1–19.

29. Roland Barthes, *Camera Lucida* (New York: Hill and Wang, 1982).

Candice Hopkins
The Golden Potlatch
*A Study in Mimesis and
Capitalist Desire*

The docking of two steamships, the *Excelsior* and the
Portland, filled with gold mined from Canada's Yukon
Territory and then-newly rich prospectors, was perhaps
the single most significant event to take place on the West
Coast during the late 1800s. Immediately boosting the
economies of individual cities as well as that of the country
as a whole, it brought the intricate relationships between
belief (in this instance belief in the *potential* for economic
prosperity), capitalist desire, and wealth into public con-
sciousness. When the *Excelsior* arrived in San Francisco's
harbour on July 15, 1897, it caused a media frenzy; pho-
tos of individuals hauling sacks and suitcases off the ship—
some cargo so full with the precious metal that it required
more than one person to lift it—quickly circulated. But it
was the *Portland*'s arrival in Seattle two days later, con-
taining even more gold, over two tons of loot, that initi-
ated the largest collective expedition for gold in North
America's history—the Klondike Gold Rush. With the
promise of riches for anyone willing to undertake the jour-
ney north, some forty thousand people, mostly from the
United States, abandoned their previous lives to become
prospectors, suppliers, and showgirls, and to pursue numer-
ous other vernacular vocations in an environment utterly
foreign to them.[1] (While the rush seemingly started over
night, gold was found and mined in the Yukon for nearly
a quarter of a century prior to the big strike.)[2] Because of
its harsh climate, the Klondike presented far more personal
risk to its prospectors than any of the previous gold rushes.[3]
Many never made it beyond the first leg of the ridiculously

gruelling journey across the Chilkoot Pass, one of the only ways to reach the mineral-rich Yukon.[4]

The *Portland* and the *Excelsior* arrived at a fortuitous moment. They docked just following a period of severe economic depression in the United States. The first depression, the Panic of 1873, was precipitated by an over-investment in railroads—an economy with slow returns—as well as the switch from bimetallism to a monometallic de facto gold standard brought about by the introduction of the United States Coinage Act of 1873. The act introduced a new monetary system whereby the standard economic unit was based on the fixed weight of gold.[5] The (over)emphasis on one metal almost immediately resulted in its being perceived as scarce. The perception was somewhat justified by the disparity between the increased demand for the metal and its rate of extraction. With the introduction of the gold standard, by law 40 percent gold bullion was required to back the US Federal Reserve, capping economic expansion at the level of available reserves.[6] The speed at which many European countries also adapted to the gold standard further contributed to the crisis that, initially, was largely imagined. Between 1873 and 1897, Germany, Belgium, Italy, Switzerland, France, Denmark, Norway, Sweden, Spain, Finland, and the Austrian Empire made the switch (following Britain, Canada adopted the gold standard much earlier, in 1853). The belief in gold's scarcity and its rapid increase in value, combined with feverish demand, had a deep effect on US citizens. Gold was quickly hoarded in "socks, sugar bowls, and under floorboards, and in personal safes."[7] Savings were withdrawn from banks, causing bank runs, and a series of economically devastating bank failures followed. The number of gold coins and gold certificates in active circulation was also rapidly reduced, and by 1892 "only one hundred and ninety million in gold coin and gold

certificates out of a total of seven hundred and thirty million" remained in the US Treasury.[8] Recognizing this as a state of emergency, then-President Cleveland borrowed $65 million in gold from J. P. Morgan and Associates, the Wall Street bank, to shore up reserves in the US Treasury.[9] An estimated fifteen thousand companies and five hundred banks failed (many in the western United States) during this period. At its peak, between 17 percent and 19 percent of the workforce was unemployed. The slump morphed into outright panic in 1893 when foreign governments lost faith that the US government could maintain its payments in gold. This was the bleakest economic period yet experienced in the United States.[10]

It is not surprising, then, that when the two ships docked, loaded with the coveted metal, the event immediately took on mythical dimensions. Images and stories of the public spectacle that surrounded this moment were widely circulated in news media, providing the very boost the economy needed. The event was read, locally and abroad, as a sign of the United States' newfound economic prosperity. (While the Klondike is in Canada, most of the gold tapped was brought to markets in the United States; because of geographic proximity and infrastructure established during previous gold rushes, the US was better equipped to handle this new influx of gold.) It is arguably this very *belief* in economic prosperity, stoked by the widely circulated "signs"—the images of two gold-filled ships—rather than the influx of real monetary resources, that had the most impact in transforming the US economy. Pierre Berton describes one of many examples of this rapid transformation: *In the first two weeks [of the gold rush]... telegraph orders on the Puget Sound National Bank, headquartered in Seattle, increased fivefold over any other period in the bank's history... the sale of bank drafts tripled and express*

business doubled [and by] August the city's total business had leaped by fifty per cent.[11]

The focus on gold had other unanticipated effects, one of which was that people began seeing it everywhere. Berton continues: *A group of Italian labourers in New York City saw gold in some sand in which they were digging and began to talk to newspapermen of fortune. A visitor to Victoria saw gold in an outcropping in a gutter near the city's post office and tried to stake a claim on the main street. Gold started to turn up in almost every state in the union. Trinity County, California, went wild over the alleged discovery of some old Spanish mines.... A report from Marquette, Michigan, claimed that the town was sitting on top of a vein of gold forty feet wide.... Peru tried to revive the gold mines of the Incas; Deadwood announced the discovery of a new gold vein; the old Caribou and Kootenay districts of British Columbia began to report new gold finds. Mexico claimed there was gold in the Yaqui country, Russia insisted there were fabulous mines just across from Alaska, and even China talked about new discoveries.*[12]

There was no consensus between newcomers and local Native people in the Yukon regarding the value of gold when the rush first started. Although gold was highly valued among many Native societies throughout the Americas as a material and resource, it had no existing function or value for Tagish and Tlingit people of the Yukon. In Meso-America, gold was the preferred material to create effigies of gods, and Indian people from the Andes considered the metal as coming directly from the heavens—for them the metal was quite literally "sun shit."[13] Once the opportunity to trade the resource arose within the micro-economies of the Klondike Gold Rush, it was also quickly brought into circulation among local Native people. Prospectors came in search of a material whose value accrued only at a

distance, once removed from the land and brought to markets in the United States, Europe, and to a lesser degree, Canada. But the prospectors were not the only ones looking to capitalize. Local Native populations had already been trading with Russians, Spaniards, and the British for nearly one hundred years, and with other Indigenous tribes since time immemorial. They saw the situation and shrewdly took it for what it was: an economic opportunity. The Chilkat people charged exorbitant fees to any unwitting prospector looking to cross their territory to enter the Yukon, and for many years leading up to the Klondike Gold Rush they deliberately held off prospectors.[14] Those heading with their supplies over the Chilkoot and White Passes (the two main routes to enter the mineral-rich gold fields) had to rely on the high-priced services of Tagish and Tlingit men and women, often the only people physically capable of carrying the prospectors' heavy supplies into the interior Yukon. There were a number of instances during the Klondike Gold Rush when the value of resources such as pack dogs, chickens, eggs, and sewing machines, as well as alcohol and entertainment (commodities with an immediate use value), far outweighed what could be traded for gold tapped from the ground.[15] Gold attained its "real" market value only outside of its local context, and much of the Klondike's economic impact asserted itself outside the Yukon. Canada was also not in a position to benefit economically from its own resources. The US, having already experienced other rushes, had developed an infrastructure enabling the country to immediately profit from the Klondike. This was accentuated by geographic conditions: the most direct route to get gold out of the Yukon was to exit back over the passes and onto ships destined for US ports. Once at those ports, the gold was weighed, processed, and sold to enter local and global markets.

Unlike at the beginnings of previous gold rushes, early rumours as well as published reports on the Yukon's burgeoning mineral wealth initially had little impact in the South. This made the ships' arrival that much more of a sensation. It was as though a situation of extreme desperation had conjured its own miraculous cure. With the events surrounding the Klondike Gold Rush the link between desire and economic prosperity was made clear; economic prosperity is the *very motor* of capitalist desire and vice versa. What these events also point to is the degree to which magic, belief, and luck remains tied to systems of exchange and, ultimately, to the accumulation of capital. Marcel Mauss describes the very origins of economic value as religious in nature. Economic activities, in his view, "retain a ceremonial character that is obligatory and effective."[16] No matter how distanced we are from our collective origins in systems of mutual reciprocity and exchange, these activities remain "full of rituals and rights."[17] In many ways then, money still possesses the magical power that Mauss first observed.[18] It is this understanding of magical power, ritual, and ceremony attached to systems of exchange that four prominent Seattle businessmen drew upon when they invented the Golden Potlatch, a city-wide festival that rather artfully combined the just-passed prosperity of the Klondike Gold Rush with the mutual reciprocity operating at the heart of the "potlatch" ceremony customary among certain Native North American societies.

Following its first iteration in 1911, the Golden Potlatch took place annually for three years (it was briefly resuscitated between 1935 and 1941 and continues today, in a much different form, as the Seafair Celebrations). Central to the festival was an elaborate performance of "sympathetic magic," including a re-enactment of the docking of the *Portland,* complete with a small-scale replica of the

original ship. The organizers—in combining the optimism and promise of wealth associated with the gold rush along with the communal gifting and redistribution of wealth characteristic of the potlatch—were perhaps ignorant of the fact that potlatch ceremonies in the United States and Canada were illegal at the time and that this ban was rigorously enforced by missionaries and Indian agents as a part of assimilationist policies in both countries.[19] (This ban was notoriously enforced in 1921 at Nimpkish chief Daniel Cranmer's potlatch in Alert Bay. Some of the ceremonial objects and regalia seized, now considered government property, were incorporated into the collections of the Canadian Museum of Civilization and the Royal Ontario Museum, while the finest pieces were sold to a private collector in New York City.)[20] Official invitations to the 1911 Golden Potlatch circulated in the form of beautifully typeset postcards. A particularly compelling example included an image of "Siwash Indian Ware Sellers" flanked by portraits of Chief Seattle and Princess Angeline.[21] The tag line promised a "Hot Time in a Cool Place."

The 1912 edition was more elaborate. Two hundred and fifty full-scale plaster replicas of totem poles were erected throughout the city along with other public ceremonial markers. Major events included a large parade down Main Street as well as plays—initiations to quite literally "infect" the public with the festival spirit—and a daily media blitz consisting of press releases containing poetry, news, songs, and images to further promote the event.[22] The parade, an unabashed advertising gesture intended to boost the city's economy, was a form of social narration. A demonstration of power through public spectacle, parades assist in solidifying connections with their audiences; as a form of tableau they rely on an elaborate symbolism that "tells" spectators a particular story about society as they pass by. The story

of the Golden Potlatch was one of "organized optimism."[23] During the parade, different ethnic groups were displayed and celebrated through dedicated floats. One image shows a float with a large banner reading "Afro-Americans,"[24] while others honoured technical advancements in transportation, burgeoning car culture, and local clubs including the Rotary.[25] Westward expansion and settlement were promoted with a float dedicated to "The First Cabin," (presumably the home of the first settler in the region). While parades commemorate history in the present moment, the Golden Potlatch also conjured a very specific idea of the future: one linked to economic prosperity and to the will for a collective redistribution of wealth offered by the purposefully borrowed idea of the potlatch.

Unlike traditional potlatch ceremonies, in the festivities associated with the Golden Potlatch no goods, materials, or other tokens were gifted or exchanged. In customary potlatch ceremonies, goods in the form of material and nonmaterial "wealth" are generally given with the intention that they be "paid back" at a future date—with interest. Potlatches, each with very specific associations and intentions depending on the local context, are one way in which Native societies honour ancestors, give names, repay debts, share resources, settle disputes, and instill social values. Peter Lamborn Wilson puts forth that "spiritual anarchy," arising from the appropriation of Native traditions and beliefs, is in fact America's oldest heritage.[26] Relative to the Golden Potlatch, this perhaps points to both a desire for economic prosperity *along with* the obligatory and ceremonial sharing of wealth.

An invention of four of the country's earliest advertising men (they are not named in texts)—from the ranks of Seattle's biggest downtown promoters, including the Chamber of Commerce; both major newspapers, the *Post-Intelligencer*

and the *Seattle Times*; and the brand new Seattle Advertising Club—the Golden Potlatch was a self-declared "advertising stunt."[27] The origins of the festival are described as follows: *Organizers explained that they had borrowed the term "potlatch" from the "quaint jargon of the Chinook," meaning a "carnival of sports, music, dancing and feasting, and the distributing of gifts by hosts to all the guests." [They] developed an extended Indian fantasy to suggest the exotic and mysterious character of the Potlatch. The* Tillikums of Elttaes *formed a local "secret order".... The narrative that shaped the Potlatch festival was that the* Hyas Tyee, *the "chief of the North," paddled to Seattle to visit "his white brethren of the South." He was attended by leaders of five Alaskan tribes, each represented by a contrived totem.... The* Hyas Tyee *shared his knowledge of the "picturesque and romantic Indian North" with Potlatch visitors, and, in return, the city of Seattle offered him access to "the ways of modernity."*[28]

The specific ceremony that the Golden Potlatch is conjuring remains integral to Tlingit society in Alaska and in the Yukon, and is practiced today. The memorial ceremony most closely resembling a potlatch is the *ḵoo.éex'*; it is central to both the spiritual and the healing dimensions of Tlingit societies and commemorates the recently deceased.[29] During the event as it is practiced now, a hall is stacked with food and other material goods ranging from berries, apples, oranges, bread, candy, juice, and soft drinks to blankets and other special gifts to be given to specific individuals. The most sacred of objects, the *at.óow*, are not displayed publicly, but are instead kept in decorated chests out of sight until they are actively used as part of the ceremony (*at.óow* include robes that are worn at the start of a *ḵoo.éex'*). It is the *at.óow*, the most highly valued objects in Tlingit society, which are considered the "masterless or ownerless things." Clan groups collectively act as their

stewards in perpetuity.[30] Currency, in the form of paper money, has also entered the ceremonial realm through its integration into the _koo.éex'._ Small amounts are exchanged as a symbolic gesture of support rather than as a display of competitive wealth and are given discreetly to friends and relatives of the opposite moiety (a moiety being one of two kinship groups making up the specific community).[31] The names of those who have given are later publicly acknowledged.[32]

The hosts begin the ceremony with the *Gáax* or "Cry Section," one of four mourning songs normally performed. This is followed by the *L S'aatí Sháa Gaaxí*, or the "Widow's Cry," a song performed by the opposite moiety (the guests). Its purpose is to respond "to remove the grief of the hosts."[33] The role of the Widow's Cry is central to understanding the ceremony: *This interaction in the Widow's Cry can be confusing at first to people outside of Tlingit tradition, because the removal of grief is directed not toward the surviving spouse, who is also of the guests' moiety [relations], but by the survivor's clan toward the clan of the departed! The speeches are directed not primarily or exclusively to the widow and her clan and moiety, but by her relatives to the family and clan of the deceased. This is not to minimize the grief of the widow (or widower), after whom this part of the ceremony is named, (and who is of the same moiety as the speakers), but to maximize the consolation offered across moiety lines to a clan of the opposite moiety who has lost a member.*[34]

This ceremony is an example of complex relationships of balance and reciprocity central to Tlingit society.[35] These relationships form the "underlying philosophy of Tlingit tradition and social structure."[36] The emphasis on economy in this context is based on symbolic and spiritual support and the exchange of actual goods for community members. When given and received, this wealth (material

and otherwise) is weighted with contractual obligations. For Marcel Mauss, the contractual relationship one enters into through a potlatch is legally binding. Through what he terms "total social phenomena," "all kinds of institutions are given expression at one and the same time—religious, juridical, and moral, which relate to both politics and the family; likewise economic ones, which suppose special forms of production and consumption, or rather, of performing total services and of distribution."[37] The *ḵoo.éex',* then, is a permanent form of contractual morality brought about through "total social phenomena," where the necessity for healing generates an economic act.

It is this ceremony, emptied of its spiritual dimensions and specific cultural context, from which the Golden Potlatch liberally borrows. Through a form of sympathetic magic—an act of mimicry performed to bring about the thing being copied—social and economic value systems from both Native and European societies were merged to create a new hybrid event. It was produced, I think, in the hope that this act of mimesis, not unlike the sensational arrival of the ships, the *Excelsior* and the *Portland*, would once again conjure a moment of economic optimism. Capitalist desire and prosperity were emphatically linked through the metaphor of sickness (an intriguing parallel to the healing dimensions of the *ḵoo.éex'*) and this link is the very thing that mobilized this narrative. In a moment of genius marketing, the men behind the Golden Potlatch created the perfect mascot for their event. Called the Potlatch Bug, it emerged in 1912 during the second iteration of the summer festival as the event's emblem and highly recognizable "brand." Represented in a style now typical of the aesthetics of Northwest Coast Native art, with its face painted in red and white with black form lines, the Bug was more human than insect-like. With a decorated crest on its

forehead, kohl-rimmed eyes, and claw-tipped fingers, the Bug's primary characteristic was its "infectious" grin. Through their marketing campaign, the organizers pointed to an intriguing link between the desire for economic prosperity and illness. The purpose of their mascot was to "*inoculate you* with the carnival spirit."[38] They even went so far as to invent a "Bug High Priest," a figure who merged religion with the organizers' understandings of the potlatch. The hypothetical virus that was to infect Seattle's populace was called "enthusiasmitis" and initiation into the Golden Potlatch Club included a mock injection of "the sacred virus of the Great Bug." With what one can imagine was a combination of religious zeal and the focus of ritual, this injection was "administered by an Ad Club member who attended the meeting in full regalia."[39] Pierre Berton similarly describes the effects of the Klondike Gold Rush (the event the Golden Potlatch attempted to conjure) as a malady. In his words: "So infectious was the Klondike epidemic that the flimsiest rumour served to send hundreds dashing to the farthest corners of the northern hemisphere."[40] The Golden Potlatch, with its performative rhetoric of the "sickness" associated with capitalist desire, enacts the *symptoms* of Western colonialism (inextricably linked with capitalism), while at the same time constituting a public acknowledgment of colonialism's existence—in this instance, perhaps revealing a need (if deeply buried) in the colonial actors for the true spirit and intent of the _koo.éex'_: that is, to be healed. Those producing the Golden Potlatch clearly saw the link between economic prosperity and collective belief—rightly understanding that the very belief in potential wealth can transform economies (something put into motion the very moment the two ships from the Klondike docked). Within the _koo.éex'_, the production and the distribution of wealth ensures the health of the

community and that societal values and obligations are upheld in perpetuity.

Of further use in understanding the grand gesture of appropriation central to the Golden Potlatch is Edward Said's notion of Orientalism, succinctly described as "a set of relationships marked by an imbalance of power that is the crossing point of divergent needs."[41] Orientalism, "in its central operation, [is characterized by] a dominant narrator [who] idealizes a [perceivably] passive subject to produce images that illustrate or embody possibilities the dominant narrator desires but can not tolerate in itself."[42] These desires (to be healed, for economic prosperity, and the communal distribution of wealth) were certainly at play in the creation of the Golden Potlatch. Another aspect central to this event, and which takes the possibilities presented by the embodiment of the Other further still, relies on the relationships between mimesis, alterity, and sympathetic magic. For Walter Benjamin, the mimetic faculty represents not only the desire to illustrate or embody characteristics desired in the Other, but is born from the very "compulsion to *become* the Other."[43] A compelling image from the Golden Potlatch shows the four progenitors of the festival dressed in stunning authentic woven Tlingit raven's tail ceremonial robes with traditional headdresses and holding elaborately carved paddles and staffs. Here they are taking on the identity of a myth of their own devising, quite literally becoming the fictitious Alaskan chiefs who paddled down from the North in search of modernity. The Golden Potlatch was at its very core a mimetic gesture, and demonstrates how objecthood (and, by extension, culture) is increasingly fetishized under capitalism.[44] Within the context of modernity, this fetishization emerges at the point where contact between people is displaced by contact between people and commodities.[45] One of the characteristics of modernity is the bringing

forth of "a sudden re-juxtaposition of the very old with the very new," and with this the re-emergence of the mimetic faculty.[46]

It is not useful to simply deem the appropriative act of the Golden Potlatch "good" or "bad," but instead to consider what can be gleaned from this act. What Michael Taussig terms "mimetic excess" is also at work in the Golden Potlatch festivities—this excess is what oscillates out from the original mimetic act, an excess or spillage that, at its most generative, creates a "reflective awareness as to the mimetic faculty."[47] In the context of post-colonialism, this awareness can provide an opportunity to "live subjunctively as neither subject nor object of history but as both, at one and the same time."[48] Perhaps the re-emergence of the *koo.éex'* in Tlingit society after legislation banning the ceremony was lifted is but one manifestation of this opportunity, where a rupture is created. Here Tlingit ceremonial culture, at once repressed, bastardized, and appropriated, breaks free from its association with (only) the past; the ongoing practice of the *koo.éex'*, and the integration of Euro-American monetary systems and goods within this ceremony, for example, bring other systems of economic exchange and value to bear on contemporary society.

The mimesis brought about by the Golden Potlatch was decidedly imperfect. From the outset its intent, I think, was not to create a perfect copy, but instead to borrow from the *idea* of the potlatch for different objectives. The festival was the public performance of a larger narrative about economic prosperity (always already from a prospector's/settler's perspective). It was a form of mimetic excess framed by individual desire for wealth and power made possible by the conjuring of modern-day capitalism. Perhaps to fully enter modernity, it was necessary for Seattle to perform this mimesis, to experience "the freedom to live reality as really

made-up."[49] It was in the moment of creative freedom and a quite liberal bastardization of "other" economic values—fuelled by generalized understandings of the potlatch—that the Golden Potlatch achieved some of Marcel Mauss's proposition for hybridized economies brought forth in his conclusion to the book *The Gift.* In his words: "These concepts of law and economies that it pleases us to contrast: liberty and obligation; liberality, generosity, and luxury, as against savings, interest, and utility—it would be good to put them in the melting pot once more."[50] Mauss argues for the re-recognition of the value of reciprocity and exchange, something that, for him, forms the very basis of social life, and by extension, social values.[51]

This essay is dedicated to the memory of my great-grand-parents, Jessie Jim and Tommy (Togo) Takamatsu. For Jessie, the niece of Keish, the changes brought forth by the Klondike Gold Rush brought much pain, pain that she handled in her own way; the story of Togo, lured to the Yukon's shores from Japan by presumably the same desires that brought the first prospectors, was one of cultural adaptation and resilience.

Keish, also known as Skookum Jim, was the Tagish prospector who, along with his brother Tagish Charlie and George Carmack, was responsible for the discovery that began the Klondike Gold Rush. My grandmother, Vera Mattson, relayed to me that upon his death, Keish gave all of his assets to the Anglican Church in Carcross, Yukon, in the hope that his resources would better benefit the future of his community.

To them: Gunalchéesh!

1. The Gold Rush had its most immediate impact in Seattle, which was the hub for gold prospectors boarding ships for the North. Documents from the period report that the city emptied out nearly overnight. The mayor was also caught in the craze. Out of town during the ships' dockings, he sent in his resignation from afar to immediately join the throngs of people heading north. See Pierre Berton, *Klondike: The Last Great Gold Rush 1896–1899* (Toronto: Random House, 1972). Differing from previous gold rushes in the United States, those struck by the potential of gold in Canada's North were not only North American but also from Europe—an anomaly that points to the fact that the desire for the metal was also present throughout a number of countries in Europe, perhaps due to their recent adoption of the gold standard.

2. For an excellent account of the early days of prospecting in the Yukon leading up to the Klondike Gold Rush, see Michael Gates, *Gold at Fortymile Creek: Early Days in the Yukon* (Vancouver: UBC Press, 1994).

3. In the beginning nearly all of the gold extracted from the Yukon was recovered by hand. Prospectors would remove the frozen earth, wait for warmer weather, melt the earth, and run the slurry through a system of wooden troughs. Gold, a relatively heavy metal, would then fall to the bottom of the slurry. This process was mechanized only at the decline of the rush, a development in which the Guggenheim family played a major role. Kevin Hillstrom and Laurie Collier Hillstrom, *The Industrial Revolution in America* (Santa Barbara: ABC-CLIO, 2006), 82.

4. A detailed description of the conditions of the pass is revealing: *The Northwest Mounted Police were stationed at the summit of both [the Chilkoot and White Passes] to ensure that every stampeder was adequately outfitted to survive one year in the Klondike. "Adequate" translated into one ton of goods per*

person, including food, tents, cooking utensils, and tools....
Stampeders walked 80 miles for every single mile they moved
their provisions. The worst part of the trail...was the "Golden
Stairs," 1,500 steps carved out of the mountain ice. Stamped-
ers moved up the stairs in a single line, clutching the rope bal-
ustrade, carrying their goods on their backs, 50–60 pounds at
a time. The term "stampede" was laughable in such crowded,
slow-moving conditions. A single trip up the "Golden Stairs"
could take as long as six hours. "The Trails," National Postal
Museum, accessed August 6, 2010, http://fillip.ca/v83h.

5. For more information see Barry J. Eichengreen and Marc
Flandreau, eds., *The Gold Standard in Theory and History*
(London: Routledge, 1997).

6. Edward C. Simmons, "The Elasticity of the Federal
Reserve," *American Economic Review* 26, no. 4 (December
1936), 683–90.

7. Pierre Berton, *Klondike: The Last Great Gold Rush, 1896–*
1899 (Toronto: Random House, 1972), 93.

8. Ibid.

9. Jerry W. Markham, "Investment Trusts and the Panic
of 1893," in *A Financial History of the United States,* vol. 1,
From Christopher Columbus to the Robber Barons (1492–
1900) (New York: M. E. Sharpe, 2001), 331.

10. The "currency famine" also brought about a number
of creative monetary substitutes including "due bills from
manufacturers, certified checks, certificates of deposit, and
cashier's cheques in small amounts." Because of the scar-
city of legal currency, it was sold in shops for "two per-
cent over its face amount [and] some large companies made
plans to issue a currency of their own that would be redeem-
able when the banks resumed cash payments." Markham,
"Investment Trusts and the Panic of 1893," 331.

11. Berton, *Klondike,* 105.

12. Ibid., 107.

13. Jimmie Durham, *Between the Furniture and the Building (Between a Rock and a Hard Place)* (Munich: Kunstverein München, 1998), 85. One of the most stunning examples of the material wealth of Indigenous cultures is found at the Smithsonian's National Museum of the American Indian in Washington, DC, where a wall filled with thousands of gold objects is on view arranged in constellations representative of the cosmologies of Indigenous societies in the Americas.

14. Gates, *Gold at Fortymile Creek*, 9–10.

15. Michael Gates describes how volatile the values for goods were in the early days of gold prospecting in the Yukon. Values were based on immediate need as well as on speculation; miners were always chasing potential (and largely imagined) riches. *Within twenty-four hours [of the Klondike gold strike], the price of a cabin in Circle [City] had dropped from $500 to nearly nothing, while the price of dogs skyrocketed. As the supply of dogs dwindled, so did the size of the teams that were being run. Those lacking dog teams pulled their own sleds—a numbing and heartbreaking task. By the time any of these men arrived in Dawson [City], hundreds of claims had already been staked and the prime ground had already been claimed.* Gates, *Gold at Fortymile Creek*, 127.

16. Marcel Mauss, *The Gift: The Form and Reason for Exchange in Archaic Society,* trans. W. D. Halls (New York: W. W. Norton, 1990), 70–74.

17. Ibid., 72.

18. Ibid.

19. The potlatch ban was repealed in Canada in 1951. In the US (where the potlatch was less of a threat to assimilationist practices as fewer of the population customarily practiced it) the ban was dropped in 1934. During the ban, when ceremonies were not forced to a halt altogether, they continued in a more subdued form or moved "underground" so as not to attract the attention of overzealous missionaries

and/or Indian agents. It was the opinion of missionaries and Indian agents that the potlatch—the very backbone of many Northwest Coast Native societies—was a "worse than useless custom." It was vehemently regarded as "wasteful, unproductive, and contrary to 'civilized' values"; even more curious then, this public emergence in the early 1900s, in the bastardized form of the Golden Potlatch. G. M. Sprout, quoted in Douglas Cole and Ira Chaikin, *An Iron Hand upon the People: The Law against the Potlatch on the Northwest Coast* (Vancouver: Douglas and McIntyre, 1990), 15.

20. After the potlatch was decriminalized in Canada, these items were successfully repatriated to the Kwagiulth Museum in Cape Mudge and the U'Mista Cultural Centre in Alert Bay following long negotiations. See Aldona Jonaitis, *Art of the Northwest Coast* (Vancouver: Douglas & McIntyre, 2006), 224–25 and 285–87.

21. See-atch, known as "Chief Seattle," and his eldest daughter Kikisoblu, known as "Princess Angeline," were local celebrities. See-atch is best known for a speech attributed to him given in December 1854 during the Treaty Proposals in Seattle. The authenticity of the speech is suspect and is known to have been embellished. It was first translated thirty-three years later by the local poet and settler Dr. Henry A. Smith, who, curiously, was not fluent in the language in which the original speech was delivered. Kikisoblu was among the first Native subjects of photographer Edward S. Curtis. Like the Golden Potlatch, the identities of Chief Seattle and Princess Angeline were largely creations of the public imagination. However, the association of these figures with the Golden Potlatch was likely another means of adding legitimacy to the event. See Bruce Trigger and Wilcomb Washburn, eds., *The Cambridge History of Native People's of the Americas* (Cambridge: University of Cambridge, 1996).

22. Lorraine McConaghy, "Seattle's Potlatch Bug, 1912," *Historylink,* July 11, 2007, http://fillip.ca/4tc3.

23. Ibid.

24. The celebration of different races and classes as part of the Golden Potlatch mirrors the permutations of assumed hierarchies and divisions between race, class, and gender that took place during the Klondike and previous gold rushes. (This was perhaps one of the first instances when cross-dressing was not only tolerated but encouraged in North American culture, Calamity Jane being but one example.) The singular focus on one resource, and the (nearly) irreducible power attributed to whoever had it in his or her possession, brought forth intriguing instances of hierarchies being challenged or even flipped on their heads. Relationships and business partnerships between people of different races previously considered unacceptable were normalized, as were partnerships, sexual relations, and marriages between the very rich and the (formerly) very poor. The existence of gold radically levelled the playing field: everyone, regardless of background, had the *potential* to strike it rich, and this potential nearly trumped all former divisions. During this time moral codes, values, and ethics were hybridized and in some cases invented anew; with these came vernacular forms of law and social justice. See, for example, Gates, *Gold at Fortymile Creek,* 83–87, and Mary E. Hitchcock, *Two Women in the Frontier* (Calgary: University of Calgary Press, 2005).

25. Images are available at http://fillip.ca/4tc3, http://fillip.ca/8hlw, and http://fillip.ca/0lb7.

26. Peter Lamborn Wilson, "Caliban's Masque: Spiritual Anarchy and the Wild Man in Colonial America," in *Gone to Croatan: Origins of North American Dropout Culture*, eds. Ron Sakolsky and James Koehnline, (Edinburgh: Autonomedia/AK Press, 1993), 112.

27. McConaghy, "Seattle's Potlatch Bug, 1912."

28. Ibid.

29. Nora Marks Dauenhauer and Richard Dauenhauer, *Haa Tuwunaagu Yís, for Healing our Spirit: Tlingit Oratory* (Seattle: University of Washington Press with the Sealaska Heritage Foundation, 1990), 38.

30. Ibid., 41–43.

31. The two kinship groups for Tlingit are the Raven and Wolf moieties.

32. Dauenhauer and Dauenhauer, *Haa Tuwunàagu Yís*, 43.

33. Ibid., 44.

34. Ibid., 47–48.

35. Dauenhauer and Dauenhauer provide a specific example of this sense of balance as follows: *The message of consolation is first expressed immediately after someone's death, and culminates later in the Cry ceremony. First in word and then in ritual action, the guests are saying, "put your spirit against mine."... This is another example of... reciprocity through the "bracing" or mutual supporting of each other and of spiritual forces* (*Haa Tuwunàagu Yís*, 49).

36. Ibid., 47–48.

37. Mauss, *The Gift*, 3.

38. McConaghy, "Seattle's Potlatch Bug, 1912"; emphasis added.

39. Ibid.

40. Berton, *Klondike*, 107.

41. Matthew Stadler discussing Edward Said, "Just Here to Help: Global Art Production and Local Meanings," Fillip 8 (Fall 2008), 8–19.

42. Ibid.

43. Walter Benjamin, quoted in Michael Taussig, *Mimesis and Alterity: A Particular History of the Senses* (New York: Routledge, 1993), xviii; emphasis added.

44. Taussig, *Mimesis and Alterity*, xviii. In Tlingit societies,

the understanding that the most sacred of objects "refuse" ownership in turn refuses their fetishization. Here an economy, understood generally as the production and distribution of wealth and systems of exchange, is produced with the well-being of the entire community as its ideological basis.

45. Taussig, *Mimesis and Alterity*, 22. Also see Karl Marx, *Capital: A Critique of Political Economy* (New York: International Publishers, 1967).

46. Taussig, *Mimesis and Alterity*, 20.

47. Ibid., 255.

48. Ibid.

49. Ibid., 250.

50. Mauss, *The Gift*, 73.

51. I would like to thank Antonia Hirsch for her engaging conversations, close readings, and astute feedback on this essay. She brought forth many ideas and connections between culture and economies that I would not have been able to see on my own.

Patricia Reed

Economies of Common Infinitude

Now fine and just actions, which political science investigates, exhibit much variety and fluctuation, so that they may be thought to exist only by convention, and not by nature.

—Aristotle[1]

The crucial issue here is not really what is one's form of life… but that one's singular life has (or partakes in) a form, and that this form, which has no need to be further defined, is always already a source of power.

—David Kishik[2]

The long and ongoing engagement with ethics in the context of philosophy and in living itself can be encapsulated by the ancient idea of *eudaimonia*—the search for a good, for a way of being, acting and orienting oneself in relation to a good life. Literally translated, *eudaimonia* is composed of two parts—*eu* (good) and *daimon* (a deity); painting a "good life" with a rather metaphysical brush, the term suggests that a good life arrives under supernatural forces, like a guiding spirit of sorts. Less literally, *eudaimonia* has come to be interpreted as "human flourishing," the quest towards the fulfillment of an augmented human being, capable of more than mere survival (*more* life and not *mere* life). Whether one apprehends the concept literally or in its more contemporary variant, what keeps the supposition relevant is the very *indefinition* of a good life. Ethics may well mean the carrying out of action in relation to a good, yet this good is an abstraction, and the corresponding point of active orientation remains obscure.

The history of ethics is marked by the preoccupation with ways to describe and valuate what a good could be, while the volume of various interpretations for said good (even among the ancients—from Aristotle and the Epicureans to the Stoics, etc.) indicates the utter instability of a steadfast conception of a good. A good is not a finite object (like goods one can consume or monopolize under principles of scarcity), yet it partakes in an economy of shareable imagination, of infinite assimilation, of infinite affect— the valuation of which increases by the very property of its utter impropriety.

A good is not a naturally given good, but is a constructed good. With no God-given or naturally determined "good" of human interaction and behaviour,[3] Aristotle decisively linked ethics with politics, with ways of doing *(ethos)* inseparable from politics (Aristotle having defined "humanness" largely based on man's capacity and outright need for politics). Considering, however, that ethics is above all an action, a doing, a way of dwelling, the principal question of a good is not necessarily what that good is or is not, but rather how a good is apprehended *as such*. Under what processual circumstances does this intangible sense of a good take hold of our symbolic imagination? How does a good become valued as such, and how does this "valued" good gain currency in the sphere of cohabitation?

A good, or a good life, as an apparatus of social cohesion is positioned as that which identifies a particular culture to a life-world of possible behaviours, underlying modes of being and governance in adherence to that very comprehension of a "world." Within this dominant portrayal, a good operates as a force of social normalization, of delineation, of ordering exchanges and behaviours in a particular fashion; *a* good, as such, becomes *the* good as it marks a finite perimeter of possible modes of inclusion within a

given order.[4] *The* good, in this regard, operates as a spectre over social congregation, becoming a part of the everyday imaginary, and, one could venture, the history of human civilization has been a popular experiment in defining and disseminating varying conceptions of this evasive good. *The* good, in this case, is deployed as a stabilizing device, the definition of which functions as an unwritten bond uniting particular populations. Subsequent to the archetypical partitioning of the "world" into nation-state territories first enacted by the Treaty of Westphalia, this good has largely been defined (and contained) under the command of those very states. The delineation of *the* good sets forth systems of belief, action, and modes of dwelling, instantiating forms of identification and, ultimately, delineating forms *over* life by determining inclusion in a given system of order. Important here is the divergence between forms *over* life and forms *of* life; whereas forms *over* life impose an imaginary limit, drawn as a perimeter of possible belonging to a given sphere, forms *of* life, which are immanently limitless, instantiate other modes of belonging to a world. In such an apprehension, *the* good is rendered as a property specific to a particular identity of peoples. Conceived thusly, *the* good is a property of the state, and all those who wish to be members are compelled to perform and identify with this property. *The* good is not a thing—not a good in the sense of a product—yet it has dramatic material consequences as we have witnessed in countless bloody battles fought over its utter signification, the insurgency in Iraq and the "winning of hearts and minds," being a quintessential example.[5] In the current state of affairs, where battles are waged less in the hopes of territorial expansion and more in relation to the occupation of cognitive territory (noo-politics, soft power, and networked organization), the fight is precisely over the semantic territorialization of

the good. When *the* good is deployed as a property that one must perform for ritual membership, *the* good becomes an imperative and thereby enters the category of the moral or unquestionable, finite good. In taking on the quality of a moral command, *the* good demarcates the very possible topology of living (forms over life), to the negation of potential and limitless forms of life.

The Virtuous Good

One should reduce and limit the realm of morality step by step: one should bring to light and honor the names of the instincts that are really at work here after they have been hidden for so long beneath hypocritical names of virtue...

—Friedrich Nietzsche[6]

There are two key points to note in the preceding description of *the* good. The first is to note that *the* good is used as an *apparatus* for the normalization of relations; and second, that *the* good is deployed as an *imperative*.

In the first instance, *the* good becomes synonymous with "virtue," what Bonnie Honig elaborates as a "virtue theory of politics"[7]—politics understood as that which reconciles social dissonance, seeking closure and administrative or juridical settlement (grounded or "archic" politics). In her argument, Honig contrasts "virtue" politics with "virtù" politics, a term borrowed from Nietzsche's *Will to Power* wherein "virtù" is a politics of perpetual contest and augmentation. For Nietzsche, virtù is an ethical position that disrupts stabilized order through the articulation of remainders of the system. Virtù is the expression of a surplus: of all that is excluded, concealed, or denied in the delineation of a system of virtue—of what is permitted to make

an appearance. It is here where we find a parallel thread in the work of Jacques Rancière, whose distinction between the "social" and "politics" is of utmost relevance. Rancière equates the social with the "police," which should not to be conflated with those men and women in uniform enacting authority; the police or the social is wholly non-pejorative. The social or the police is characterized by a hegemonic consensus that is performed through modes of being and appearing that are in accordance with their appropriate function, place, speech-act, and identity, and as such mark an *understanding* of the "partitioning of the sensible" that can be internalized (sensed) by its constituent members.[8] The "social," as such, can be defined as a settled apprehension of virtue, the stabilized "good," that traverses a given community as *sense* (the common understanding of the signification of *the* good).

Politics, on the other hand, for Rancière, is the contestation relative to the very formation of a territory-in-common, to the ways in which something makes an appearance and the ways of making sense of that appearance. Politics shifts the symbolic ordering of the social creating new economies of equivalence between those who "count" and those who do not. Akin to Nietzsche's virtù, which takes into account the remainders of a system, Rancière's politics is the demonstration of the "part with no part," the surplus community, function, place, identity, and so on, unaccounted for in the given sensibility of the social order. The part with no part is that which does not yet exist (it is a *potential* party— a party being s/he or that which is recognized as partaking in the partitioning of the sensible) in the given symbolic order and, as such, it is not merely a dispute between parties; it is the very constitution of a party *as* a part(y). Politics is a clash of sense and sense, namely dissensus: the struggle between the partitioning of the sensible (the

hegemonic social) and the ways of making sense of it.[9]

When *the* good is deployed as a normalizing force, it is apolitical; it is a virtuous good upholding the habitual symbolic order of the social—and to reiterate, this is not necessarily pejorative, simply normative. The social good subtends a particular community of sense to the neglect of all that is supernumerary to its condition and its modes of interaction. *The* good, as virtue, imposes an economy of scarcity of other possible worlds as it is reinforced by the repetition of its consensual performance played out in daily rituals. *The* good, then, portrayed as a social entity according to which relations of consensus play out—to and in the world—is a form *over* life, a sign that delineates a proper place, function, and behaviour of members who are (ac)counted (for), to the exclusion of any possible supernumerary condition.

The second aspect of *the* good (and not *a* good) to be addressed, in tandem with its normalizing force, is the notion of *the* good symbolically defined as an imperative. Are there ethical principles at work in the deployment of an imperative, and, if so, what becomes of subjectivity when *the* good is figured as a prescriptive undertaking? As Alain Badiou has said, there are no ethics in general but only the capacity of humanity to conceptually recognize a good in particular situations—a good is, above all, *a* situated good and not *the* given good.[10] Giorgio Agamben echoes this point when he writes that there are no mere tasks in being that need to be fulfilled[11] (being in the world is not merely composed of fulfilling a certain checklist of duties), and it is in this taskless nature of being that the need for ethics arises. The generalized good as imperative, thusly, falls under the rubric of morality as outlined by Michel Foucault, that is, a "prescriptive code one is obliged to follow."[12] When *the* good, as a symbolic imaginary, is used to normalize the social via

a commandment to obey its force as virtue, it is the moral good—the social good and not *a* political good.

Unbounding the Naturalized Good

Although calling for augmented conceptions of politics in various, and often oppositional, guises, many authors, including Rancière, have denounced a so-called "return to ethics," condemning such a return as the reification of normalized (and therefore exclusionary) consensual social structures. Rancière, for example, has condemned the celebration of an "ethical turn" (positioning ethics within the realm of the police/social), describing the "fashion" of ethics as nothing more than old-world morals—in other words, ethics apprehended as (absolutely) socially prescriptive. Rancière diagnoses a social condition in which ethics mirrors a generalized state of normativity within which a hegemony of judgment plays out; this state of normativity falsely identified as ethics neglects, as it were, potential or not-yet-existing forms of life.[13] In his characterization, the ethical turn of politics dissolves norms into fact and fact into law, merging what *is* with what *could be*—Badiou's concise definition of consensus.[14] Ethics, positioned in these terms, functions as a quasi law against which the possibility of evaluation and decision, viz. judgment, is markedly impeded as it is continually subordinate to this (false) law. The lack of distinction between fact and law that constitutes the ethical turn of politics, in Rancière's view, traps ethics within the confines of a consensual social system, resulting in the erosion of politics proper.[15] In equating "ethics" with regimes of consensus, however, Rancière ends up relegating "ethics" to a natural law discourse and, consequently, its permeation throughout the social body—where ethics is apprehended as an outright

(innate) task—becomes un-situated and non-negotiable. What we are faced with in Rancière's "ethical" diagnosis is the conflation of ethics with morality. In heeding a philosophy that demonstrates the importance of "mere words," and the relevance of defending them (Rancière having battled to rescue "democracy" from the shackles of its equation with a mode of governance),[16] it seems crucial to deploy this defence of "mere words" *against* a conflation of ethics/ morality suggested by Rancière's own writing—towards the politicization of ethics, asserting the relevance of *a* good.

A Good as Demand

As Rancière reminds us, before ethics signifies moral norms, it signifies "both the dwelling and the way of being... that corresponds to this dwelling."[17] He goes on to acknowledge that in the ethical turn, when norms become law, our very ways of being and modes of action within an environment are conjoined—our modes of being (forms *of* life) are subjugated to this steadfast (false) law (forms *over* life) and we are trapped in a given order of things (we can only act in what *is* and not what *could be*). What Rancière's etymological excavation of "ethics" precariously neglects, however, is the linking of the word with its enaction, with the activity that constitutes ethics. If ethics is a mode of being in relation to an environment, then it is an action subject to forces of will and motivation. In taking on the question of motivational force in regards to dissensus (not merely a normative imperative), Simon Critchley looks to ethics as a metapolitical moment that provides "propulsion into political action."[18] A good, for Critchley, is a concept that is subjectively perceived as a demand to which a self binds itself in approval. When the self adheres in fidelity to this perceived

demand of a good, a system of ethics ensues. A good, as a subjectively identified *sense*, is thus a capacity for judgment enacted, that capacity of judgment for what *could be* against an environment and forms over life that already *are*.

In the unabashedly heroic tone of Badiou, the capacity to imagine a good is in fact what gives humans their humanity; it is what gives humankind what Badiou calls "immortality," a humanity beyond the mere biological finitude of human existence, liberating it from the victimizing fate of certain organic death (where immortality is the affirmation of infinite forms of life). Consequently, to reject the possibility of imagining a good is to deprive humankind of humanity as such.[19] For Critchley, the perception of a good is manifest in the figuration of the other; this perception is equal to the capacity to perceive what the other is demanding, and because the demand is immeasurable, it can never be fulfilled. The demand, as it were, is one's perceptive, life-long labour, an incommensurable labour. It is precisely this imbrication of "a good" or "could-ness" with otherness that constitutes an ethical system where we may articulate a conception of ethics dissensually, that is, towards the creation of other topologies of sense. Rather than denouncing the fashion of ethics trapped in the social, we need to reconstitute the could-ness embodied in the enaction of ethics itself to get out of the consensual bind. For it is by way of the could-ness of an intangible otherness that dissensus is demonstrated, a could-ness of a good, which, as I shall later discuss, comes by way of a wrong.

The Surplus Subject

The affective quality of Critchley's perceived demand in approval and fidelity to a good is an aesthetic affinity—an

affinity to that which is apprehended sensorially. Considering that a demand is aesthetic and must be perceived, the structure of the demand is always already relational. It is precisely in this ethical structure of an internalized relation (the apprehension of the could-ness of a good, the perception of an *other* possibility) where Critchley calls into doubt the sovereignty of autonomy, calling the subject *dividual*—that is, annexed—since one's sovereignty is inflected by the experience of a *relational* demand; the *dividual* is thusly a subject that is more than one, an overfull subject, a surplus subject. Borrowing Deleuze's term where the *dividual* is "neither divisible nor indivisible,"[20] Critchley's *dividual* is better understood as a compounded subject rather than a split self. The *dividual* is a self amalgamated by the demand of an other, an other that is not (yet) in existence, yet sensed as a good.

Non-sovereign Autonomy

Rancière's lamentation of the "social turn of ethics" is less about a critique of ethics per se, but more a critique of how ethics has been conjoined with a way of life that *must adhere* to given conditions if it is to be considered ethical. The mistrust of the (consensual) ethical turn is ultimately linked to the collapse of *situated* judgment under a regime of morality-turned-law, displacing one's capacity for autonomous negotiation.

What does it mean, exactly, to evoke "autonomous judgment"? When autonomy is defined as self-governance, what does it mean to "govern oneself"? Why is the association between autonomy and freedom (as absolute total licence) so pervasive? And why is autonomy so often reduced to functions of the ego, to the "me" generation of

the 1960s and the "my" generation of the 2000s? Considering that we are thrown into a world of undecideable plurality, an inescapable life of cohabitation,[21] self-governance, as a principle, is impossible, for the self is always in and of the world, and this condition is as ineluctable as the force of gravity on earth. If the precondition of autonomy is a relation to, with, and in the world, how may it be redefined outside of the rule of the ego—how may autonomy be supplemented with a demand of the other or of being otherwise?

In reference to the Italian Autonomia movement (beginning in Northern Italy in the 1950s and rendered more concrete in the late 1970s across all of Italy through the diffusion of localized radio stations and newspapers), Sylvère Lotringer describes autonomy as the "body without organs of politics."[22] The "body without organs," a Deleuzian term, places emphasis on the virtual forces at work in all bodies situated in a perceived "stable" reality (actuality), such as the flows of language, information, and so forth. Deleuze's conception of emancipation, as such, is deeply tied to the activation of the potential of said forces beyond the actual body, towards other immanent becomings of that very body.[23] In Autonomia, autonomy is positioned as a mode of collectivity (through the co-determined nature of shaping one's own life-rules), rhizomatic in structure, and "characterized by the refusal to separate economics from politics and politics from existence"[24] (witnessed by the inclusion of wageless labourers, such as students and domestic workers, within the framework of class struggle from which they are excluded by conventional Marxism). Autonomia, as such, becomes qualified as a kind of connective (living) fibre, not merely seeking abstract policy reform in existing (actual) structures, but within the imbroglio of complex modes of existence—the material of life with forms

of life and the creation of worlds in which those very lives partake in simultaneity. Autonomy in Autonomia is, above all, situated and relational, dramatically shifting away from island-states of autarchic governance, towards forms of life in common, tapping into the infinite reservoir of the virtual and not a particular structure of forms over life.

There are palpable echoes of Romanticism woven into Autonomia's particular emphasis on modes of existence that can be traced back to Friedrich Schiller's critique of the French Revolution. For Schiller, a "real" revolution works radically upon the sensibility or experience of life itself, undoing the polarities between a state of absolute non-governance and a state of what we could call outright moralism, the latter being demarcated by the quasi-transcendental hand of law and order and the blind obedience to said transcendentals. The third state, or "true" revolution, comes by way of play—what Schiller called *Spieltrieb* (play-drive), qualifying it as essential to humanity: humans deploy imagination towards the autonomous invention of new rules of the game (rules not blindly followed), thereby ascribing other uses and sensibilities to objects, forms, people, and places conventionally ascribed a specific place in the partitioning of the sensible. In Schiller's revolutionary Romanticism (and most importantly, put into practice in Autonomia), autonomy is an apparatus of relational agency towards the creation of alter-experiences of living, the enactment of a surplus upon an economy of perception—with the "eco" of economy etymologically denoting a relation to the world.

If autonomy is political only insofar as it can demonstrate other modes of existing, other modes of sense-making, other modes of creating signs and signification, this form of autonomy is not only pertaining to the self but is shared. It is an *affective* autonomy as it were, since it

holds the capacity to suspend normative categories of sensory apprehension, producing other communities of sense and sensibility. In this very contingency on relationality and the capacity to redistribute given topologies of sense, the desire for autonomy is not a sovereign desire, it is a certain drive of incommensurable communicability between the task-less decision to generate an experience of something other and an other that perceives possible otherness.

Co-autonomous Ethics

If the politicity[25] of autonomy lies in its non-sovereignty (its creation of a relation of heterogeneous and shareable experience)—evoking Critchley's ethical *dividual*—we are left with a notion of autonomy that is incongruous with sovereignty. I will name this paradox *co-autonomy*, and, in so doing, will not resolve the contradiction but deploy it as an ethical concept articulating a position of tension between self and otherness; between spectatorship and action; between self and (plural) world. The two-part composition of "co-autonomy" is both connected *and* separated by a hyphen, where the "co" indicates a situated "with-ness" or relational property of autonomy, a with-ness that is *connected via separation*. Co-autonomy inheres to the self, yet concurrently indicates a sphere of heterogeneous experience thus created. The with-ness of the "co"—which is a compounding of autonomy—indicates that it is not extracted from the world as a sovereign agent, but is implicated in the relational experience of other sensorial orders as an *agency* of perception. We can recall that the agency inherent to perceiving a demand is only ethical insofar as it *affirms* the demand in fidelity to its call—and, for Critchley, it can never be totally fulfilled because this

demand is infinite. The fidelity to a demand, as such, oper-
ates as a mode-of-being (a processual state), rather than a
normative measure, or a demand that can be completely
satisfied through action. The complex of co-autonomy
contains three interwoven claims:

1. Autonomy is not sovereign but relational. It con-
stitutes itself on two levels: in the politicity of alter-
experience of life and on the part of the actor who responds
to the perceived demand of a good thereby creating alter-
experiences, producing other sensorial worlds.

2. The "co" of co-autonomy does not strip a sub-
ject of agency (it is not sacrificial); it annexes the subject
(Critchley's *dividual*), but this separation also denotes
linkage to a world via otherness—an affirmative (motiva-
tional) with-ness relative to contexts and situations within
which, for which, and against which one responds. The
"co" moves away from the "vacuum-state" of (modern)
autonomy, and situates subjects in relation to environments
of possible perception.

3. With-ness relative to the world is infinite (there are
innumerable ways of being in the world); accordingly, the
demands of co-autonomy are infinite. It is a life's work,
rather than the fulfilment of *a* work; it is incommensura-
ble labour. Co-autonomy is a shared process among self,
other, and territories of heterogeneous experience; it is not
an exclusive property of one element over another, but the
movement among these elements.

A Good as Critical Impulse?

How can we conceive and apprehend those elusive
demands *as* demands with regards to the non-sovereign
nature of co-autonomy, to the sharing of alter-sense? As a

(co-autonomous) good is precisely what *could be*, it is of the domain of imagination, the domain of speculation. How does the fidelity to the imagination of the not-yet-there "good" manifest? The short answer is, through critique: a good can be manifest in a critical impulse, but only inso-far as one takes on the enaction of critique as a process, and not as a position of privileged knowledge. While analyses and sensitivities towards the given spatio-social environ-ments are wholly necessary in sensing a possible good, cri-tique cannot stop at what *is*, self-congratulatory in a position of hierarchical knowing better. Critique, through the vital lens of Foucault and Judith Butler, is not merely diagnostic or accusatory in nature but is a space of resistant creation (negation *through* affirmation—that is, repudiation through the creation of something other); the "art" of critique is equal to the creation of conditions for other life practices to emerge. For Foucault critique is not definable apart from the object of its attention (as there is no ethics in general, there is also no critique in general); critique is always in relation to an object, it is always heteronymous, and it is always *with* the world. In taking up his genealogical position (a willful non-philosophy), Foucault suggests a more vague instance of critique—not merely imposing evaluations on objects, but demonstrating the scaffold of the process of evaluation itself.[26] As Butler reiterates, how do our "epistemological certainties turn out to support a way of structuring the world that forecloses alternative possibilities of ordering?"[27]

Given the current plight of global neoliberal fiscaliza-tion, we may ask through which epistemological structures have we become limited to Margaret Thatcher's alternative-lessness, to no-such-thing-as-society world,[28] for example. Critique, in this regard, becomes more about understand-ing how certain normative limits have been forged upon our very apprehension of the world (and its (im)possible

becoming) in an effort to articulate those very boundaries and how those delimitations may be questioned. This "art" of critique is not merely an impulse to take knowledge to the limits for the excitement of doing so, but arises under moments of epistemological duress relative to the world into which we are thrust, when an awareness presents itself that the partitioning of the sensible world produces a certain asymmetry to the exclusion of that which cannot be said, seen, heard, and shared. This awareness renders the epistemological network of the social fundamentally contingent, and it is through this rendering contingent that the "art" of critique takes hold in what Butler calls a discursive impasse—when a regime of knowing, saying, and sense-making arrives at a cul-de-sac. The "art" of critique becomes synonymous with the practice of virtue for Foucault, who, in an interesting turn, positions virtue as that which challenges the existing (given) order, as that which is not fulfilled by strict obedience to existing norms[29]—equal to what Nietzsche, as we recall, explicitly defined as "virtù" (which I will uphold as a distinct term).

The fidelity to an "ethical" good, manifest through a critical inclination, is thusly equal to the discursive impasse that may be perceived in the given partitioning of the sensible. The expression of this impasse, in the parlance of Rancière, goes by the name of a "wrong"; it is the antagonistic bringing into relationship of a supernumerary part with no part (virtù's remainders of a system) within a given symbolic ordering. This articulation of this "virtù-ous" appearance sets "up a community by the fact of placing in common a wrong that is nothing more than this very confrontation, the contradiction of two worlds in a single world: a world where they are, and the world where they are not."[30] Rancière deploys the example of the Plebeians making their voice heard *as speech*, and not merely as expressive, noisy utterances, in

relationship to the ruling Patricians, in order to illustrate the setting in motion of a wrong as constitutive of a political relationship. The wrong is the creation of a heterogeneous world in conjunction with the given territory of perceptibility, and, in this regard, it is the spirit of fidelity to a could-ness—an otherness—articulated in the face of what *is*.

A Wrong in Common

The perception of the could-ness of a wrong in common, the articulation of an impasse or that which does not yet exist, is a faculty of imagination (and not the imaginary, which already exists as a sense in the mind). Immanuel Kant declares imagination to be the "faculty of having present what is absent,"[31] meaning that objects are in a way internalized so that the subject does not need to directly confront them in order to be affected by them. The important question then is, can this notion of imagination be extended to that which is not only absent (but is accounted for somewhere), but more importantly, that which does not yet exist (absolutely unaccounted for)? Can imagination become an imaginary? Can the figuration of the supernumerary, that which does not yet exist, be transformed into a palpable, shareable sense of the wrong as a good?

When the politicity of ethics is co-autonomous in nature, how is the imagination of a good/wrong rendered shareable *(sensus communis)* as a sense of impasse, rather than being a private sense *(sensus privatus)*? At work in this translation from not-yet-in-existence imagination to imaginary (and therefore shareable) sense, is the interplay of *logos* and *mythos*, of reasoned thinking and unprovable belief, the interplay between sign and signified, the interplay between the "rationality" of *homo economicus* and those "animal spirits"[32]

of market illogicality, the deployment of the virtual at work in the present, in the actual—and not the utopian. The path of translation from imagination to the imaginary in relation to the demand of a good/wrong is a "being under grace." "Being under grace" is the expression used by Badiou to "indicate the path of the spirit"[33] in fidelity to an event; the event, for my purposes, being the very articulation of a good/wrong in common. "Being under grace" is the opposite of "being under law"; it is the difference between a form *of* life and a form *over* life. For Badiou the intangible force of fidelity to a good/wrong is qualified as a truth, not because it is provable or tangibly known, but because the subject declares it to be so, the subject publicly speculates as to this declaration. This subject, Badiou continues, is a "not…but."[34] The "not" can be understood as the (sensible) suspension of the given, partitioned world (an impasse, a wrong), and the "but" is constitutive of the affirmation of a surplus (overfull) repartitioning of the sensible world. The "not" resides in the perception of the subject towards a demand of a good, inclining himself or herself in fidelity to said relational demand (a co-autonomous relation, the demand of an impasse or a wrong) all within the realm of imagination; the "but" articulates said "wrong in common" through the creation of a sign (something sensible, shareable) ascribing other significations to the given. It is in this movement where the given reality is made incomprehensible, that the "not…but" of the co-autonomous subject inscribes misunderstanding into the world.

The Politicity of Misunderstanding

To misunderstand the given is nothing less than the instantiation of relations of heterogeneity, of appearing otherwise in a world, of creating other possibilities for

sense-making. The double signification of misunderstanding, as Rancière has noted, is both that of failed apprehension and of disagreement based on the misinterpretation of signs.[35] Construing misunderstanding as a negative event reveals a will to solidify meaning, to freeze sense-making, to petrify the interpretation of gestures and modes of identification, thereby projecting a world where words, images, people, and events define things absolutely. The articulation of misunderstanding affirms the contingencies among signs and semantics, between what is given and what is possible—it disentangles the actual from the sensible constraints of unconditional reiteration. It is in the speculative work of creating conditions of and for sensory misunderstanding that demands a situated fidelity to an intangible good; a faithfulness to potential modes of sensibility in the face of a normative and consensual thrust towards semantic and operative fixity.

The given is a hegemonic condition through which "common sense" (customs, "virtues," common identities, and so on) unites and binds particular communities. The economy of this hegemonic condition is, as we have discussed, not only real but symbolic (*logos and mythos*, actual *and* virtual), setting up a chain of equivalence between signs and signified, between things, people, places, functions, and value(s). Such an extended picture of "economy" mirrors the migration of the term from the domain of ancient household affairs *(oikos)*, to its absolute presence (and utter dominance) of the political sphere (the *polis*). As David Kishik writes: "today's world is not a cosmopolis, but more precisely, an ecopolis, where economic and political forces operate as a single field of tensions without maintaining even the pretense that they are independent of one another."[36] The "ecopolis," as such, is a particular world subtended by an economy of symbols, virtues, beliefs, and so forth—it

cannot come into operation in any other way than through the consensual performance of these core interactions, values, and behaviours. Consumption of finite objects, is, of course, one (of many) of the core values and behaviours in our current neoliberal ecopolis, but, as Maurizio Lazzarato points out, consumption cannot be reduced to the operation of buying and selling, for above all, this practice involves adhering to, and, more importantly, *apprehending*, a particular world, a particular partitioning of the world.[37]

Inconsumable Commons

Efforts at politicizing this world as evoked by Lazzarato must begin with the presupposition of apprehending a particular world, without (falsely) limiting the ecopolis to economic categories of use value and exchange value, which ultimately do nothing more than attempt to measure value (and varied ways of distributing it). In resurrecting the work of Gabriel Tarde, Lazzarato places emphasis rather on the creation and constitution of values (beyond those that can be measured, such as truth value, pleasure value). This revaluation of value not only dissolves the dichotomy between material and immaterial labour, it situates the "cooperation between brains" as the principal force driving innovation (and not merely reproduction).[38] As Lazzarato states, "Cooperation between minds, unlike cooperation in the Smithian and Marxian factory, produces public, collective or common goods [infinite informational and affective resources]: knowledge, language, science, culture, art, information, forms of life, relations with oneself, others and the world etc."[39] He distinguishes "common goods" from those outlined in political economy, such as water, air, nature, etc., relative to the goods of all that do not fall under

producer-consumer relations, or those of finite availability. These cooperative common goods (knowledge, language, experience of art, science, and so on), are "inconsumable," that is, they can be assimilated by anyone, but belong (as property) to no one, and, most importantly, their legitimacy increases by being imitated, taken up, and shared.[40]

As has been widely acknowledged, the sphere of cooperative common goods has itself been capitalized in the current state of affairs. In what Lazzarato qualifies as the "capital-labour relationship," cooperative common goods are reduced to private property (some calling this the communism of capital). In such a procedure a false scarcity is imposed upon a productive shared "cooperation of minds" that is fundamentally infinite, indivisible, and that is always already a surplus (for one cannot deplete the resource of language, for example, as it knows no finitude). Considering the economy as not only the (re)production of ownable goods and services, but the particular life-world complex within which desires, beliefs, language, signs, and sensibilities of community circulate, the point of resistance cannot rest on the mere remeasurement and reattribution of wealth, but must work upon the transformation of the very forms of life that subtend such practices. As Foucault makes abundantly clear, "life does not become the object of power without it also becoming at the same time the basis for new forms of resistance."[41]

The Force of Surplus Life

It is this very condition of surplus value reduced to scarcity that gives rise to an impasse, that makes a re-evaluation of value within the ecopolis acutely perceptible. If, as the postmodernists would have it, there is no outside of the

system (all alternatives will be normalized and subsumed within the given social order), it is the speculative work within the conflictual complex core—symbolic and material—where new life-worlds can be articulated and reassigned, working towards other imaginaries of a good, a shareable good. The infinite production at work in cooperative common goods is mirrored in the *dividual,* the co-autonomous ethical self, that is also a compounded, virtual self. The surplus ethical self is, as such, inherently asymmetrical (the self *compounded* by the demand of otherness situated in a plural world), and it is in this asymmetry (an excess of being) that other forms of life may find their force.

It is precisely on this precarious adjacency between forms *over* live (the capitalization of life) and forms *of* life (the excess energy of cooperative common goods) where the demand for ethics presents an urgent call to articulate "the contradiction of two worlds in a single world,"[42] the world where life is captured and the world where it expresses its inherent supernumerary potentiality. The creation of said world in difference can only be a shared one, and the ethical call, as it were, is towards the creation of alter-signs: that is, towards other economies of equivalence between sign and signified that buttress our apprehension of the world, and the "critical" articulation of misapprehension. The creation of signs endures, even when actual events may stagnate. Signs endure in virtuality and have the quality of communicability. At this moment when life seems caught in regimes of endless fiscalization, the real work begins with the reassignment of the force of living itself, an incommensurable force of living that is guided by the spirit of a shared imaginary otherness. This shared otherness is thrust into the world through the articulation of misunderstanding, the supernumerary apprehension of a good that generates misunderstanding, affirming the

contingencies among signs and semantics, between what is given and what is possible—it does not delight in revealing the actual state of things, but disentangles the actual from the sensible constraints of unconditional (naturalized) reification. It is in the speculative work of creating conditions of and for sensory misunderstanding that demands a situated fidelity to an intangible valuation of a good; a faithfulness to potential modes of sensibility in the face of a normative will for consensual semantic and operative fixity. The enactment of critical misunderstanding is precisely where the normative equivalences between object/gesture/thing/life and value (fiscal or semantic) are rendered contingent, thrown into impasse and otherwise sensed. The affirmation of contingencies rendered shareable is nothing less than the enactment of the surplus innate to life and living itself—an articulation of life's virtualities—always already more than finite and inherently composed of the more than singular.

1. Aristotle, *Nicomachean Ethics, Book I,* in *The Complete Works of Aristotle*, ed. Jonathan Barnes, trans. W. D. Ross (Princeton: Princeton University Press, 1984), 3.

2. David Kishik, *The Power of Life: Agamben and the Coming Politics* (Stanford: Stanford University Press, 2012), 113.

3. Paolo Virno, "Anthropology and Theory of Institutions," in *Art and Contemporary Critical Practice*, eds. Gerald Raunig and Gene Ray (London: May Fly Books, 2009), 95–112.

4. This, I believe, requires a distinction between ethics and morality. I deploy "morality" as a rule-based code of behaviour that one is obliged to unquestioningly follow (the law) and ethics as situated, behavioural negotiation (*anarchic*, or preclusive of grounding). Many authors refuse this

distinction saying it has no base etymologically speaking (preferring to use terms such as "normative ethics" or "non-normative ethics," for example), yet for the purposes of decisive vernacular, I will adhere to the distinction advocated by authors such as Michel Foucault to allow for more clarity.

5. Andrew Garfield, "The U.S. Counterpropaganda Failure in Iraq," *Middle East Quarterly*, Fall 2007, http://fillip.ca/4w9u.

6. Friedrich Nietzsche, *The Will to Power*, ed. Walter Kaufmann, trans. R. J. Hollingdale and Walter Kaufmann (New York: Random House, 1967), 178–79 (§327).

7. Bonnie Honig, *Political Theory and the Displacement of Politics* (Ithaca: Cornell University Press, 1993), 2.

8. Jacques Rancière, "Ten Theses on Politics," in *Dissensus: On Politics and Aesthetics*, ed. Steven Corcoran, trans. Davide Panagia and Rachel Bowlby (London: Continuum, 2010), 36.

9. Jacques Rancière, "The Paradoxes of Political Art," in *Dissensus*, 134–51.

10. Alain Badiou, *Ethics: An Essay on the Understanding of Evil*, trans. Peter Hallward (London: Verso, 2001), 16.

11. Giorgio Agamben, *The Coming Community*, trans. Michael Hardt (Minneapolis: University of Minnesota Press, 1993), 43.

12. John Rajchman, "Ethics after Foucault," *Social Text*, no. 13/14 (Winter/Spring, 1986), 165–83.

13. Jacques Rancière, "The Ethical Turn of Aesthetics and Politics," trans. J. P. Deranty, *Critical Horizons* 7, no. 1 (2006), 2.

14. Alain Badiou, *Infinite Thought: Truth and the Return to Philosophy*, trans. Oliver Feltham and Justin Clemens (London: Continuum, 2005), 56.

15. Rancière, *Aesthetics and Its Discontents*, trans. Steven Corcoran, 109–32.

16. Jacques Rancière, *Hatred of Democracy*, trans. Steven Corcoran (London: Verso, 2006).

17. Rancière, "The Ethical Turn of Aesthetics and Politics," 1–2.

18. Simon Critchley, *Infinitely Demanding: Ethics of Commitment, Politics of Resistance* (New York: Verso, 2007), 11.

19. Badiou, *Ethics*, 14.

20. Gilles Deleuze, *Cinema 1: The Movement-Image*, trans. Hugh Tomlinson and Barbara Habberjam (London: Athlone Press, 1986), 14.

21. Judith Butler, "Hannah Arendt and Judgment," seminar at the European Graduate School (Saas-Fee, Switzerland), August 2009.

22. Sylvère Lotringer and Christian Marazzi, "The Return of Politics," in *Autonomia: Post-Political Politics*, trans. Peter Caravetta and John Johnston (Los Angeles: Semiotext(e), 2007), 8.

23. Gilles Deleuze, *The Logic of Sense*, trans. Mark Lester (New York: Continuum, 2004), 214–24.

24. Ibid., 9.

25. A neologism in English, "politicity" is a translation of the French *politicité*, indicating the capacity to be political.

26. Judith Butler, "What Is Critique? An Essay on Foucault's Virtue," *Transversal*, May 2001, http://fillip.ca/sqx1.

27. Ibid.

28. Margaret Thatcher, "Interview for *Woman's Own*," Margaret Thatcher Foundation, accessed March 27, 2012, http://fillip.ca/6fq9. Originally published in *Woman's Own*, September 23, 1987.

29. Ibid.

30. Jacques Rancière, *Disagreement: Politics and Philosophy*, trans. Julie Rose (Minnesota: University of Minnesota Press, 1998), 27.

31. Hannah Arendt, *Lectures on Kant's Political Philosophy*,

ed. Ronald Beiner (Chicago: University of Chicago Press, 1992), 66.

32. Matteo Pasquinelli, *Animal Spirits* (Rotterdam: NAi Publishers, 2008).

33. Alain Badiou, *Saint Paul: The Foundation of Universalism*, trans. Ray Brassier (Stanford: Stanford University Press, 2003), 63.

34. Ibid.

35. Jacques Rancière, "Literary Misunderstanding," trans. Mary Stevens, *Paragraph* 28, no. 2 (July 2005), 91–103.

36. Kishik, *The Power of Life*, 108.

37. Maurizio Lazzarato, "From Capital-Labour to Capital-Life," trans. V. Fournier, A. Virtanen, and J. Vähämäkip, in *ephemera: theory & politics in organization* 4, no. 3 (2004), 189.

38. Pasquinelli, *Animal Spirits*, 111.

39. Lazzarato, *From Capital-Labour to Capital-Life*, 199.

40. Ibid., 204.

41. Ibid., 205.

42. Rancière, *Disagreement*, 27.

Forum Discussion Transcript

November 19, 2011

Respondent: Clint Burnham

Identified Speakers: Lorna Brown, Juan Gaitán, Melanie Gilligan, Richard Ibghy, Olaf Nicolai, Monika Szewczyk, and Jan Verwoert

Clint Burnham: What I will do here is sort of an inverse Bataillian economy of surplus or waste, where I had done all this work beforehand from looking at two of the papers, and then there was one paper from today that I had not yet seen, so I took more notes on that, but I have two points for each paper and then we can maybe get a discussion going. I will start chronologically, with Melanie Gilligan.

There are two things I was thinking about around affect in particular, and around shared affect and the economic, and so on. I tweeted about this yesterday, because I have been thinking about barebacking and the economic. Barebacking, of course, is having sex without proper protection, and it especially refers to men having sex with each other without proper protection; it is a subculture that—at least according to Tim Dean, the queer theorist—has been around for the past ten or fifteen years, and, in his book *Unlimited Intimacy: Reflections on the Subculture of Barebacking* (2009), Dean talks about barebacking as being much more common, say, in North America than in Berlin, apparently, where guys will use protection. Dean talks about this in terms of the death drive, and this kind of jouissance…or as my friend said, it is like "juggling with knives."

Perhaps we can think about barebacking in terms of the subprime

mortgage and volatility crisis since 2008. I bring this up in conjunction, in part, because I saw both the films *Contagion* (2011) and *Margin Call* (2011) in the same week. *Margin Call* is the film about the subprime mortgage crisis. To a degree, both films deal with the idea of how much you know about what you are transmitting, about how dangerous or toxic it is, and the way in which that knowledge is actually irrelevant in comparison to the affect that surrounds your actions. This would be an example of fetishistic disavowal— and I am going to talk about fetish in a little bit—that is to say, the people buying and selling subprime mortgages know very well that these things are toxic and yet they still buy and sell them, so knowledge is not educating, in the same way men barebacking know very well that it is a very dangerous thing to do, to have sex without protection because of the risk of HIV transmission, and yet they still do it. So education in terms of addressing our rational selves is not very effective.

But then I also wanted to address the relationship between affect or affect theory and psychoanalysis, because it is a very fraught relationship. In some aspects of affect theory, for example by Massumi and the Deleuzians, there is this notion of the poverty of psychoanalysis, and from a psychoanalytic perspective of things, critics, like for example Bruce Fink, argue that affect theory is a poor man's psychoanalysis. This kind of debate is very productive and very useful, but when Melanie was talking about affect—and I cannot remember whether it was affect, feeling, or emotion…which is the membrane?

Melanie Gilligan: I called feeling a membrane.

<u>Clint Burnham:</u> Membrane—and we get back to barebacking—which is to say, affect would be the Real, feeling would be the Imaginary (that is, it is still personal), and emotion would be the Symbolic where things take on names and so on. Bruce Fink would argue that even affect is already Symbolic, it is already a language—you have to name things in some sort of way—that it is not before language. This is the critique of affect theory: affect theory proposes that affect is pre-individual or pre-language, whereas emotion, then, is social—it is shared in some kind of way, it is something in which we engage with the world.

Monika Szewczyk was talking about the Occupy movement earlier. When Antonia and I met earlier in the week, we were discussing the relation between this forum and Occupy. One interesting aspect of what Occupy is doing—which I think might be one of the most important legacies of the Occupy movement—is that it does not make demands. I presume everybody in this room has been in demonstrations where the problem is that you are asking the—whatever you want to call it—the "big Other," or the government, or "The Man," to do something, thereby giving them the ability to respond in a certain kind of way. In psychoanalytic terms, then, you are acting out as the hysteric. You are placing this demand onto the government or onto the private corporation or what have you. Whereas Occupy casts the media and the government in the role of the hysteric. It hysterizes the media and the government, causing them to ask: "What is your demand?" "What do you want?" The Occupy movement takes on the position of the analyst—to me, this is very interesting.

I also want to share three very quick little textual grabs, sound bites, about the fetish. From [Karl] Marx's *Capital* (1867): "A commodity appears, at first sight, a very trivial thing, and easily understood. Its analysis shows that it is, in reality, a very queer thing, abounding in metaphysical subtleties and theological niceties. So far as it is a value in use"—that is, use value—"there is nothing mysterious about it, whether we consider it from the point of view that by its properties it is capable of satisfying human needs, or that it first takes on these properties as the product of human labour. It is as clear as noon-day, that man, by his industry, changes the forms of the materials furnished by Nature, in such a way as to make them useful to him. The form of wood, for instance, is altered, by making a table out of it. Yet, for all that, the table remains to be that common, every-day thing, wood. But, so soon as it steps forth as a commodity, it changes into something transcendent. It not only stands with its feet on the ground, but, in relation to all other commodities, it stands on its head, and evolves out of its wooden brain grotesque ideas, far more wonderful than 'table-turning' ever was." And of course you know, because you have read this, the footnote to this section of text [See footnote 26a in Karl Marx, "The Fetishism of Commodities and the Secret Thereof," part 1, chap. 1, section 4, of *Capital*, vol. 1, 1887, http://fillip.ca/yauo.] refers to the fascination with seances in 1850s Germany, so that is what is referred to by the "table-turning," turning the table on its head.

And [Sigmund] Freud, from *Fetishism* (1927): "In later life, the fetishist feels that he enjoys yet another advantage from his substitute for a genital."—I was really thinking about

this in terms of art—"The meaning of the fetish is not known to other people, so the fetish is not withheld from him: it is easily accessible and he can readily obtain the sexual satisfaction attached to it. What other men have to woo and make exertions for can be had by the fetishist with no trouble at all." So we will just say that in the art world, what was previously devalued takes on an interest for the artist or for the art world itself precisely because it was devalued, and is therefore more readily available.

And finally, this quote by [Slavoj] Žižek on fetishistic disavowal, from *The Sublime Object of Ideology* (1989), about "the way we behave towards the materiality of money: we know very well that money, like all other material objects, suffers the effects of use, that its material body changes through time, but in the social *effectivity* of the market we none the less *treat* coins as if they consist 'of an immutable substance...'" The structure "of fetishistic disavowal is therefore the following: 'I know very well, but still...'"

Moving on, finally, to the discussion between Olaf and Antonia; there were two things I pulled out of there: one was that Olaf kept talking in this very interesting way about the trope of the mirror, as both a conceptual hook in his work and also embodied, as it were, in the work itself. On the one hand, you [Olaf] made the reference to [Jean] Baudrillard and the notion of the simulation or the simulacrum—which, as I always tell students, is a copy with no original. That is to say, the idea of the commodity itself is a simulacrum; you go into Toys 'R' Us and there are all the dolls, or the video games, and you say, "I want the fourth one from the left, that is the original."

I want to think about simulacra in Lacanian terms in relationship to the mirror. There is the mirror stage: you look in there and you see yourself, or what you think is yourself—it is an image; it appears more coherent, more capable than you yourself are. You identify with this image, but you are alienated from it at the same time, because it is not you, it is something that is over there. So this is Imaginary identification, whereas Symbolic identification is identifying with the point of view that looks at you from the outside.

At the very beginning of your conversation, Olaf, you talked about how, in 1996, you did not want to talk about the Eastern bloc. You wanted to resist that Symbolic identification, a Westerner's fetishization of, "Oh, what was it like in 1989? Tell me about Eastern Europe, tell me about..."—whether the person was from the left ("tell me about how wonderful socialism was") or from the right ("tell me about the horrors of totalitarianism"). I saw this as, in a way, a reaction against a kind of Symbolic identification.

Then what was very useful for me was your discussion around [Georg] Lukács. On the one hand Lukács argued against identifying fascism as rationalism in the 1930s. There was the Brecht-Lukács debate around that topic—"better the bad new days, than the good old days," as [Bertolt] Brecht put it. That debate was picked up again by Habermas— I do not want to do the obvious Marx quote of "first time tragedy, second time farce"—but [Jürgen] Habermas repeated that argument in the '80s with his resistance to French theory, seeing it as irrational; and I think he perhaps also identified Nietzscheism as a problem with French theory—its lack of humanism.

Of course, I haven't read [Walter] Benjamin in German, but to say that Benjamin knew nothing about art, this is something I just cannot accept. I certainly think he knew something about photography when he discusses mechanical reproducibility and aura. In talking about reproduction, to my mind, he addresses exactly your point about the attempt on the part of the GDR to break social class reproduction, by determining that if you were the son or the daughter of a doctor than you should become a bricklayer, but if you are the son or the daughter of a bricklayer, then you would go on to have a university education and so on. Which is almost like the cultural revolution in China, that notion that the intellectual or city people should leave the city, go to the country and work. And of course we still have, I think, that class competition. It is the dirty secret of the art world, right? The very lack of a representative class composition in terms of who ends up at these microphones—that is problematic. I think that it may have been this ham-fisted, bureaucratic, non-communist attempt to deal with what in the West is still a very real kind of problem. So that is where I am starting and we can see where it leads us…

Audience Member 1: Thank you, Clint. I am just going to ask you first to explain what you just said at the end. I do get your point that the "dirty little secret" of the art world is that everybody is of a certain class, but then…I think you were trying to say more than just that.

Clint Burnham: I think in some ways the "dirty little secret" plays out as a fantasy of an identification with Occupy, with the people, or the masses

or whatever—in a sort of fetishistic disavowal. With academics for example, it is a similar kind of situation where in the past couple of weeks we have been saying "We are the 99%," and yet as an academic—I mean, I have a job and if I get tenure in a few years, I am making a, say, six figure salary—I may be part of the 99% strictly speaking, but I am also part of the, say, top 5% within North America. The reason why there is a fantasy of identification, I think, on the part of intellectuals, artists, or academics—and I realize that there is a different economic status in which a lot of artists and probably everyone in this room finds themselves in comparison—but that identification (and this is Bourdieu 101) comes from the fact that intellectuals, artists, academics, what have you, are the oppressed class of the oppressing class. They are the bottom of the top, and so therefore they identify with the bottom of the entire spectrum, because they have the feeling that "Oh, well, I'm not as rich as George Soros, therefore I have more in common with somebody on the Downtown Eastside [of Vancouver]." That may be true objectively, and yet that ignores the role of cultural capital, of being in places like this on a Saturday, and having the time and education to think about things, and so on.

Audience Member 2: I was really interested in your discussion of barebacking, mostly because I have been doing some reading around this as well. Tim Dean talks about it in the sense of sharing this virus, as embodying a community that has this kind of new concept of intersubjectivity. In Melanie Gilligan's discussion, she mentioned the horizontal decision-making process

happening at Occupy as a new type of intersubjectivity.

Clint Burnham: The horizontality of decision-making at sites like Occupy is super interesting. I think there are two things that are interesting to me about what has happened in terms of what Occupy is doing itself, as opposed to attempts to oppress it or evacuate it. On the one hand, like I said, it creates a public space by taking over a public space. On the other, it creates new possibilities. People complain about the process of decision-making—like on the first day of Occupy in Vancouver, there were three hours of deciding what hand signals to use. Even though I am a Leninist, I still think that those things are very important. I think you can short circuit those things, but the fact that the Occupiers are engaging in that kind of discussion, for me, is tremendously productive and useful.

Melanie Gilligan: This point about a virus—i.e., an agent that is supposed to be damaging—also being something that could cohere a community, or that at least speaks to something that has cohered a community, I think that is interesting. It really picks up on Clint's point about how there are affects around fears that can be in excess of the thing you are afraid of. You were making this kind of parallel between, on the one hand, crises, bad debts, and, on the other hand, HIV. These are interesting parallels—they both can somehow cohere a community and, at the same time, there are affective fears for both; this multivalence is really interesting.

Juan A. Gaitán: This is more about Clint's earlier discussion.... First of all, I do not think it is a secret by any means that the intellectual world is a class that exists and continues to exist as an offshoot of the bourgeois principle. Once you acknowledge that, as you are asking us to do, what is the point?

Clint Burnham: To try to change it.

Juan A. Gaitán: But the way you present it, you are basically saying that intellectuals and artists are incapable of forming solidarity with the people in the Occupy movement. I do not know what your point is—the class issue is like all these pragmatic issues: the moment we start presenting them in this way, we are actually fragmenting society, approaching it from the point of view in which people are unable to communicate with each other. Of course we are on some level incapable of understanding each others' conditions, but an intellectual says, "I am part of the 99%." They know they are not, but they are existing in solidarity with—what do they call it—"the great minority." It is a way of approaching a problem while realizing that you are not necessarily the subject of its condition.

Clint Burnham: Yes, okay two things, Juan. I think that maybe it is an issue of disavowal. A concrete example of this would be this article I read in the *Chronicle of Higher Education*, which is the trade journal for postsecondary education in America. There they talk about the schools, about Cornel West and Žižek having gone to, or lectured at, Harvard or Boston, but there is no discussion of, for example, the role that tuition plays in the US in maintaining class division; no mention of the fact that those intellectuals themselves are very well compensated for their intellectual

transgressions. I like their intellectual transgressions and I hope to do some of my own, and maybe even make some of that money that they make, although it is not very likely, but the point is that the discussion does not always acknowledge these factors. And it is not a guilt trip I am talking about—there are structural inequities that are part of how that system itself works. And so what do we do about it? We try and create a society in which class does not play that kind of determinate role. Unlike other identity politics, the point is to get rid of class, not to celebrate class, not to have class culture day and class pride day. There should be no class pride day. Getting rid of class should be part of a left agenda, a critical intellectual artistic agenda.

Juan A. Gaitán: Of course we should get rid of class, but you are not the only one who wants this. There are right-wing politicians that want to get rid of class—basically eliminating those who are not part of their own class.

Monika Szewczyk: I am just going to piggyback on what [Juan] is saying. Not bareback [laughter].... I was really struck by what Olaf said about considering himself an entrepreneur—or the general notion of the artist as entrepreneur. It seems that a lot of people who are part of the Occupy Wall Street movement are in that kind of strange category also. They are quite entrepreneurial in a way that is not necessarily separate from the intellectual and the proletarian, but then these terms name quite antiquated notions of how class is divided. I think the situation is more messy, because of course we look around us and there are a lot of affluent people in the art world,

but there are also a lot of very poor people with aristocratic pretentions. There are really weirdly configured class categories. So maybe it is more interesting to consider that mess: the beginnings of the breakdown and the possibility of a solidarity in some ways. I guess I am agreeing with Juan and I want to hear a bit more of this notion of entrepreneurship.

Jan Verwoert: I find this discussion around class very interesting because it is a way of situating oneself within an economic scenario that is also a historical scenario. For example, how has profit been distributed in society? And people? I think in German history, the one force that almost pushed the class system to collapse was the Nazis. *The Damned* [Luchino Visconti, 1969] is a great film that analyzes this. By pushing the military-industrial complex to the point of absolute overproduction followed by the entire destruction of the country, Hitler also kind of destroyed [German] "old money." As a result, the upper class, after two lost world wars, was left relatively disempowered. That did not happen in Britain, for instance.... The reason why someone like [Claus von] Stauffenberg tried to stop Hitler was because Stauffenberg was part of a conservative resistance and he saw that Hitler would eventually destroy the class system. The class system in Britain was always a force of containment against modernism, but also against fascism. That is the irony. So on the one hand I would also, of course, be against class repression, but the idea to abolish the class system—when I look at the past of my country—I have bit of an ambivalent feeling towards that.

Thinking about the intellectual (not the academic), I had this experience last year when I was being audited.

I had to explain to the tax people why I was working and travelling like a business man, but had a salary approximating something like [makes gesture to indicate something very small]. "How can that be?" And it's not that the question is, "Why would you want to work like that?" I had to prove that the money I was not making actually did not exist. So my poverty was making me suspicious. If I had an academic job, tenure track and everything, these questions would not be raised. This is not a way of saying [my position] is subversive or in any way heroic—but you are suddenly faced with the consequences that someone is really fucking you up the ass, because you refuse to operate according to certain principles.

Berlin, in particular, has a kind of nasty feeling to it. The city is shit poor and tries to pretend that art—because it creates so much activity—will also create income. It is the lie that everybody thrives on and they are refusing to see that art is this constant activity that creates absolutely no income; it costs money, this activity. So suddenly someone has to pay for politicians desperately searching for the fiction of a new economy. It is particularly bitter when you think, "I'm lower middle class and my ability to talk is really my only ticket." I have nothing to fall back on apart from my skills. There are two historical figures that were also in the same position— unmoored from any class position through their sheer skill to speak, to observe, and to travel—and that is the liar and the fool. In the beginning of Spanish literature, there is a picture of Lázarillo who is a poor man's son, who gets kicked out, travels throughout society, always accompanying other liars, and who is, therefore, able to describe society. The other is

Candide, who also gets kicked out of paradise because he has a love affair. He is an idiot; he gets tossed around the world and sees everything. I feel that these are the people I am strangely condemned to be solidaric with: liars and fools.

Clint Burnham: This is an issue in the current municipal election—that artists are the biggest subsidizers of art, in the Canadian context at least. There is a debate about whether there should be state subsidiary, and yet most of the subsidies come from artists themselves working after-hours, or having another job, or having a spouse, or having a low income level, and so on. But I think in the art world, as in the academic world, there are some people who make a certain level of income, and then there are a lot of people who do not, and then end up leaving the field. So, in some ways, both systems depend on people who do not make money to maintain that system itself, exactly in the way that you are talking about. But then, cleaning ladies are not flying from one continent to another to be at conferences—or maybe some of them are?

Jan Verwoert: Yes, of course, there is a difference. But this difference is no longer one of income necessarily, but rather of a kind of circulation paradigm. Sometimes I feel like, "What is this pretense of cultural capital?"

Melanie Gilligan: What you are describing is a generalized condition in which a lot of people who earn a middle range of income are increasingly finding out that they are proletarianized. A lot of protests are happening because of this.

Clint Burnham: Student debt.

Melanie Gilligan: Yes, exactly—student debt. In North America, or at least in the US, a lot of the discussion around the Occupy movement or around the problems of the US economy right now are referring to middle class problems not being addressed, and yet, in a way the problems I am hearing about have a lot to do with what I would associate with the working class.

Audience Member 3: This discussion is making me feel an intense sort of frustration. I was thinking about my own experience in what has been this sort of ideological fight. I grew up in this place where intellectualism was looked down upon, and so it was a constant fight growing up to push past that in a way. Within the art world, I experience what I would call "ethical boundaries"— trying to continue to make work in an honest sort of way without compromising myself or feeling like I need to inhabit some sort of a higher class position.

Clint Burnham: Again, this reminds me of [Theodor W.] Adorno, who said something like "criticizing privilege becomes a privilege—the world's course is as dialectical as that." And yet we are all glad that these [forums] can happen. We know it takes a great deal of work in order to make them happen, and it is this volunteerism that we all provide that makes them possible.

Jan Verwoert: It is also important to hear from those who argue that there are different sources for determining value. Something like: "Okay. I am here because I want to do this. Period." No? Because all other values are then created through contextual

analysis—a commitment to something. That, then, creates value.

Audience Member 1: I guess you could call Walter Benjamin a fool, because I think he was a fool in a lot of ways—like the way he tried to live and continue living in Paris when everybody else had gone, including Adorno. He kept doing things that were foolish, like going back in time, and following the scent of [Charles] Baudelaire everywhere as if he was going to tell him something about the late '30s.

Richard Ibghy: I would like to bring the discussion back to something that Olaf said. You mentioned that, at one point [within the GDR], when people stopped using things either in quantity or things that were desired, money became useless and yet, people continue to have desires even though all their needs were met. What is interesting is that it is not money that is permitting them to get these things, it is other forms of behaviour. I would argue that the economy is fundamentally social—it is part of the social sphere, it is about behaviour and getting things that you want, but also about the spread of desires. So I am wondering, was there ever any thinking about these ways that people get what they want without money as actually being fundamentally part of economy and an integral part of economic forms of behaviour?

Olaf Nicolai: If you look at how Marx describes the transition from a feudalist to a capitalist economy, he emphasizes the transformation of social dependencies in this shift from a feudal economy based on social behaviours and relations to an economy based on the production

and exchange of commodities, as in capitalism. The more personal relationships in feudalism are replaced by abstract relationships. When you create an economy based on social exchange—it often is a poor economy, with no development. You have an economy that has no dynamics anymore—it is a mafia economy, a godfather economy: "I take care of you—behave! Do not worry, we manage things." It is the opposite of an economy based on money—which produces alienation. The ambivalent character of money appears as the contradictory connection between alienation and freedom, so freedom is a very difficult thing: freedom for what or from what, that is the question. What I want to suggest is a kind of dialectic, not simple oppositions, meaning that the opposite poles are mutually dependent with regard to their existence. If the proletariat disappears, the bourgeoisie is also gone. And that is what we have today. We have this kind of elaborate system where it's difficult to really say, "This is the proletarian in me, and this is the bourgeois in me." A lot of people who are now a part of the Occupy movement are not criticizing the system, or making demands, because they do not know what to demand. It is not about being smart; it is just that they do not know what to ask for. It is just a helpless moment and that is frightening, because, in these moments—like, as Jan pointed out, in the case of Germany in the twentieth century—the easiest answer to that helplessness is offered by right-wing politics. Often its answer lies in a critique of modernity: go back to the simple life, take care of your community. This is a populist answer that often carries quite a bit of weight within politics, and I am afraid of all these kinds of constellations. If you read what some

of this movement—the so-called multitudes—put out, sometimes you cannot believe it—not just because it is foolish, but because it's reactionary.

Regarding what I said about Benjamin: I want to be very clear, I am not calling him a fool. I disagree with Benjamin correlating political progress with the development of artistic means of production. That was a direct link for him, and, as an artist, I do not agree. It limits art to a social welfare activity, and art is not that; I mean it can be that, but it is much more. I experienced exactly this, living in a system in East Germany where art transgressed all the time—and it was a totally bourgeois art. It had to do with concepts of beauty, for example. There was a very nice short story by Chyngyz Aitmatov about a couple living under the conditions of capitalism whose love is not working out. What we learned in school is "OK, under socialism, this would not happen." [laughter] And I went: "Stop! No love troubles under socialism?" The real trouble starts when the social problems are solved.

Monika Szewczyk: I want to raise a bit of an issue with regard to this connection between today's moment and the '30s. I tend to make that connection, too—I am also afraid of the populists and, in a way, it does feel like late Weimar in Europe right now. It is freaky. But I also think that we [make this comparison] too much. It is actually very complicated. You [Olaf] were speaking about Lukács and the critique of irrationality in the Nazi cause, though there was an incredible emphasis on order and rationality in Nazi pageantry and propaganda, so we must assume that it could be both that can lead us down the path to the gas chambers. I think this kind of logic is really not productive.

Olaf Nicolai: I never mentioned gas chambers; I just was talking about totalitarianism.

Monika Szewczyk: Okay, take out the gas chambers, then. Just totalitarianism.

Jan Verwoert: Socialism—there are different kinds of socialism. If we discuss the history of socialism and radical social change—there is Marxist Socialism and National Socialism—and in all of the fantasies of revolution and the moments when revolutions are really enacted, there are historical examples of revolutions put into place by socialist movements, one being…

Monika Szewczyk: …of course. But I am seeing the discussion here, and there is a tendency to say, "What you are saying led us down that path." I am trying to acknowledge that logic, and say, "We have to open it up a bit." Maybe this is too constricting, because [the Nazi] example is so powerful that it makes everybody look extremely sad and freaked out…

Jan Verwoert: The point I am also trying to make, Monika, is that we are not so far apart from each other. I was just using irony as a way of saying I do not think flirting with radicalism is the answer. I am arguing for a more moderate path. I am against this flirtation with radicalism or flirtation with the idea of revolution, because I think that if you look at history, we might have to look at more complicated models of how to negotiate or renegotiate structures.

Lorna Brown: But is not the message of Occupy, *affect*? There is no rational, logical sound bite. The reason that it is capturing people's attention

is that it encapsulates anger, this dissatisfaction. Its message is not articulated in ways that whoever—the "big Other"—actually recognizes. And so it comes back again to this conversation around affect, emotion, and the membrane. Right?

Clint Burnham: And also, I think, blankness—the lack of affect in some ways, too. That is, not the people standing there holding signs being angry all day long; they are just setting up a tent and trying to figure out how to feed people—very boring kind of stuff, which, I guess, is another kind of affect. But I think that there is that side of things, around the notion of affect, and then the other side of things, around issues of spatiality and blankness.

Richard Ibghy: With respect to the silence of the Occupy movement, there is another way of reading it—through the logic of the "loaded question," where, no matter what answer you give, you are accepting the terms of the question. Sometimes the demands are so fundamentally radical, you want change on such a deep and epistemological level, that to even articulate something that could be changed is to accept the foundation that you want to disrupt to begin with. There is a way of thinking about protest in this way: we do not really know what this new space looks like because we have not even begun to change the kinds of desires that permit the manifestation and the propagation of the system that we live in now.

Melanie Gilligan: Thank you, Richard. I agree with you that we cannot really know what the appropriate way is to realize the kind of profound change that people feel needs to

happen, how that should come about. I also wanted to respond to Jan's last point. As I interpreted it, you were arguing that having the picture of revolution in mind is not necessarily productive, because of the sort of violence and rupture it can produce. I think that is an interesting point. What came to mind though, was the political system that we have today, despite what we were discussing regarding feudalism and how there were interesting things about pre-capitalism—it was overthrown and became, I think, a much better situation after the French Revolution. And that was a revolution that was creating incredible ruptures, incredible violence in everyday life, in a lot of ways, but also liberation of a lot of things in people's daily lives as well. A whole new evolution of society could happen from that point onward. In a way it is kind of what Olaf was saying before about capitalism: that it evokes this strong image in one's mind, and so in serving up a particular picture, more nuance may not be possible; in some way revolution might be a similar term. I feel like I can use both the words "capitalism" and "revolution" and that I could have a nuanced discussion, but I also understand that it may seem like an un-nuanced term in other contexts or for other people.

Juan A. Gaitán: I think I agree with you in a way. There was a discussion we had earlier this year with a group of friends who are from Egypt about the use of the word "revolution" and its relationship to what was happening in Tahrir Square. Some of us thought that word should be avoided, because it is immediately linked to a historical continuity to which it does not necessarily belong. As

Lorna was suggesting, the Occupy movement's lack of demands does not mean that it also lacks a point. Their point has been made, in a certain way—they are just making it in person, by choosing Wall Street as the site of their protest. Perhaps, if there were demands, it is very possible that the group of people would have disbanded. Their presence and their solidarity depends on a kind of temporary suspension of other aspects [of their identity, or politics] that would make them an irreconcilable group if fully expressed. This is how this movement of solidarity functions right now and this is why they need to remain, in some way, beyond the grasp of the segmented categories of normal society.

Melanie Gilligan: The absence of a demand also preserves the potential of their individuality to a certain extent. They do not have to assimilate to one particular identity for the group, or something. I also think—even though I am not sure if my presentation fully communicated this—the problem is, in a lot of senses, to be able to think of what is good for the collective at the same time as preserving one's individuality and subjecthood.

Jan Verwoert: Just one quick comment to this. It is true that it is not helpful to drag things back to a particular past. Yet when we talk about feeling, there are particular feelings in a family that kind of give a certain colouring to the way you hear specific words. I am only bringing this up now because I am curious about the emotional resonances of other people. My two great grandfathers were both working class, my two grandfathers wanted class mobility, and that is why they joined the Party…

Clint Burnham: ...the Nazi Party or the Communist Party? ...They joined the Nazi Party?

Jan Verwoert: ...The Nazi Party. They had better-looking uniforms and they had better technology. It was nothing to do with their rationalism, just the promise of entrepreneurial life and new technologies. The promise of revolution for my one grandfather was very concrete, very material. It had to do with motorcycles—fast revolving, no? And the whole Nazi promise.... And then he got a motorcycle and rode for them, and he crashed it and died. And so I think he probably made the wrong choice there, no? And so I am not going to make that same choice: fast-revolving vehicles? I am not going to get on a bike like that. That is what I hear when I hear the word "revolution." I am interested in these concrete emotional resonances, because I think on that level we understand what a word means.

Olaf Nicolai: I remember this nice story by Benjamin, who said that revolution is not characterized by speed, but rather it is embodied by the emergency break on a train—it is exactly the opposite, it is the stopping of movement.

Jan Verwoert: Getting back to what Melanie and Juan were saying: on the one hand, it is incredibly important to identify that a suspension of identity categories or representational claims allows for solidarity— it is amazing. [Giorgio] Agamben, in the *Coming Community,* writes that Tiananmen was a moment when people just wanted democracy as a manifestation of a historic singularity. And that is very, very true. But at the same time, Agamben also realized even within a generation skeptical of authority models and representing claims—that there seems to be also a problem that there is no potential spokesperson. We see that in Egypt now and also with Occupy.... It can't be [Julian] Assange, or Slavoj Žižek doing his Daffy Duck routine.... So, to a certain degree, even given our own skepticism, there is a general crisis of authority or authorship. What would it even mean? Who would be the voice? Who could authorize a voice that would then formulate a demand?

Monika Szewczyk: This crisis of authority is perhaps tied to the kind of drab procedural element of Occupy Wall Street. It seems to me that there is a real discipline there—trying to get around the problem [of authority], to formulate a way of pressing on without a strong figurehead. What that movement has understood is that it is a matter of practice, it is not about "How are we going to nominate the new authority?" The *thing* is its own authority and it somehow works through practice.

Jan Verwoert: ...or authorship...

Monika Szewczyk: Authority and authorship—I think both can be a real problem. This is exactly what happened in the Eastern bloc after the solidarity movement in Poland. If you claim authority too quickly, then you are finished—the thing is to delay that claim as long as possible, I think, and in the meantime, commit to a kind of practice that somehow resolves this condition not as a crisis but through an actual understanding of the condition itself. It is perhaps a bit of a lame thing to invoke, but we are living in a networked world that provides a kind of opportunity for practicing this lack of centralized authority.

Audience Member 4: I am wondering: the Occupy movement seems to be so specifically, and by design, leaderless—but I am not quite sure that there is a real question of authority. I think there is quite a bit of design around how authority is being played out. For example, you have the hashtag of Occupy, "#OWS," and that becomes the stand-in for the figurehead, or the [Guy Fawkes] mask that was so humorously taken up in the Spanish revolution last May. There is this hilarious picture of one of the police commissioners there looking very blank, very puzzled, and holding up this mask and saying, "We have captured him!"

Regarding this notion of the blank—it is interesting that you have a very strong Occupywallst.org, which is a central location for a kind of reflective practice, carefully documenting all of the activities [of OWS], putting up links to images, trying to create a kind of reflection of what is happening, to create a kind of narrative, to self-narrate the movement. As someone who is following this through Facebook, what I find interesting is that I have to force myself to go to the *New York Times* and other news sources to see what everyone else seeing. It seems to me that the Occupy movement—or the image of the Occupy movement in the collective imagination—is being produced by two opposing media engines. And it seems to me that within those two kinds of apparatuses and mechanisms you have the opportunity for a kind of blank: this space between these two perspectives creates an opportunity for a change in how people think. There was a *Washington Post* article a day or two ago that showed polls of what people think about the Tea Party and the Occupy Wall Street movement,

and what is interesting is that the vast majority of people, at least in the US, do not agree with either. It [OWS] is very unpopular, but, at the same time, there is an enormous percentage of people in the US who think that it would be very good for the rich to be taxed in order to help [the broader population]. So, what I am wondering is whether within this blank space between these two perspectives—this kind of ambiguity between what the mainstream media is saying and what the Occupy movement is saying about itself— if there is potential to influence the opinions of the voting public.

Lorna Brown: I am really appreciating what you have to say about this. I think this blankness has to do with the vocabulary and rhetoric that is developing out of the Occupy movement—like "mic checks," and various other types of tactics. With mic checks, its clear that what's about to unfold is a discourse around resistance. And yet any voice can say "mic check," and in any kind of context—so suddenly everybody is a performance artist.

Going back to Juan's comments about identification—in the injunction that came down yesterday [in Vancouver], the city and the courts are trying to say "yes, but." They are allowing people to go back to the space [they are occupying in Vancouver] during the day and so what they are really banishing are the tents. So is the issue staying overnight, or is it about the visible occupation of space? In every jurisdiction of every Occupy, the regulatory conditions of each particular space are being articulated in much more detail [than before], and people are starting to understand the conditions of public space much better.

Thinking about this broader question of a possible identification between those involved and those not involved in the Occupy movement, it might come back to this question of the right to public space. People in privileged positions have never questioned their right to be in public space—and this new articulation of regulations around public space may force them to engage in this kind of questioning.

Melanie Gilligan: I wanted to put together two different points that came up in the audience around Occupy: on the one hand, the question was raised about a crisis of authority...

Juan A. Gaitán: ...Jan was talking about authorship...

Melanie Gilligan: ...Yes, a crisis of authorship that got converted into a crisis of authority—it still works for my point. And on the other hand, somebody suggested earlier that within the movement, the figurehead has been replaced by the meme, or a hashtag. It was interesting, there were these really heavy-duty protests just the other day in New York, and on TV they were discussing the new meme that came out of it—something like, "You cannot evict an idea." It occurs to me that, in some ways, the ways in which celebrity and authority are constituted might be changing. This slightly different configuration has to do with a changing scale of time in general of our lives. We have an ever-expanding population, there is also less and less a sense of a centre. On a micro-scale, you look at the art world and the way it has transformed: there used to be a much more stable star system not that long ago. And I remember that,

at some point in the early 2000s, it felt like things were becoming much more multiple. This bandwidth [of stardom] was becoming shorter and shorter. I honestly think that there is a transformation that has been happening for quite a while related to the role of authors and figureheads.

Jan Verwoert: Can I just clarify the difference between authorship and authority, because it might be interesting. Benjamin writes about the author as producer, because authorship—if you dissociate it slightly from authority, or claims to representation—can also be a skill set, one that you can put at the disposal of a collective. I just had a super positive experience with a political group in Berlin where it was actually possible to formulate collective demands. You just have to spend some time, be patient, get everybody to write something, and then someone who has trained themselves to write, like myself, can sit down and write a coherent text out of it—which does not represent my authority, I am just using my authorship as a skill that is then put at the group's disposal. With the process that you are describing, things become more multiple on the one hand, but, also, certain skills are lost that could be put at the disposal of such a situation. That is the moment when it is not necessarily about personality, it is not necessarily about leadership, but it is almost about techniques— techniques for constructing a voice that, if it is authorized, does not even have to be the voice of one person, but rather, perhaps, that of a collective subjectivity created through a particular kind of skill set of authorship.

Plate 1

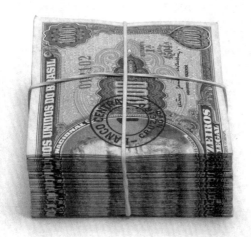

Plate 2

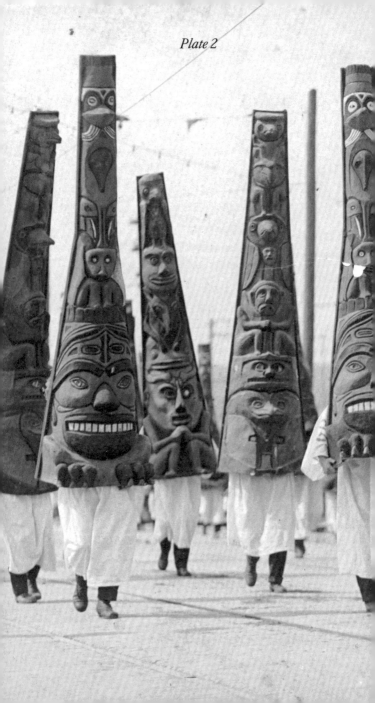

Plate 2

Plate 3

Plate 4

Calvin Klein
underwear

Plate 5

Plate 6

Plate 7

BILLBOARDS

THEY ARE BLANK

WHAT A WASTE

COULD HAVE BEEN USED FOR ART

Plate 1
Cildo Meireles, *Tree of Money*, 1969. One hundred folded One Cruzeiro banknotes. Photo by Pat Kilgore. Courtesy of Galerie Lelong, New York.

Plate 2
The Tilikums of Elttaes at the Golden Potlatch Parade, 1912. Courtesy of University of Washington.

Plate 3
Gagaku dance mask (the unhappy husband), c. 1550, Japan.

Plate 4
Mario Sorrenti, Calvin Klein ad, 1993.

Plate 5
Andrea Fraser, *May I Help You?*, 1991. Stills from performance documentation. Photos by Lamay Photo. Courtesy of Friedrich Petzel Gallery, New York.

Plate 6
David Shankbone, protesters at Occupy Wall Street, New York, 2011.

Plate 7
David Shrigley, *Untitled*, 2011. Acrylic and ink on paper. 29.7 × 21 cm. Courtesy of BQ, Berlin.

Clint Burnham teaches at Simon Fraser University in Burnaby and Surrey, British Columbia, Canada. His latest book, *The Only Poetry that Matters: Reading the Kootenay School of Writing*, was published by Arsenal Pulp Press in 2011. His art criticism has appeared in *Artforum*, *Fillip*, and the *Times-Colonist*, and he has lectured at the Art Institute of Chicago, Witte de With Center for Contemporary Art (Rotterdam), and the Carnegie Community Centre (Vancouver). He lives in Mount Pleasant, Vancouver.

Juan A. Gaitán is a curator and writer. Recent exhibitions include *I*, YAMA (Istanbul); *The End of Money*, Witte de With Center for Contemporary Art (Rotterdam); *Models for Taking Part*, Presentation House Gallery (Vancouver) and Justina M. Barnicke Gallery (Toronto); and *K*, CCA Wattis Institute for Contemporary Arts (San Francisco). His writing has been published in *Afterall*, *The Exhibitionist*, and *Mousse*, among others. Gaitán currently lives in Mexico City.

Melanie Gilligan is an artist and writer based in London and New York. Gilligan has written for magazines and journals such as *Texte zur Kunst*, *Mute*, *Artforum*, and *Grey Room*. In 2008, Gilligan released *Crisis in the Credit System*, a four-part fictional mini-drama made specifically for Internet viewing. Her most recent serial video works, *Popular Unrest* and *Self-Capital*, look at the current state of politics in the midst of capital's ongoing crisis.

Hadley+Maxwell have been working together since 1997. They have performed, published, and exhibited their work internationally in solo exhibitions at the Contemporary Art Gallery (Vancouver), Künstlerhaus Bethanien (Berlin), Kunstverein Göttingen, and SMART Project Space (Amsterdam), among others, and in group exhibitions at the National Gallery of Canada (Ottawa), the Taipei Fine Arts Museum, the Seattle Art Museum, La Kunsthalle Mulhouse, Witte de With Center for Contemporary Art (Rotterdam), Manif d'art 5 de Québec (Quebec City), and the 4th Marrakech Biennale. They studied media philosophy at the European Graduate School in Switzerland (2004), teach at the Piet Zwart Institute in Rotterdam, and live in Berlin.

Antonia Hirsch is Associate Editor at Fillip and an artist whose work has been exhibited at the Contemporary Art Gallery (Vancouver), the Power Plant (Toronto), the Taipei Fine Arts Museum, Tramway (Glasgow), and ZKM Museum of Contemporary Art (Karlsruhe), among others. Her work can be found in public collections such as that of the Vancouver Art Gallery, the National Gallery of Canada (Ottawa), and the Sackner Archive of Concrete & Visual Poetry (Miami Beach). Her writing and projects have appeared in publications including *artecontexto*, *C Magazine*, *Fillip*, and *The Happy Hypocrite*.

Candice Hopkins is a curator at the National Gallery of Canada (Ottawa) and former Director and Curator of Exhibitions at the Western Front (Vancouver). Her writing has been published by MIT Press, Black Dog Publishing, New York University Press, and the National Museum of the American Indian (Washington, DC), among others. She has lectured at Witte de With Center for

Contemporary Art (Rotterdam), Tate Modern and Tate Britain (London), and the 2004 Dakar Biennale, among others. In 2012, she led the residency *Trading Post* at the Banff Centre, which looked at the relationships between indigenous forms of economy and exchange, and she was a keynote speaker for dOCUMENTA (13) on the topic of sovereign imagination.

Olaf Nicolai is an artist who lives and works in Berlin. His work has been exhibited at documenta X, the Sydney Biennale 2002, the 51st Venice Biennale, and the Busan Biennale 2012, as well as at the Moderna Museet (Stockholm), the Museum of Modern Art (New York), the Kestnergesellschaft (Hanover), and Kunsthalle Münster, among others. He teaches at the Akademie der Bildenden Künste München.

Patricia Reed is an artist and writer who has participated in research and residency programs including at CCA Kitakyushu, Akademie Schloss Solitude (Stuttgart), the Banff Centre, and CCA Ujazdowski (Warsaw). She exhibits internationally, with recent and upcoming shows at Kunsthaus Langenthal; Botkyrka Konsthall (Stockholm), 0047 Projects (Oslo), the Limerick Art Gallery, Audain Gallery (Vancouver), PROGRAM (Berlin), and Württembergischer Kunstverein (Stuttgart). As a writer, Reed has contributed to magazines and journals including *Art Papers*, *C Magazine*, *Fillip*, *Framework*, *Shifter*, and *YYZ Essays*. Selected book contributions include *Cognitive Architecture* (010 Publishers, 2010), *And The Seasons* (0047, 2011), *Waking Up From The Nightmare of Participation* (Expodium, 2011), and *Critical Spatial Practice* (Sternberg, 2012).

Monika Szewczyk divides her time between writing, curating, editing, and teaching. She has contributed essays to numerous catalogues as well as journals such as *Afterall*, *A Prior*, *C Magazine*, *Camera Austria*, *Canadian Art*, *F.R. DAVID*, *Mousse*, and *e-flux journal*, which has published installments of her ongoing project, *Art of Conversation*. Between 2008 and 2012, she was head of publications at Witte de With Center for Contemporary Art and a tutor at the Piet Zwart Institute, both in Rotterdam. Previously, Szewczyk was Assistant Curator at the Vancouver Art Gallery and an instructor at Emily Carr University of Art + Design (Vancouver). As of July 2012 she holds the position of Visual Arts Program Curator at the Reva and David Logan Center for the Arts, University of Chicago.

Jan Verwoert is a Berlin-based critic and author of *Bas Jan Ader: In Search of the Miraculous* (2006) published by MIT Press/Afterall Books. *Tell Me What You Want, What You Really, Really Want*, a comprehensive collection of his essays, was co-published by Sternberg Press and the Piet Zwart Institute in 2010. Verwoert teaches at the Piet Zwart Institute (Rotterdam), De Appel Curatorial Programme (Amsterdam), and the Hamidrasha School of Art (Tel Aviv).

Fillip Staff Listing

Fillip gratefully acknowledges the ongoing support of
the Andy Warhol Foundation for the Visual Arts, the
City of Vancouver, the Canada Council for the Arts, and
the British Columbia Arts Council.

Colophon

Intangible Economies
Published by Fillip Editions
Folio Series: B
Editor: Antonia Hirsch
Copyeditor: Jaclyn Arndt
Design: The Future
Printed in Belgium by Die Keure

This book was made possible through the support
of the Canada Council for the Arts.

Fillip's Folio Series presents anthologies of new and previously published
writing by critics, artists, and curators that engages specific and recurring
questions on international contemporary art.

Cataloguing data available from Library and Archives Canada.

Fillip Editions
305 Cambie Street
Vancouver, BC
Canada V6B 2N4
www.fillip.ca